D1257287

CIRCLE

CIRCLE

INTERNATIONAL SURVEY OF CONSTRUCTIVE ART

EDITORS

J. L. MARTIN BEN NICHOLSON N. GABO

LONDON

FABER AND FABER LIMITED

First published in 1937
by Faber and Faber Limited
3 Queen Square London WC1
Reprinted 1971
Printed in Great Britain by
John Dickens & Co Ltd Northampton

ISBN 0 571 09552 6 (cloth edition)
ISBN 0 571 09553 4 (paper edition)

EDITORIAL

A NEW cultural unity is slowly emerging out of the fundamental changes which are taking place in our present-day civilization; but it is unfortunately true that each new evidence of creative activity arouses a special opposition, and this is particularly evident in the field of art. The inaccessibility of certain branches of science at least relieves the scientist from outside interference: the obvious utility of other advances gives the technician more or less freedom—it is not, of course, difficult to recall several far-reaching innovations which the public has shown itself willing to accept. But the creative work of the artist, for which it is difficult to claim any of the more practical virtues, is never free from interference in one form or another. Even a new development in architecture where it is certainly possible to show an advance in efficiency and economy of means, will not necessarily find itself applauded when it becomes clear that architecture, in changing its means, must also change its formal appearance.

It is indeed fair to say, that popular taste, caste prejudice, and the dependence upon private enterprise, completely handicap the development of new ideas in art. But, in spite of this, the ideas represented by the work in this book have grown spontaneously in most countries of the world. The fact that they have, in the course of the last twenty years, become more crystallized, precise, and more and more allied to the various domains of social life, indicates their organic growth in the mind of society and must prove that these creative activities cannot be considered as the temporary mood of an artistic sect, but are, on the contrary, an essential part of the cultural development of our time.

In starting this publication we have a dual purpose; firstly, to bring this work before the public, and secondly, to give to artists—painters, sculptors, architects and writers—the means of expressing their views and of maintaining contact with each other. Our aim is to gather here those forces which seem to us to be working in the same direction and for the same ideas, but which are,

v

at the moment scattered, many of the individuals working on their own account and lacking any medium for the interchange of ideas.

Finally, this publication is not intended to be merely an impartial and disinterested survey of every kind of modern art. At the same time, we have no intention of creating a particular group circumscribed by the limitations of personal manifestos: the combined range of contributors represented here is a large one. We have, however, tried to give this publication a certain direction by emphasising, not so much the personalities of the artists as their work, and especially those works which appear to have one common idea and one common spirit: the constructive trend in the art of our day. By placing this work side by side we hope to make clear a common basis and to demonstrate, not only the relationship of one work to the other but of this form of art to the whole social order.

CONTENTS

CONTENTS

viii

THE CONSTRUCTIVE IDEA IN ART
By N. Gabo

OUR century appears in history under the sign of revolutions and disintegration. The revolutions have spared nothing in the edifice of culture which had been built up by the past ages. They had already begun at the end of the last century and proceeded in ours with unusual speed until there was no stable point left in either the material or the ideal structure of our life. The war was only a natural consequence of a disintegration which started long ago in the depths of the previous civilization. It is innocent to hope that this process of disintegration will stop at the time and in the place where we want it to. Historical processes of this kind generally go their own way. They are more like floods, which do not depend on the strokes of the oarsmen floating on the waters. But, however long and however deep this process may go in its material destruction, it cannot deprive us any more of our optimism about the final outcome, since we see that in the realm of ideas we are now entering on the period of reconstruction.

We can find efficient support for our optimism in those two domains of our culture where the revolution has been the most thorough, namely, in Science and in Art. The critical analysis in natural science with which the last century ended had gone so far that at times the scientists felt themselves to be in a state of suspension, having lost most of the fundamental bases on which they had depended for so many centuries. Scientific thought suddenly found itself confronted with conclusions which had before seemed impossible, in fact the word 'impossibility' disappeared from the lexicon of scientific language. This brought the scientists of our century to the urgent task of filling up this emptiness. This task now occupies the main place in all contemporary scientific works. It consists in the construction of a new stable model for our apprehension of the universe.

THE CONSTRUCTIVE IDEA IN ART

However dangerous it may be to make far-reaching analogies between Art and Science, we nevertheless cannot close our eyes to the fact that at those moments in the history of culture when the creative human genius had to make a decision, the forms in which this genius manifested itself in Art and in Science were analogous. One is inclined to think that this manifestation in the history of Art lies on a lower level than it does in the history of Science, or at least on a level which is accessible to wider social control. The terminology of Science alone plunges a layman into a state of fear, humility and admiration. The inner world of Science is closed to an outsider by a curtain of enigmas. He has been educated to accept the holy mysticism of these enigmas since the beginning of culture. He does not even try to intrude in this world in order to know what happens there, being convinced that it must be something very important since he sees the results in obvious technical achievements. The average man knows, for instance, that there is electricity and that there is radio and he uses them every day. He knows the names of Marconi and Edison, but it is doubtful whether he has ever heard anything about the scientific work of Hertz, and there is no doubt that he has never heard anything about the electro-magnetic waves theory of Maxwell or his mathematical formulae.

Not so is the attitude of the average man to Art. Access to the realm of Art is open to every man. He judges about Art with the unconstrained ease of an employer and owner. He does not meditate about those processes which brought the artist or the group of artists to make one special kind of Art and not another, or if occasionally he does he never relinquishes his right to judge and decide, to accept or reject; in a word, he takes up an attitude which he would never allow himself to take with Science. He is convinced that on his judgments depend the value and the existence of the work of art. He does not suspect that through the mere fact of its existence a work of art has already performed the function for which it has been made and has affected his concept of the world regardless of whether he wants it to or not. The creative processes in the domain of Art are as sovereign as the creative processes in Science. Even for many theorists of Art the fact remains unperceived that the same spiritual state propels artistic and scientific activity at the same time and in the same direction.

At first sight it seems unlikely that an analogy can be drawn between a scientific work of, say, Copernicus and a picture by Raphael, and yet it is not difficult to discover the tie between them. In fact Copernicus' scientific theory of the world is coincident with Raphael's concept in Art. Raphael would

2

never have dared to take the naturalistic image of his famous Florentine pastry-cook as a model for the 'Holy Marie' if he had not belonged to the generation which was already prepared to abandon the geocentric theory of the universe. In the artistic concept of Raphael there is no longer any trace of the mythological religious mysticism of the previous century as there is no longer any trace of this mysticism in Copernicus' book, *The Revolution of the Celestial Orbits*. In the work of both, the earth is no longer the cosmic centre and man is no longer the crown of creation and the only hero of the cosmic drama; both are parts of a larger universe and their existence does not any more appear as the mystical and dematerialized phenomenon of the mediaeval age. At that time one and the same spirit governed the artistic studios of Florence and held sway under the arches of the Neapolitan Academy for the Empirical Study of Nature led by Telesio. This tie between Science and Art has never ceased to exist throughout the history of human culture, and we can discern it in whatever section of history we look. This fact explains many phenomena in the spiritual processes of our own century which brought our own generation to the Constructive idea in Art.

The immediate source from which the Constructive idea derives is Cubism, although it had almost the character of a repulsion rather than an attraction. The Cubistic school was the summit of a revolutionary process in Art which was already started by the Impressionists at the end of the last century. One may estimate the value of particular Cubistic works as one likes, but it is incontestable that the influence of the Cubistic ideology on the spirits of the artists at the beginning of this century has no parallel in the history of Art for violence and intrepidity. The revolution which this school produced in the minds of artists is only comparable to that which happened at approximately the same time in the world of physics. Many falsely assume that the birth of Cubistic ideology was caused by the fashion for negro art which was prevalent at that time; but in reality Cubism was a purely European phenomenon and its substance has nothing in common with the demonism of primitive tribes. The Cubistic ideology has a highly differentiated character and its manifestation could only be possible in the atmosphere of a refined culture. In fact it wants an especially sharpened and cultivated capacity for analytic thought to undertake the task of revaluation of old values in Art and to perform it with violence as the Cubistic school did. All previous schools in Art have been in comparison merely reformers, Cubism was a revolution. It was directed against the fundamental basis of Art. All that was before holy and intangible for an artistic mind,

3

namely, the formal unity of the external world, was suddenly laid down on their canvases, torn in pieces and dissected as if it were a mere anatomical specimen. The borderline which separated the external world from the artist and distinguished it in forms of objects disappeared; the objects themselves disintegrated into their component parts and a picture ceased to be an image of the visible forms of an object as a unit, a world in itself, but appeared as a mere pictural analysis of the inner mechanism of its cells. The medium between the inner world of the artist and the external world has lost its extension, and between the inner world of the perceptions of the artist and the outer world of existing things there was no longer any substantial medium left which could be measured either by distance or by mind. The contours of the external world which served before as the only guides to an orientation in it were erased; even the necessity for orientation lost its importance and was replaced by other problems, those of exploration and analysis. The creative act of the Cubists was entirely at variance with any which we have observed before. Instead of taking the object as a separate world and passing it through his perceptions producing a third object, namely the picture, which is the product of the first two, the Cubist transfers the entire inner world of his perceptions with all its component parts (logic, emotion and will) into the interior of the object penetrating through its whole structure, stretching its substance to such an extent that the outside integument explodes and the object itself appears destroyed and unrecognizable. That is why a Cubistic painting seems like a heap of shards from a vessel exploded from within. The Cubist has no special interest in those forms which differentiate one object from another.

Although the Cubists still regarded the external world as the point of departure for their Art they did not see and did not want to see any difference between, say, a violin, a tree, a human body, etc. All those objects were for them only one extended matter with a unique structure and only this structure was of importance for their analytic task. It is understandable that in such an artistic concept of the world the details must possess unexpected dimensions and the parts acquire the value of entities, and in the inner relations between them the disproportion grows to such an extent that all inherited ideas about harmony are destroyed. When we look through a Cubistic painting to its concept of the world the same thing happens to us as when we enter the interior of a building which we know only from a distance—it is surprising, unrecognizable and strange. The same thing happens which occurred in the world of physics when the new Relativity Theory destroyed the borderlines between Matter and

4

Energy, between Space and Time, between the mystery of the world in the atom and the consistent miracle of our galaxy.

I do not mean to say by this that these scientific theories have affected the ideology of the Cubists, one must rather presume that none of those artists had so much as heard of or studied those theories. It is much more probable that they would not have apprehended them even if they had heard about them, and in the end it is entirely superfluous. The state of ideas in this time has brought both creative disciplines to adequate results, each in its own field, so that the edifice of Art as well as the edifice of Science was undermined and corroded by a spirit of fearless analysis which ended in a revolutionary explosion. Yet the destruction produced in the world of Art was more violent and more thorough.

Our own generation found in the world of Art after the work of the Cubists only a conglomeration of ruins. The Cubistic analysis had left for us nothing of the old traditions on which we could base even the flimsiest foundation. We have been compelled to start from the beginning. We had a dilemma to resolve, whether to go further on the way of destruction or to search for new bases for the foundation of a new Art. Our choice was not so difficult to make. The logic of life and the natural artistic instinct prompted us with its solution.

The logic of life does not tolerate permanent revolutions. They are possible on paper but in real life a revolution is only a means, a tool but never an aim. It allows the destruction of obstacles which hinder a new construction, but destruction for destruction's sake is contrary to life. Every analysis is useful and even necessary, but when this analysis does not care about the results, when it excludes the task of finding a synthesis, it turns to its opposite, and instead of clarifying a problem it only renders it more obscure. Life permits to our desire for knowledge and exploration the most daring and courageous excursions, but only to the explorers who, enticed far away into unknown territories, have not forgotten to notice the way by which they came and the aim for which they started. In Art more than anywhere else in the creative discipline, daring expeditions are allowed. The most dizzying experiments are permissible, but even in Art the logic of life arrests the experiments as soon as they have reached the point when the death of the experimental objects becomes imminent. There were moments in the history of Cubism when the artists were pushed to these bursting points; sufficient to recall the sermons of Picabia, 1914-16, predicting the wreck of Art, and the manifestos of the Dadaists who already celebrated the funeral of Art with chorus and demonstrations. Realizing how near to com-

plete annihilation the Cubist experiments had brought Art, many Cubists themselves have tried to find a way out, but the lack of consequence has merely made them afraid and has driven them back to Ingres (Picasso, 1919-23) and to the Gobelins of the sixteenth century (Braque, etc.). This was not an outlet but a retreat. Our generation did not need to follow them since it has found a new concept of the world represented by the Constructive idea.

The Constructive idea is not a programmatic one. It is not a technical scheme for an artistic manner, nor a rebellious demonstration of an artistic sect; it is a general concept of the world, or better, a spiritual state of a generation, an ideology caused by life, bound up with it and directed to influence its course. It is not concerned with only one discipline in Art (painting, sculpture or architecture) it does not even remain solely in the sphere of Art. This idea can be discerned in all domains of the new culture now in construction. This idea has not come with finished and dry formulas, it does not establish immutable laws or schemes, it grows organically along with the growth of our century. It is as young as our century and as old as the human desire to create.

The basis of the Constructive idea in Art lies in an entirely new approach to the nature of Art and its functions in life. In it lies a complete reconstruction of the means in the different domains of Art, in the relations between them, in their methods and in their aims. It embraces those two fundamental elements on which Art is built up, namely, the Content and the Form. These two elements are from the Constructive point of view one and the same thing. It does not separate Content from Form—on the contrary, it does not see as possible their separated and independent existence. The thought that Form could have one designation and Content another cannot be incorporated in the concept of the Constructive idea. In a work of art they have to live and act as a unit, proceed in the same direction and produce the same effect. I say 'have to' because never before in Art have they acted in such a way in spite of the obvious necessity of this condition. It has always been so in Art that either one or the other predominated, conditioning and predetermining the other.

This was because in all our previous Art concepts of the world a work of art could not have been conceived without the representation of the external aspect of the world. Whichever way the artist presented the outside world, either as it is or as seen through his personal perceptions, the external aspect remained as the point of departure and the kernel of its content. Even in those cases where the artist tried to concentrate his attention only on the inner world of his perceptions and emotions, he could not imagine the picture of this inner

world without the images of the outer one. The most that he could dare in such cases was the more or less individual distortions of the external images of Nature; that is, he altered only the scale of the relations between the two worlds, always keeping to the main system of its content, but did not attack the fact of their dependence; and this indestructible content in a work of art always predicted the forms which Art has followed down to our own time.

The apparently ideal companionship between Form and Content in the old Art was indeed an unequal division of rights and was based on the obedience of the Form to the Content. This obedience is explained by the fact that all formalistic movements in the history of Art, whenever they appeared, never went so far as to presume the possibility of an independent existence of a work of art apart from the naturalistic content, nor to suspect that there might be a concept of the world which could reveal a Content in a Form.

This was the main obstacle to the rejuvenation of Art, and it was at this point that the Constructive idea laid the cornerstone of its foundation. It has revealed an universal law that the elements of a visual art such as lines, colours, shapes, possess their own forces of expression independent of any association with the external aspects of the world; that their life and their action are self-conditioned psychological phenomena rooted in human nature; that those elements are not chosen by convention for any utilitarian or other reason as words and figures are, they are not merely abstract signs, but they are immediately and organically bound up with human emotions. The revelation of this fundamental law has opened up a vast new field in art giving the possibility of expression to those human impulses and emotions which have been neglected. Heretofore these elements have been abused by being used to express all sorts of associative images which might have been expressed otherwise, for instance, in literature and poetry.

But this point was only one link in the ideological chain of the constructive concept, being bound up with the new conception of Art as a whole and of its functions in life. The Constructive idea sees and values Art only as a creative act. By a creative act it means every material or spiritual work which is destined to stimulate or perfect the substance of material or spiritual life. Thus the creative genius of Mankind obtains the most important and singular place. In the light of the Constructive idea the creative mind of Man has the last and decisive word in the definite construction of the whole of our culture. To be sure, the creative genius of Man is only a part of Nature, but from this part alone derives all the energy necessary to construct his spiritual and material edifice. Being a

7

result of Nature it has every right to be considered as a further cause of its growth. Obedient to Nature, it intends to become its master; attentive to the laws of Nature it intends to make its own laws, following the forms of Nature it re-forms them. We do not need to look for the origin of this activity, it is enough for us to state it and to feel its reality continually acting on us. Life without creative effort is unthinkable, and the whole course of human culture is one continuous effort of the creative will of Man. Without the presence and the control of the creative genius, Science by itself would never emerge from the state of wonder and contemplation from which it is derived and would never have achieved substantial results. Without the creative desire Science would go astray in its own schemes, losing its aim in its reasoning. No criterion could be established in any spiritual discipline without this creative will. No way could be chosen, no direction indicated without its decision. There are no truths beyond its truths. How many of them life hides in itself, how different they are and how inimical. Science is not able to resolve them. One scientist says, 'The truth is here'; another says, 'It is there'; while a third says, 'It is neither here nor there, but somewhere else'. Everyone of them has his own proof and his own reason for saying so, but the creative genius does not wait for the end of their discussion. Knowing what it wants, it makes a choice and decides for them.

The creative genius knows that truths are possible everywhere, but only those truths matter to it which correspond to its aims and which lie in the direction of its course. The way of a creative mind is always positive, it always asserts; it does not know the doubts which are so characteristic of the scientific mind. In this case it acts as Art.

The Constructive idea does not see that the function of Art is to represent the world. It does not impose on Art the function of Science. Art and Science are two different streams which rise from the same creative source and flow into the same ocean of the common culture, but the currents of these two streams flow in different beds. Science teaches, Art asserts; Science persuades, Art acts; Science explores and apprehends, informs and proves. It does not undertake anything without first being in accord with the laws of Nature. Science cannot deal otherwise because its task is knowledge. Knowledge is bound up with things which are and things which are, are heterogeneous, changeable and contradictory. Therefore the way to the ultimate truth is so long and difficult for Science.

The force of Science lies in its authoritative reason. The force of Art lies

8

in its immediate influence on human psychology and in its active contagious-ness. Being a creation of Man it re-creates Man. Art has no need of philosophical arguments, it does not follow the signposts of philosophical systems; Art, like life, dictates systems to philosophy. It is not concerned with the meditation about what is and how it came to be. That is a task for Knowledge. Knowledge is born of the desire to know, Art derives from the necessity to communicate and to announce. The stimulus of Science is the deficiency of our knowledge. The stimulus of Art is the abundance of our emotions and our latent desires. Science is the vehicle of facts—it is indifferent, or at best tolerant, to the ideas which lie behind facts. Art is the vehicle of ideas and its attitude to facts is strictly partial. Science looks and observes, Art sees and foresees. Every great scientist has experienced a moment when the artist in him saved the scientist. 'We are poets', said Pythagoras, and in the sense that a mathematician is a creator he was right.

In the light of the Constructive idea the purely philosophical wondering about real and unreal is idle. Even more idle is the intention to divide the real into super-real and sub-real, into conscious reality and sub-conscious reality. The Constructive idea knows only one reality. Nothing is unreal in Art. What-ever is touched by Art becomes reality, and we do not need to undertake re-mote and distant navigations in the sub-conscious in order to reveal a world which lies in our immediate vicinity. We feel its pulse continually beating in our wrists. In the same way we shall probably never have to undertake a voy-age in inter-stellar space in order to feel the breath of the galactic orbits. This breath is fanning our heads within the four walls of our own rooms.

There is and there can be only one reality—existence. For the Construc-tive idea it is more important to know and to use the main fact that Art possesses in its own domain the means to influence the course of this existence enriching its content and stimulating its energy.

This does not mean that this idea consequently compels Art to an imme-diate construction of material values in life; it is sufficient when Art prepares a state of mind which will be able only to construct, co-ordinate and perfect in-stead of to destroy, disintegrate and deteriorate. Material values will be the inevitable result of such a state. For the same reason the Constructive idea does not expect from Art the performance of critical functions even when they are directed against the negative sides of life. What is the use of showing us what is bad without revealing what is good? The Constructive idea prefers that Art perform positive works which lead us towards the best. The measure of this

9

perfection will not be so difficult to define when we realize that it does not lie outside us but is bound up in our desire and in our will to it. The creative human genius, which never errs and never mistakes, defines this measure. Since the beginning of Time man has been occupied with nothing else but the perfecting of his world.

To find the means for the accomplishment of this task the artist need not search in the external world of Nature; he is able to express his impulses in the language of those absolute forms which are in the substantial possession of his Art. This is the task which we constructive artists have set ourselves, which we are doing and which we hope will be continued by the future generation.

I. PAINTING

1. MALEVICH 1916

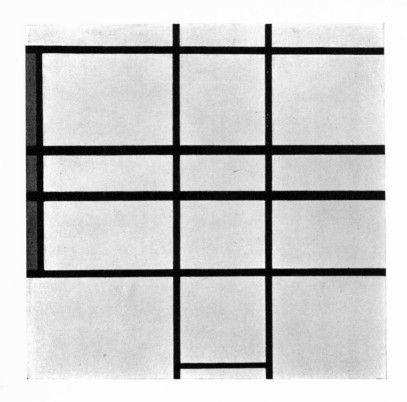

2. MONDRIAN 1935-36

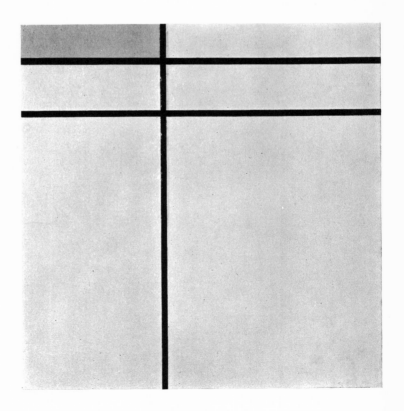

3. MONDRIAN 1934

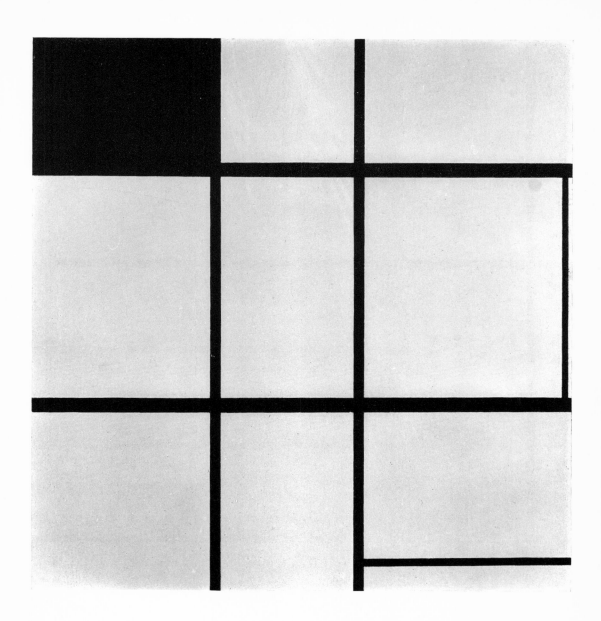

4. MONDRIAN 1934

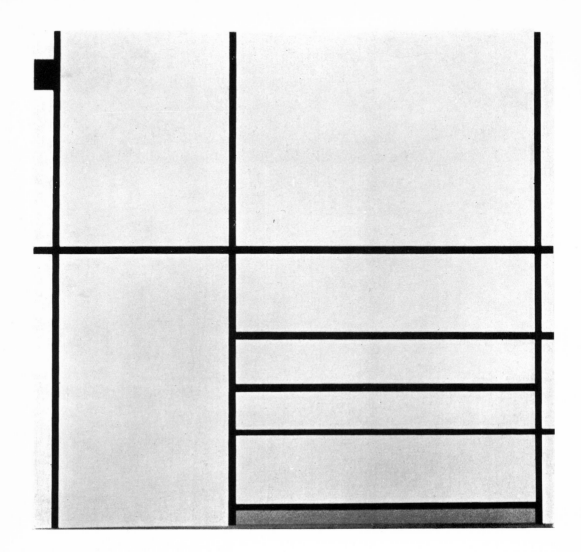

5. MONDRIAN 1936

6. NICHOLSON 1936

7. NICHOLSON 1935

8. NICHOLSON 1936

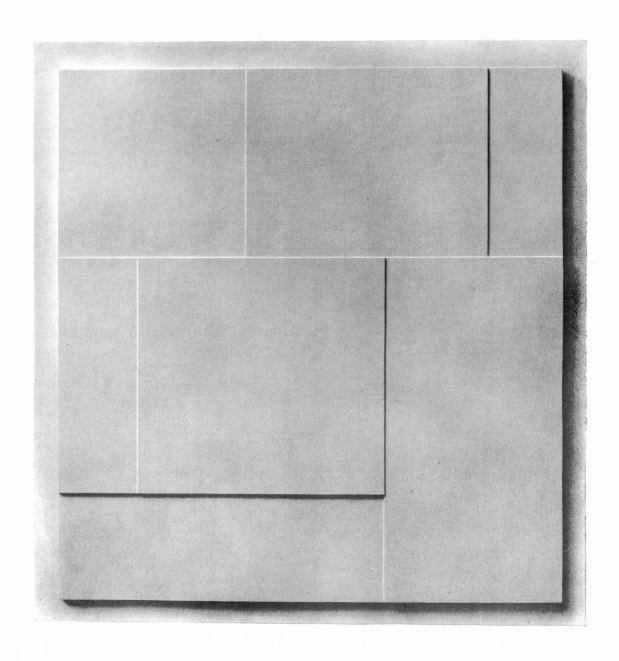

9. NICHOLSON 1936

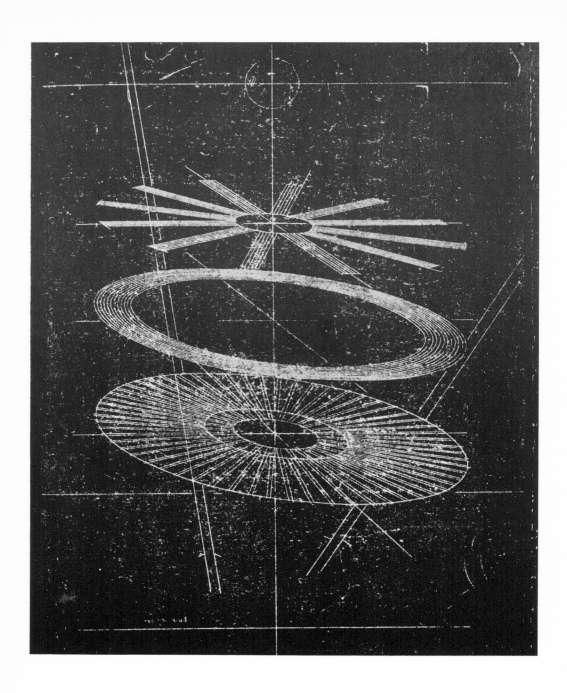

10. DUCHAMP

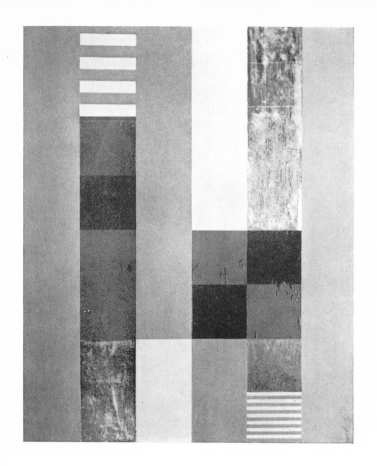

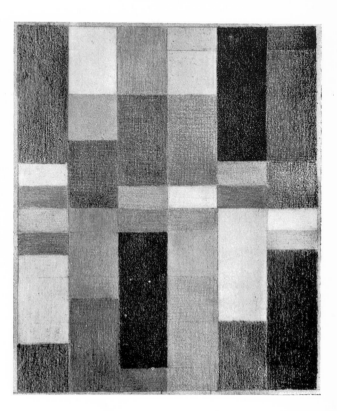

12. TAEUBER-ARP 1915-16

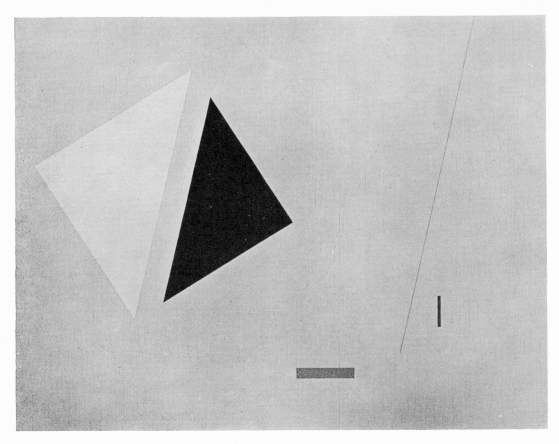

13. VORDEMBERGE-GILDEWART 1935

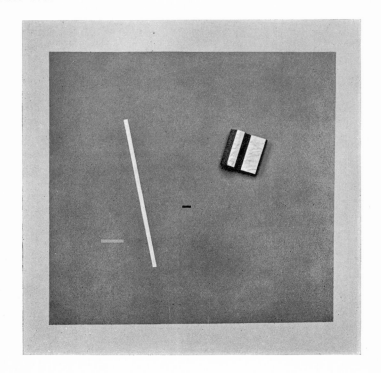

14. VORDEMBERGE-
GILDEWART 1936

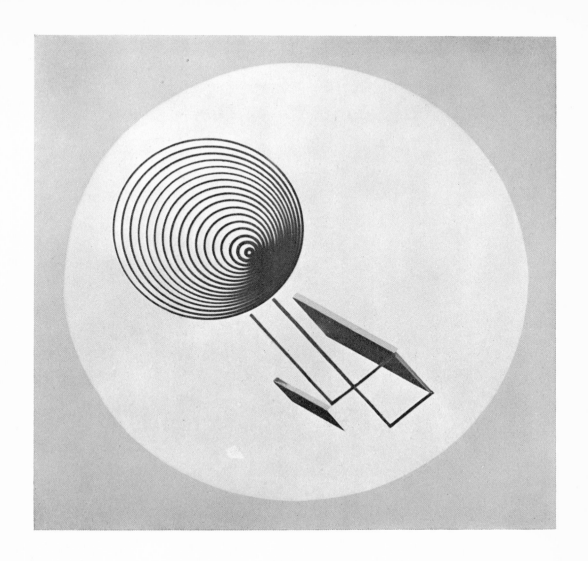

15. LISSITZKY

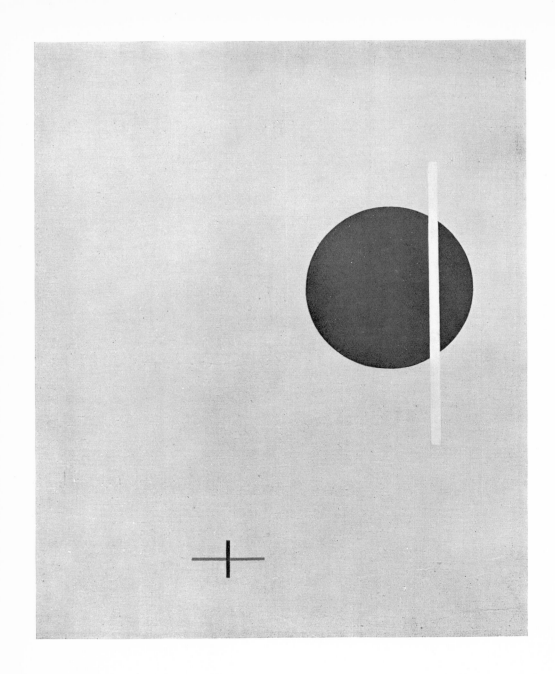

16. MOHOLY-NAGY 1923

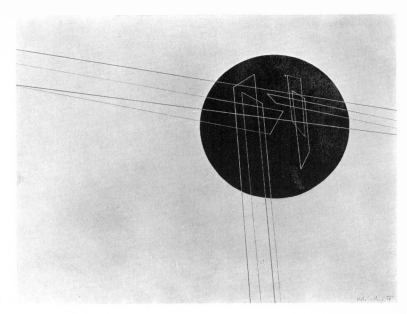

17. MOHOLY-NAGY 1931

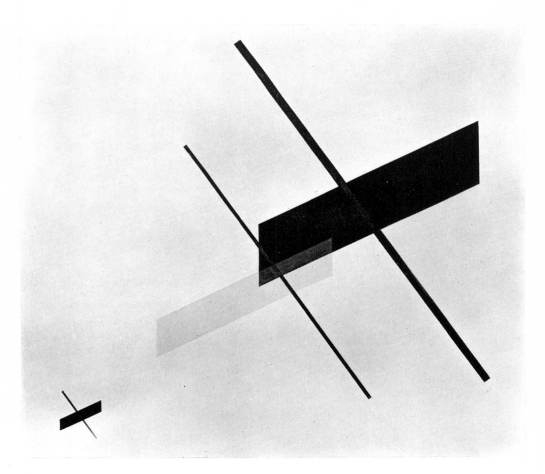

18. MOHOLY-NAGY 1923

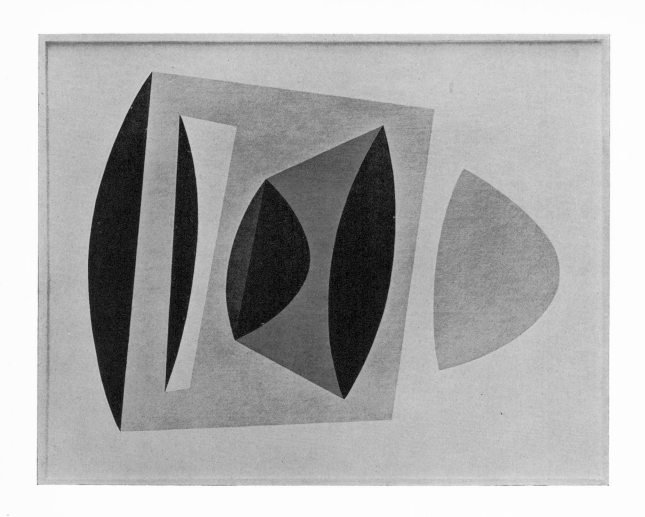

19. JACKSON 1936

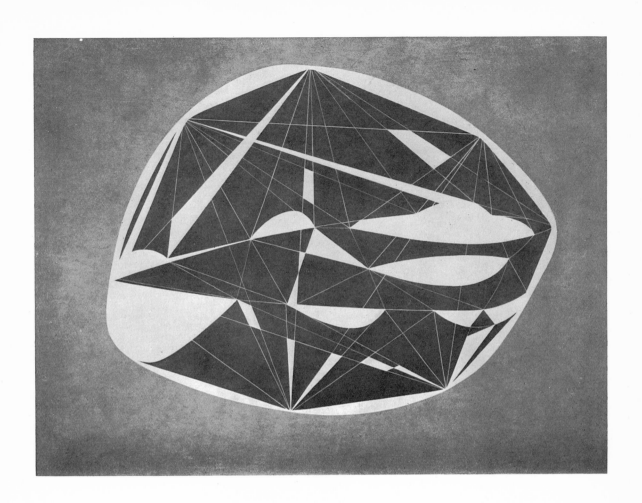

20. JACKSON 1936

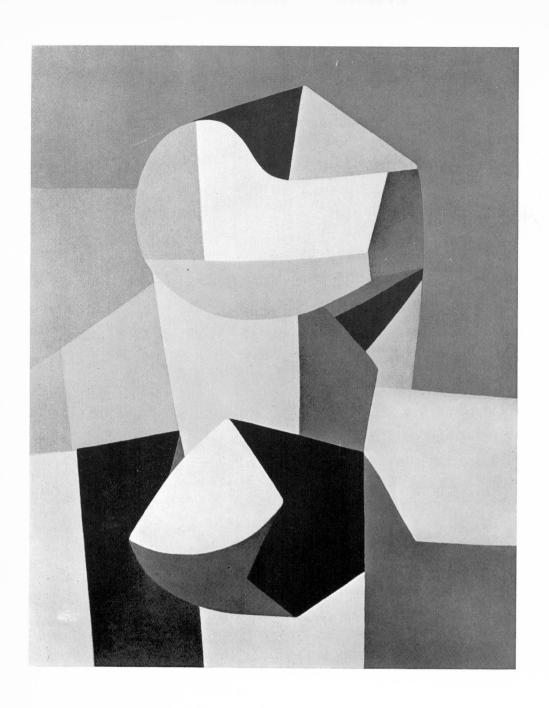

21. HÉLION 1936

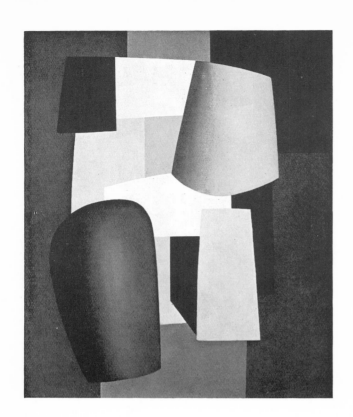

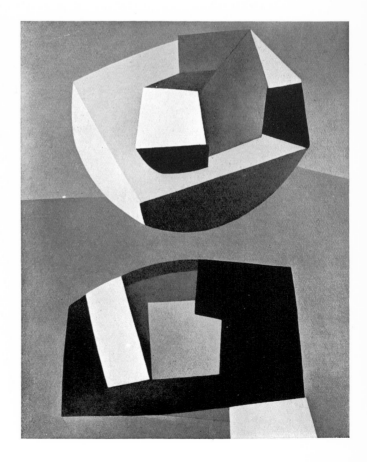

23. HÉLION 1936

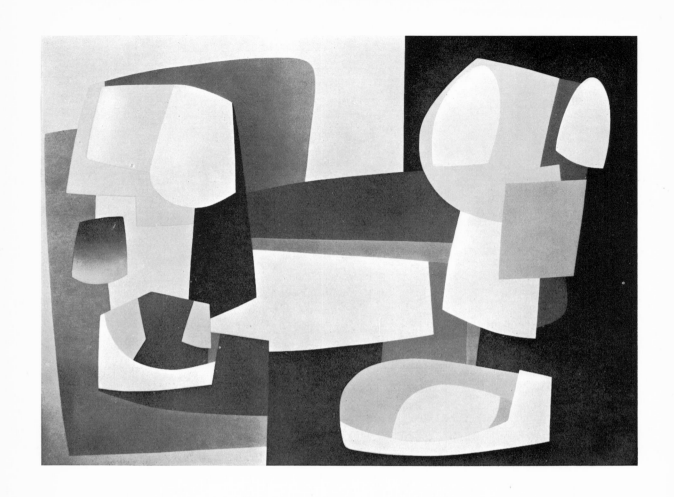

24. HÉLION 1935-36

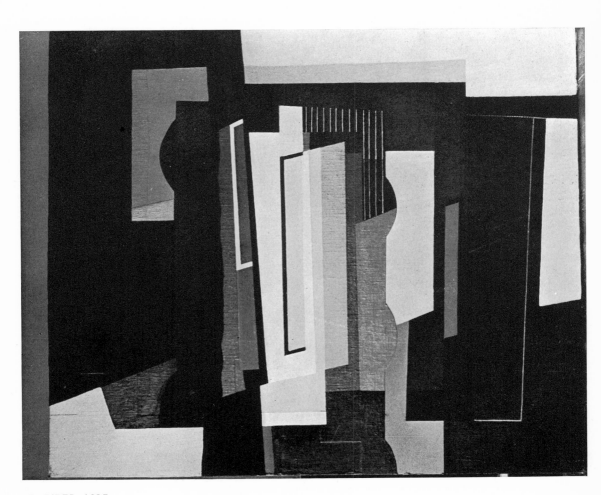

25. PIPER 1935

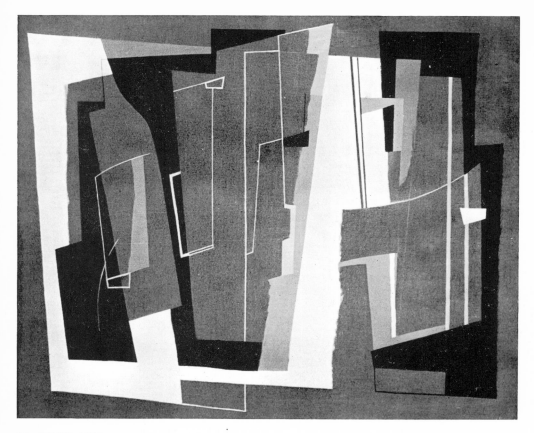

26. PIPER 1936

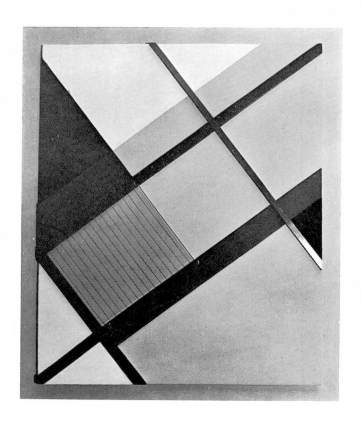

27. DOMELA 1930

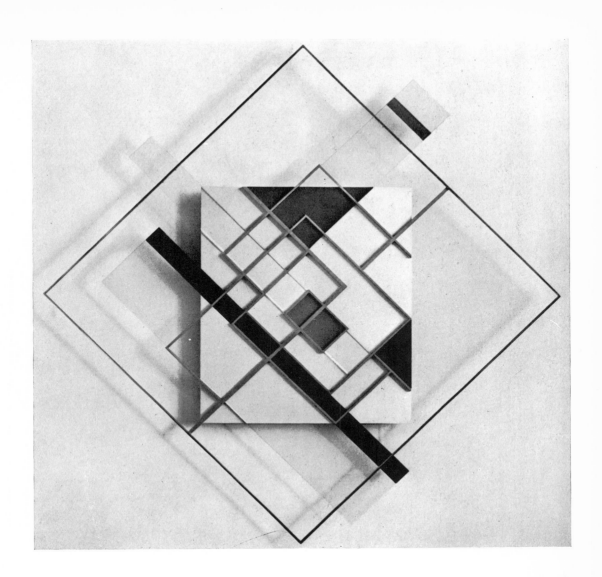

28. DOMELA 1932

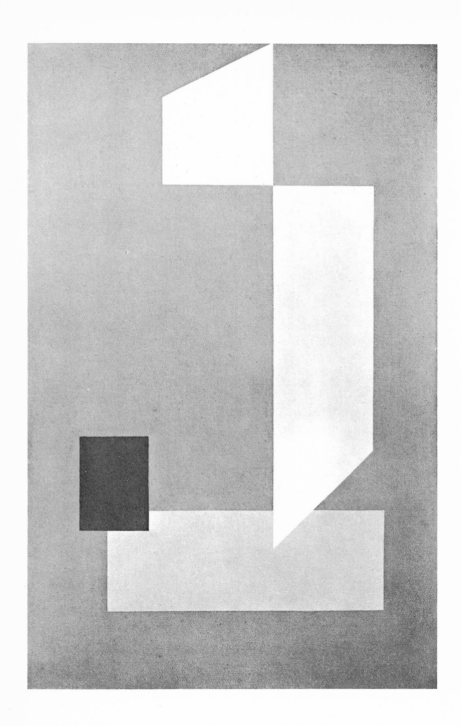

29. STEPHENSON 1937

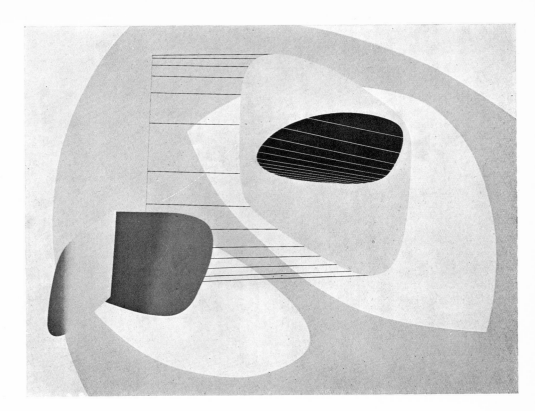

30. ERNI 1934

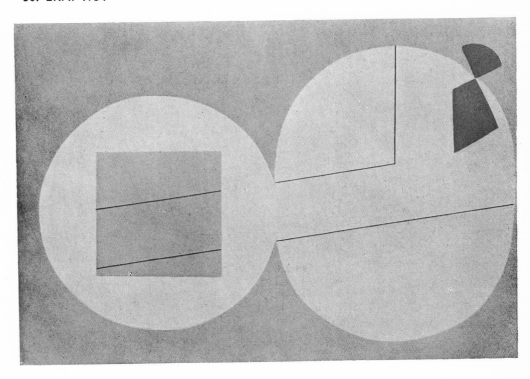

31. DACRE 1935

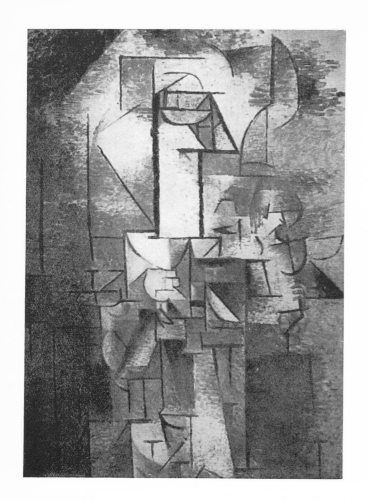

32. PICASSO 1911

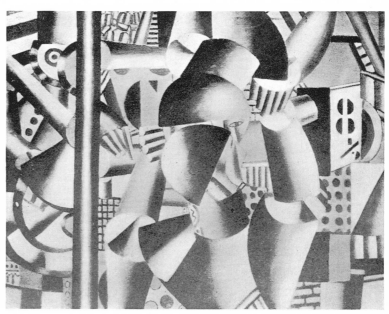

33. LÉGER 1918

34. BRAQUE 1911

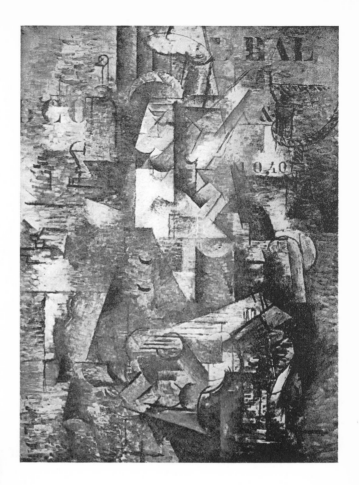

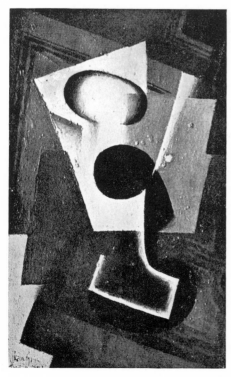

35. GRIS 1917

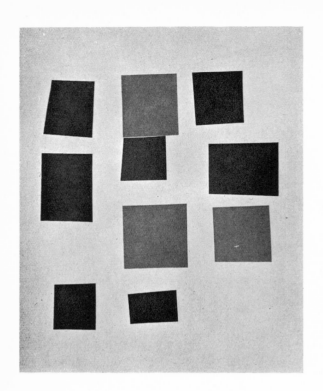

36. ARP 1916

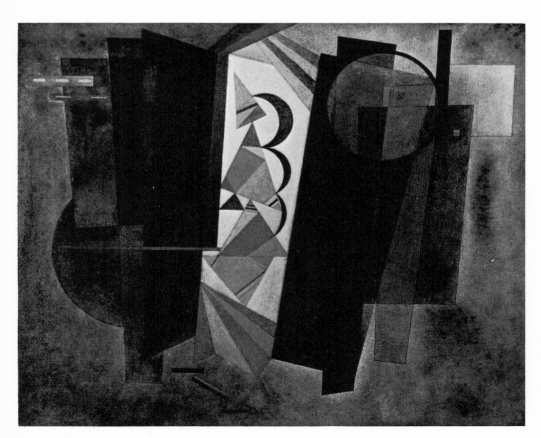

37. KANDINSKY 1933

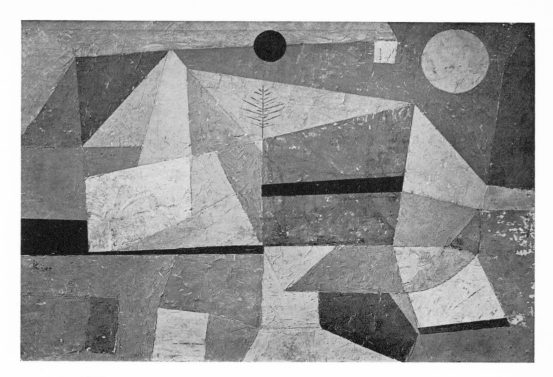

38. KLEE 1929

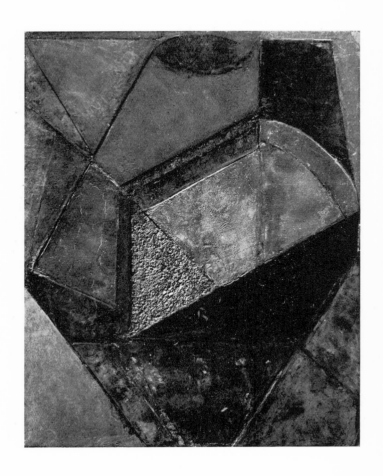

39. PEVSNER 1913

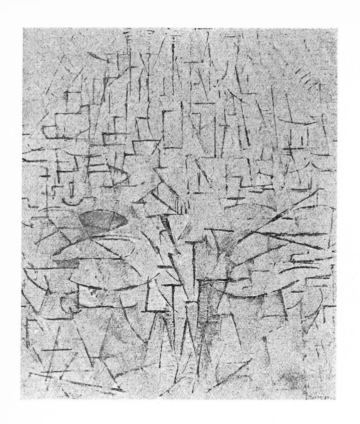

40. MONDRIAN 1911

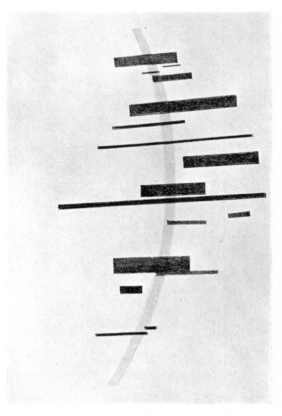

41. MALEVICH 1916

PLASTIC ART AND PURE PLASTIC ART
(Figurative Art and Non-Figurative Art)
By Piet Mondrian

PART I

ALTHOUGH art is fundamentally everywhere and always the same, nevertheless two main human inclinations, diametrically opposed to each other, appear in its many and varied expressions. One aims at the *direct creation of universal beauty*, the other at the *aesthetic expression of oneself*, in other words, of that which one thinks and experiences. The first aims at representing reality objectively, the second subjectively. Thus we see in every work of figurative art the desire, objectively to represent beauty, solely through form and colour, in mutually balanced relations, and, at the same time, an attempt to express that which these forms, colours and relations arouse in us. This latter attempt must of necessity result in an individual expression which veils the pure representation of beauty. Nevertheless, both the two opposing elements (universal—individual) are indispensable if the work is to arouse emotion. Art had to find the right solution. In spite of the dual nature of the creative inclinations, figurative art has produced a harmony through a certain co-ordination between objective and subjective expression. For the spectator, however, who demands a pure representation of beauty, the individual expression is too predominant. For the artist the search for a unified expression through the balance of two opposites has been, and always will be, a continual struggle.

Throughout the history of culture, art has demonstrated that universal beauty does not arise from the particular character of the form, but from the dynamic rhythm of its inherent relationships, or—in a composition—from the mutual relations of forms. Art has shown that it is a question of determining the relations. It has revealed that the forms exist only for the creation of new

41

relationships: that forms create relations and that relations create forms. In this duality of forms and their relations neither takes precedence.

The only problem in art is to achieve a balance between the subjective and the objective. But it is of the utmost importance that this problem should be solved, in the realm of plastic art—technically, as it were—and not in the realm of thought. The work of art must be 'produced', 'constructed'. One must create as objective as possible a representation of forms and relations. Such work can never be empty because the opposition of its constructive elements and its execution arouse emotion.

If some have failed to take into account the inherent character of the form and have forgotten that this—untransformed—predominates, others have overlooked the fact that an individual expression does not become a universal expression through figurative representation, which is based on our conception of feeling, be it classical, romantic, religious, surrealist. Art has shown that universal expression can only be created by a *real equation of the universal and the individual*.

Gradually art is purifying its plastic means and thus bringing out the relationships between them. Thus, in our day two main tendencies appear: the one maintains the figuration, the other eliminates it. While the former employs more or less complicated and particular forms, the latter uses simple and neutral forms, or, ultimately, the free line and the pure colour. It is evident that the latter (non-figurative art) can more easily and thoroughly free itself from the domination of the subjective than can the figurative tendency; particular forms and colours (figurative art) are more easily exploited than neutral forms. It is, however, necessary to point out, that the definitions 'figurative' and 'non-figurative' are only approximate and relative. For every form, even every line, represents a figure, no form is absolutely neutral. Clearly, everything must be relative, but, since we need words to make our concepts understandable, we must keep to these terms.

Among the different forms we may consider those as being neutral which have neither the complexity nor the particularities possessed by the natural forms or abstract forms in general. We may call those neutral which do not evoke individual feelings or ideas. Geometrical forms being so profound an abstraction of form may be regarded as neutral; and on account of their tension and the purity of their outlines they may even be preferred to other neutral forms.

If, as a conception, non-figurative art has been created by the mutual inter-

42

action of the human duality, this art has been *realized* by the mutual interaction of *constructive elements and their inherent relations*. This process consists in mutual purification; purified constructive elements set up pure relationships, and these in their turn demand pure constructive elements. Figurative art of today is the outcome of figurative art of the past, and non-figurative art is the outcome of the figurative art of today. Thus the unity of art is maintained.

If non-figurative art is born of figurative art, it is obvious that the two factors of human duality have not only changed, but have also approached one another towards a mutual balance; towards unity. One can rightly speak of an *evolution in plastic art*. It is of the greatest importance to note this fact, for it reveals the true way of art; the only path along which we can advance. Moreover, the evolution of the plastic arts shows that the dualism which has manifested itself in art is only relative and temporal. Both science and art are discovering and making us aware of the fact that *time is a process of intensification*, an evolution from the individual towards the universal, of the subjective towards the objective; towards the essence of things and of ourselves.

A careful observation of art since its origin shows that artistic expression seen from the outside is *not a process of extending but of intensifying one and the same thing*, universal beauty; and that seen from the inside *it is a growth*. Extension results in a continual repetition of nature; it is not human and art cannot follow it. So many of these repetitions which parade as 'art' clearly cannot arouse emotions.

Through intensification one creates successively on more profound planes; extension remains always on the same plane. Intensification, be it noted, is diametrically opposed to extension; they are at right angles to each other as are length and depth. This fact shows clearly the temporal opposition of non-figurative and figurative art.

But if throughout its history art has meant a *continuous and gradual change in the expression of one and the same thing*, the opposition of the two trends—in our time so clear-cut—is actually an unreal one. It is illogical that the two principal tendencies in art, figurative and non-figurative (objective and subjective) should be so hostile. Since art is in essence universal, its expression cannot rest on a subjective view. Our human capacities do not allow of a perfectly objective view, but that does not imply that the plastic expression of art is based on subjective conception. Our subjectivity realizes but does not create the work.

If the two human inclinations already mentioned are apparent in a work of art, they have both collaborated in its realization, but it is evident that the

work will clearly show which of the two has predominated. In general, owing to the complexity of forms and the vague expression of relations, the two creative inclinations will appear in the work in a confused manner. Although in general there remains much confusion, today the two inclinations appear more clearly defined as two tendencies: *figurative and non-figurative art.* So-called non-figurative art often also creates a particular representation; figurative art, on the other hand, often neutralizes its forms to a considerable extent. The fact that art which is really non-figurative is rare does not detract from its value; evolution is always the work of pioneers, and their followers are always small in number. This following is not a clique; it is the result of all the existing social forces; it is composed of all those who through innate or acquired capacity are ready to represent the existing degree of human evolution. At a time when so much attention is paid to the collective, to the 'mass', it is necessary to note that evolution, ultimately, is never the expression of the mass. The mass remains behind yet urges the pioneers to creation. For the pioneers, the social contact is indispensable, but not in order that they may know that what they are doing is necessary and useful, nor in order that 'collective approval may help them to persevere and nourish them with living ideas'. This contact is necessary only in an indirect way; it acts especially as an obstacle which increases their determination. The pioneers create through their reaction to external stimuli. They are guided not by the mass but by that which they see and feel. They discover consciously or unconsciously the fundamental laws hidden in reality, and aim at realizing them. In this way they further human development. They know that humanity is not served by making art comprehensible to everybody; to try this is to attempt the impossible. One serves mankind by enlightening it. Those who do not see will rebel, they will try to understand and will end up by 'seeing'. In art the search for a content which is collectively understandable is false; the content will always be individual. Religion, too, has been debased by that search.

Art is not made for anybody and is, at the same time, for everybody. It is a mistake to try to go too fast. The complexity of art is due to the fact that different degrees of its evolution are present at one and the same time. The present carries with it the past and the future. But we need not try to foresee the future; we need only take our place in the development of human culture, a development which has made non-figurative art supreme. It has always been only one struggle, of only one real art; to create universal beauty. This points the way for both present and future. We need only continue and develop what

already exists. The essential thing is that *the fixed laws of the plastic arts must be realized*. These have shown themselves clearly in non-figurative art.

Today one is tired of the dogmas of the past, and of truths once accepted but successively jettisoned. One realizes more and more the relativity of everything, and therefore one tends to reject the idea of fixed laws; of a single truth. This is very understandable but does not lead to profound vision. For there are 'made' laws, 'discovered' laws, but also laws—a truth for all time. These are more or less hidden in the reality which surrounds us and do not change. Not only science, but art also, shows us that reality, at first incomprehensible, gradually reveals itself, by the mutual relations that are inherent in things. Pure science and pure art, disinterested and free, can lead the advance in the recognition of the laws which are based on these relationships. A great scholar has recently said that pure science achieves practical results for humanity. Similarly, one can say that pure art, even though it appear abstract, can be of direct utility for life.

Art shows us that there are also constant truths concerning forms. Every form, every line has its own expression. This objective expression can be modified by our subjective view but it is no less true for that. Round is always round and square is always square. Simple though these facts are they often appear to be forgotten in art. Many try to achieve one and the same end by different means. In plastic art this is an impossibility. In plastic art it is necessary to choose constructive means which are of one piece with that which one wants to express.

Art makes us realize that there are *fixed laws which govern and point to the use of the constructive elements of the composition and of the inherent inter-relationships between them*. These laws may be regarded as subsidiary laws to the *fundamental* law of equivalence which creates *dynamic equilibrium and reveals the true content of reality*.

PART II

We live in a difficult but interesting epoch. After a secular culture, a turning point has arrived; this shows itself in all the branches of human activity. Limiting ourselves here to science and art, we notice that, just as in medicine some have discovered the natural laws relating to physical life, in art some have discovered the artistic laws relating to plastics. In spite of all opposition, these facts have become movements. But confusion still reigns in them. Through science we are becoming more and more conscious of the fact that our physical

state depends in great measure on what we eat, on the manner in which our food is arranged and on the physical exercise which we take. Through art we are becoming more and more conscious of the fact that the work depends in large measure on the constructive elements which we use and on the construction which we create. We will gradually realize that we have not hitherto paid sufficient attention to constructive physical elements in their relation to the human body, nor to the constructive plastic elements in their relation to art. That which we eat has deteriorated through a refinement of natural produce. To say this, appears to invoke a return to a primitive natural state and to be in opposition to the exigencies of pure plastic art, which degenerates precisely through figurative trappings. But a return to pure natural nourishment does not mean a return to the state of primitive man; it means on the contrary that cultured man obeys the laws of nature discovered and applied by science.

Similarly in non-figurative art, to recognize and apply natural laws is not evidence of a retrograde step; the pure abstract expression of these laws proves that the exponent of non-figurative art associates himself with the most advanced progress and the most cultured minds, that he is an exponent of denaturalized nature, of civilization.

In life, sometimes the spirit has been over-emphasized at the expense of the body, sometimes one has been preoccupied with the body and neglected the spirit; similarly in art content and form have alternately been over-emphasized or neglected because *their inseparable unity* has not been clearly realized.

To create this unity in art *balance of the one and the other must be created*.

It is an achievement of our time to have approached towards such balance in a field in which disequilibrium still reigns.

Disequilibrium means conflict, disorder. Conflict is also a part of life and of art, but it is not the whole of life or universal beauty. Real life is the *mutual interaction of two oppositions of the same value but of a different aspect and nature*. Its plastic expression is universal beauty.

In spite of world disorder, instinct and intuition are carrying humanity to a real equilibrium, but how much misery has been and is still being caused by primitive animal instinct. How many errors have been and are being committed through vague and confused intuition? Art certainly shows this clearly. But art shows also that in the course of progress, intuition becomes more and more conscious and instinct more and more purified. Art and life illuminate each other more and more; they reveal more and more their laws according to which a real and living balance is created.

46

Intuition enlightens and so links up with pure thought. They together become an intelligence which is not simply of the brain, which does not calculate, but which feels and thinks. Which is creative both in art and in life. From this intelligence there must arise non-figurative art in which instinct no longer plays a dominating part. Those who do not understand this intelligence regard non-figurative art as a purely intellectual product.

Although all dogma, all preconceived ideas, must be harmful to art, the artist can nevertheless be guided and helped in his intuitive researches by reasoning apart from his work. If such reasoning can be useful to the artist and can accelerate his progress, it is indispensable that such reasoning should accompany the observations of the critics who talk about art and who wish to guide mankind. Such reasoning, however, cannot be individual, which it usually is; it cannot arise out of a body of knowledge outside plastic art. If one is not an artist oneself one must at least know *the laws and culture of plastic art*. If the public is to be well informed and if mankind is to progress it is essential that the confusion which is everywhere present should be removed. For enlightenment, a clear demonstration of the *succession of artistic tendencies is necessary*. Hitherto, a study of the different styles of plastic art in their progressive succession has been difficult since the expression of the essence of art has been veiled. In our time, which is reproached for not having a style of its own, the content of art has become clear and the different tendencies reveal more clearly the progressive succession of artistic expression. Non-figurative art brings to an end the ancient culture of art; at present therefore, one can review and judge more surely *the whole culture of art*. We are not at the turning-point of this culture; *the culture of particular form is approaching its end. The culture of determined relations has begun.*

It is not enough to explain the value of a work of art in itself; it is above all necessary to show *the place which a work occupies on the scale of the evolution of plastic art*. Thus in speaking of art, it is not permissible to say 'this is how I see it' or 'this is my idea'. True art like true life takes a *single road*.

The laws which in the culture of art have become more and more determinate are *the great hidden laws of nature which art establishes in its own fashion*. It is necessary to stress the fact that these laws are more or less hidden behind the superficial aspect of nature. Abstract art is therefore opposed to a natural representation of things. But it *is not opposed to nature* as is generally thought. It is opposed to the raw primitive animal nature of man, but it is one with true human nature. It is opposed to the conventional laws created during the cul-

47

ture of the particular form but it is one with the laws of the culture of pure relationships.

First and foremost there is the fundamental law of *dynamic equilibrium* which is opposed to the static equilibrium necessitated by the particular form.

The important task then of all art is to destroy the static equilibrium by establishing a dynamic one. Non-figurative art demands an attempt of what is a consequence of this task, the *destruction* of particular form and the *construction* of a rhythm of mutual relations, of mutual forms or free lines. We must bear in mind, however, a distinction between these two forms of equilibrium in order to avoid confusion; for when we speak of equilibrium pure and simple we may be for, and at the same time against, a balance in the work of art. It is of the greatest importance to note the destructive-constructive quality of dynamic equilibrium. Then we shall understand that the equilibrium of which we speak in non-figurative art is not without movement of action but is on the contrary a continual movement. We then understand also the significance of the name 'constructive art'.

The fundamental law of dynamic equilibrium gives rise to a number of other laws which relate to the constructive elements and their relations. These laws determine the manner in which dynamic equilibrium is achieved. The relations of *position* and those of *dimension* both have their own laws. Since the relation of the rectangular position is constant, it will be applied whenever the work demands the expression of stability; to destroy this stability there is a law that relations of a changeable dimension-expression must be substituted. The fact that all the relations of position except the rectangular one lack that stability, also creates a law which we must take into account if something is to be established in a determinate manner. Too often right and oblique angles are arbitrarily employed. All art expresses the rectangular relationship even though this may not be in a determinate manner; first by the height and width of the work and its constructive forms, then by the mutual relations of these forms. Through the clarity and simplicity of neutral forms, non-figurative art has made the rectangular relation more and more determinate, until, finally, it has established it through free lines which intersect and appear to form rectangles.

As regards the relations of dimension, they must be varied in order to avoid repetition. Although, as compared with the stable expression of the rectangular relationship, they belong to individual expression, it is precisely they that are most appropriate for the destruction of the static equilibrium of all

form. By offering him a freedom of choice the relations of dimension *present the artist with one of the most difficult problems.* And the closer he approaches the ultimate consequence of his art the more difficult is his task.

Since the constructive elements and their mutual relations form an inseparable unity, the laws of the relations govern equally the constructive elements. These, however, have also their own laws. It is obvious that one cannot achieve the same expression through different forms. But it is often forgotten that varied forms or lines *achieve—in form—altogether different degrees in the evolution of plastic art.* Beginning with natural forms and ending with the most abstract forms, *their expression becomes more profound.* Gradually form and line gain in tension. For this reason the straight line is a stronger and more profound expression than the curve.

In pure plastic art the significance of different forms and lines is very important; it is precisely this fact which makes it pure.

In order that art may be really abstract, in other words, that it should not represent relations with the natural aspect of things, the law of the *denaturalization of matter* is of fundamental importance. In painting, the primary colour that is as pure as possible realizes this abstraction of natural colour. But colour is, in the present state of technique, also the best means for denaturalizing matter in the realm of abstract constructions in three dimensions; technical means are as a rule insufficient.

All art has achieved a certain measure of abstraction. This abstraction has become more and more accentuated until in pure plastic art not only a transformation of form but also of matter—be it through technical means or through colour—a more or less neutral expression is attained.

According to our laws, it is a great mistake to believe that one is practising non-figurative art by merely achieving neutral forms or free lines and determinate relations. For in composing these forms one runs the risk of a figurative creation, that is to say one or more particular forms.

Non-figurative art is created by establishing *a dynamic rhythm of determinate mutual relations* which *excludes the formation of any particular form.* We note thus, that to destroy particular form is only to do more consistently what all art has done.

The dynamic rhythm which is essential in all art is also the essential element of a non-figurative work. In figurative art this rhythm is veiled.

Yet we all pay homage to clarity.

The fact that people generally prefer figurative art (which creates and finds its continuation in abstract art) can be explained by the dominating

49

force of the individual inclination in human nature. *From this inclination arises all the opposition to art which is purely abstract.*

In this connection we note first the *naturalistic conception* and the *descriptive or literary orientation*: both a real danger to purely abstract art. From a purely plastic point of view, until non-figurative art, artistic expression has been naturalistic or descriptive. To have emotion aroused by pure plastic expression one must abstract from figuration and so become 'neutral'. But with the exception of some artistic expressions (such as Byzantine art)* there has not been the desire to employ neutral plastic means, which would have been much more logical than to become neutral oneself in contemplating a work of art. Let us note, however, that the spirit of the past was different from the spirit of our own day, and that it is only tradition which has carried the past into our own time. In past times when one lived in contact with nature and when man himself was more natural than he is today, abstraction from figuration in thought was easy; it was done unconsciously. But in our more or less denaturalized period, such abstraction becomes an effort.

However that may be, the fact that figuration is a factor which is unduly taken into account, and whose abstraction in the mind is only relative, proves that today even great artists regard figuration as indispensable. At the same time these artists are already abstracting from figuration to a much greater extent than has been done before. More and more, not only the uselessness of figuration, but also obstacles which it creates, will become obvious. In this search for clarity, non-figurative art develops.

There is, however, one tendency which cannot forego figuration without losing its descriptive character. That is surrealism. Since the predominance of individual thought is opposed to pure plastics it is also opposed to non-figurative art. Born of a literary movement, its descriptive character demands figuration. However purified or deformed it may be, figuration veils pure plastics. There are, it is true, surrealist works whose plastic expression is very strong and of a kind that if the work is observed at a distance, i.e. if the figurative representation is abstracted from, arouse one's emotions by form, colour and their relations alone. But if the purpose was nothing but plastic expression, why then use figurative representation? Clearly, there must have been the intention to express something outside the realm of pure plastics. This of course is often the case even in abstract art. There, too, there is sometimes added to the ab-

*As regards these works we must note that, lacking a dynamic rhythm, they remain, in spite of the profound expression of forms, more or less ornamental.

50

stract forms something particular, even without the use of figuration; through the colour or through the execution, a particular idea or sentiment is expressed. There it is generally not the literary inclination but the naturalistic inclination which has been at work. It must be obvious that if one evokes in the spectator the sensation of, say, the sunlight or moonlight, of joy or sadness, or any other determinate sensation, one has not succeeded in establishing universal beauty, one is not purely abstract.

As for surrealism, we must recognize that it deepens feeling and thought, but since this deepening is limited by individualism it cannot reach the foundation, the universal. So long as it remains in the realm of dreams, which are only a re-arrangement of the events of life, it cannot touch true reality. Through a different composition of the events of life, it may remove their ordinary course but it cannot purify them. Even the intention of freeing life from its conventions and from everything which is harmful to the true life can be found in surrealist literature. Non-figurative art is fully in agreement with this intention but it achieves its purpose; it frees its plastic means and its art from all particularity. The names, however, of these tendencies, are only indications of their conceptions; it is the realization which matters. With the exception of non-figurative art, there seems to have been a lack of realization of the fact that it is possible to express oneself profoundly and humanely by plastics alone, that is, by employing a neutral plastic means without the risk of falling into decoration or ornament. Yet all the world knows that even a single line can arouse emotion. But although one sees—and this is the artist's fault—few non-figurative works which live by virtue of their dynamic rhythm and their execution, figurative art is no better in this respect. In general, people have not realized that one can express our very essence through neutral constructive elements; that is to say we can express the essence of art. The essence of art of course is not often sought. As a rule, individualist human nature is so predominant, that the expression of the essence of art through a rhythm of lines, colours and relationships appears insufficient. Recently, even a great artist has declared that 'complete indifference to the subject leads to an incomplete form of art'.

But everybody agrees that art is only a problem of plastics. What good then is a subject? It is to be understood that one would need a subject to expound something named 'Spiritual riches, human sentiments and thoughts'. Obviously, all this is individual and needs particular forms. But at the root of these sentiments and thoughts there is one thought and one sentiment: these do not easily define themselves and have no need of analogous forms in

which to express themselves. It is here that neutral plastic means are demanded.

For pure art then, the subject can never be an additional value, it is the line, the colour and their relations which must 'bring into play the whole sensual and intellectual register of the inner life' . . . not the subject. Both in abstract art and in naturalistic art colour expresses itself 'in accordance with the form by which it is determined', and in all art it is the artist's task to make forms and colours living and capable of arousing emotion. If he makes art into an 'algebraic equation' that is no argument against the art, it only proves that he is not an artist.

If all art has demonstrated that to establish the force, tension and movement of the forms, and the intensity of the colours of reality, it is necessary that these should be purified and transformed; if all art has purified and transformed and is still purifying and transforming these forms of reality and their mutual relations; if all art is thus a continually deepening process: why then stop halfway? If all art aims at expressing universal beauty, why establish an individualist expression? Why then not continue the sublime work of the cubists? That would not be a continuation of the same tendency, but on the contrary, *a complete break-away from it and all that has existed before it.* That would only be going along the same road that we have already travelled.

Since cubist art is still fundamentally naturalistic, the break which pure plastic art has caused consists in becoming abstract instead of naturalistic in essence. While in cubism, from a naturalistic foundation, there sprang forcibly the use of plastic means, still half object half abstract, the abstract basis of pure plastic art must result in the use of purely abstract plastic means.

In removing completely from the work all objects, 'the world is not separated from the spirit', but is on the contrary, *put into a balanced opposition* with the spirit, since the one and the other are purified. This creates a perfect unity between the two opposites. There are, however, many who imagine that they are too fond of life, particular reality, to be able to suppress figuration, and for that reason they still use in their work the object or figurative fragments which indicate its character. Nevertheless, one is well aware of the fact that in art one cannot hope to represent in the image things as they are, nor even as they manifest themselves in all their living brilliance. The impressionists, divisionists, and pointillistes have already recognized that. There are some today who, recognizing the weakness and limitation of the image, attempt to create a work of art through the objects themselves, often by composing them in a more or

52

less transformed manner. This clearly can not lead to an expression of their content nor of their true character. One can more or less remove the conventional appearance of things (surrealism), but they continue nevertheless to show their particular character and to arouse in us individual emotions. To love things in reality is to love them profoundly; it is to see them as a microcosmos in the macrocosmos. *Only in this way can one achieve a universal expression of reality.* Precisely on account of its profound love for things, nonfigurative art does not aim at rendering them in their particular appearance.

Precisely by its existence non-figurative art shows that 'art' *continues always on its true road.* It shows that 'art' is *not the expression of the appearance of reality such as we see it, nor of the life which we live,* but that *it is the expression of true reality and true life . . . indefinable but realizable in plastics.*

Thus we must carefully distinguish between two kinds of reality; one which has an individual and one which has a universal appearance. In art the former is the expression of space determined by particular things or forms, the latter establishes expansion and limitation—the creative factors of space—through neutral forms, free lines and pure colours. While universal reality arises from determinate relations, particular reality shows only veiled relations. The latter must obviously be confused in just that respect in which universal reality is bound to be clear. The one is free, the other is tied to individual life, be it personal or collective. Subjective reality and relatively objective reality: this is the contrast. Pure abstract art aims at creating the latter, figurative art the former.

It is astonishing therefore, that one should reproach pure abstract art with not being 'real', and that one should envisage it as 'arising from particular ideas'.

In spite of the existence of non-figurative art, one is talking about art today as if nothing determinate in relation to the new art existed. Many neglect the real non-figurative art, and looking only at the fumbling attempts and at the empty non-figurative works which today are appearing everywhere, ask themselves whether the time has not arrived 'to integrate form and content' or 'to unify thought and form'. But one should not blame non-figurative art for that which is only due to the ignorance of its very content. If the form is without content, without universal thought, it is the fault of the artist. Ignoring that fact, one imagines that figuration, subject, particular form, could add to the work that which the plastic itself is lacking. As regards the 'content' of the work, we must note that our 'attitude with regard to things, our organized individuality with its impulses, its actions, its reactions when in contact with reality, the lights and shades of our spirit', etc., certainly do modify the non-

53

figurative work, but they do not constitute its content. We repeat, that its content cannot be described, and that it is only through pure plastics and through the execution of the work that it can be made apparent. Through this indeterminable content, the non-figurative work is 'fully human'. Execution and technique play an important part in the aim of establishing a more or less objective vision which the essence of the non-figurative work demands. The less obvious the artist's hand is the more objective will the work be. This fact leads to a preference for a more or less mechanical execution or to the employment of materials produced by industry. Hitherto, of course, these materials have been imperfect from the point of view of art. If these materials and their colours were more perfect and if a technique existed by which the artist could easily cut them up in order to compose his work as he conceives it, an art more real and more objective in relation to life than painting would arise. All these reflections evoke questions which have already been asked many years ago, mainly: is art still necessary and useful for humanity? Is it not even harmful to progress? Certainly the art of the past is superfluous to the new spirit and harmful to its progress: just because of its beauty it holds many people back from the new conception. The new art is, however, still very necessary to life. In a clear manner it establishes the laws according to which a real balance is reached. Moreover, it must create among us a profoundly human and rich beauty realized not only by the best qualities of the new architecture, but also by all that the constructive art in painting and sculpture makes possible.

But although the new art is necessary, the mass is conservative. Hence these cinemas, these radios, these bad pictures which overwhelm the few works which are really of our era.

It is a great pity that those who are concerned with the social life in general do not realize the utility of pure abstract art. Wrongly influenced by the art of the past, the true essence of which escapes them, and of which they only see that which is superfluous, they make no effort to know pure abstract art. Through another conception of the word 'abstract', they have a certain horror of it. They are vehemently opposed to abstract art because they regard it as something ideal and unreal. In general they use art as propaganda for collective or personal ideas, thus as literature. They are both in favour of the progress of the mass and against the progress of the elite, thus against the logical march of human evolution. Is it really to be believed that the evolution of the mass and that of the elite are incompatible? The elite rises from the mass; is it not therefore its highest expression?

54

To return to the execution of the work of art, let us note that it must contribute to a revelation of the subjective and objective factors in mutual balance. Guided by intuition, it is possible to attain this end. The execution is of the greatest importance in the work of art; it is through this, in large part, that intuition manifests itself and creates the essence of the work.

It is therefore a mistake to suppose that a non-figurative work comes out of the unconscious, which is a collection of individual and pre-natal memories. We repeat that it comes from pure intuition, which is at the basis of the subjective-objective dualism.

It is, however, wrong to think that the non-figurative artist finds impressions and emotions received from the outside useless, and regards it even as necessary to fight against them. On the contrary, all that the non-figurative artist receives from the outside is not only useful but indispensable, because it arouses in him the desire to create that which he only vaguely feels and which he could *never represent in a true manner without the contact with visible reality and with the life which surrounds him.* It is precisely from this visible reality that he draws the objectivity which he needs in opposition to his personal subjectivity. It is precisely from this visible reality that he draws his means of expression: and, as regards the surrounding life, it is precisely this which has made his art non-figurative.

That which distinguishes him from the figurative artist is the fact that in his creations he frees himself from individual sentiments and from particular impressions which he receives from outside, and that he breaks loose from the domination of the individual inclination within him.

It is therefore equally wrong to think that the non-figurative artist creates through 'the pure intention of his mechanical process', that he makes 'calculated abstractions', and that he wishes to 'suppress sentiment not only in himself but also in the spectator'. It is a mistake to think that he retires completely into his system. That which is regarded as a system is nothing but constant obedience to the laws of pure plastics, to necessity, which art demands from him. It is thus clear that he has not become a mechanic, but that the progress of science, of technique, of machinery, of life as a whole, has only made him into a living machine, capable of realizing in a pure manner the essence of art. In this way, he is in his creation sufficiently neutral, that nothing of himself or outside of him can prevent him from establishing that which is universal. Certainly his art is art for art's sake . . . for the sake of the art *which is form and content at one and the same time.*

PLASTIC ART AND PURE PLASTIC ART

If all real art is 'the sum total of emotions aroused by purely pictorial means' his art is the sum of the emotions aroused by plastic means.

It would be illogical to suppose that non-figurative art will remain stationary, for this art contains *a culture* of the use of new plastic means and their determinate relations. Because the field is new there is all the more to be done. What is certain is that no escape is possible for the non-figurative artist; he *must stay within his field and march towards the consequence of his art*.

This consequence brings us, in a future perhaps remote, towards the end of *art as a thing separated from our surrounding environment, which is the actual plastic reality*. But this end is at the same time a new beginning. Art will not only continue but will realize itself more and more. By the unification of architecture, sculpture and painting, a new plastic reality will be created. Painting and sculpture will not manifest themselves as separate objects, nor as 'mural art' which destroys architecture itself, nor as 'applied' art, but *being purely constructive* will aid the creation of an atmosphere not merely utilitarian or rational but also pure and complete in its beauty.

UNKNOWN COLOUR
By Winifred Dacre

COLOUR has been used chiefly in the past as a means to display form—form being thought of as its obvious master.

The freedom of abstract thought has come, and shows us a future lying ahead of colour as one of the three great abstract arts.

Mathematics—music—colour. To those artists whose inspiration comes in the form of shape and shape relationships, colour may continue to be the means of expressing those shapes, unless it be that they find that light and shade is a more suitable means for their purpose.

But to those artists whose inspiration comes in the form of colour, of colour alone, without reference to object or object sense, it is no longer necessary to set about seeking some form into which the colour may be tagged to give it being. Naturally colour must have area, space—but let that area be directed by the needs of the colour itself and not by some consideration of form. A large blue square is bluer than a small blue square. A blue pentagon is a different blue from a triangle of the same blue. Let the blueness itself evolve the form which gives its fullest expression. This, the starting-point within secret artistic creation.

From thence, the breadth of the field of colour comes into view—its importance as yet little explored to abstract research. For abstract research a scale is invaluable upon which to base discoveries, and from which to measure them. Mathematics, with its number scale from one to infinity, has been up till now the medium of man's intellectual abstract thought. There is no scale of number discernible in nature. This was born within the intellect of man—not within his emotions, for there is no emotional quality in Mathematics. Music, with its scale from base to treble, has been the medium for abstract emotion. Its scale of sound is not audible in Nature and was discovered by the Spirit of

man and has been carried to a high pitch of development. It is strange that its sister art of colour has been left in its primitive state. It is only in the last fifty years that its potency has begun to stir in the minds of artists. The scale of colour is visible in nature in the Rainbow and the Prism. Light is one, and can be seen and thought of as one. By prismatic action it can be broken into its component rays, each one a distinct colour. Red, orange, yellow, green, blue, violet—a scale line ascending and descending from red hot to violet cold.

But as well as being a line it has a quality also of being a circle of rhythmic change. One can see if one looks intently enough below the hot red a cerise which merges into harmony with the violet, and next to that violet with an almost imperceptible glow of magenta pink which echoes that cerise. This affinity is perceived when one considers that one can have a red with more or less violet in it—and a violet with more or less pink or rose in it. But one cannot have a green with the least bit of either red or violet in it. It can also be seen in nature in the wave-like sequence of double and treble rainbows, following the bright arc of the first rainbow. Music differs from colour in this: you cannot have a sound in which all musical notes are contained. In the simplicity of the great white light all colour lives.

Any true colour picture gives out light like a lamp. In twilight it looks like a luminosity—in a better light the differences in the colours begin to tell, and they grow more and more distinct, markedly individual, as the light intensifies, to fall back again into a luminosity, a glow if the light wanes. It is only in the clearest, most unclouded light of the sun that you can see the greatest attenuation and differences of hue. The same yellow is quite a different colour on a clear grey day than it is on a day of Mediterranean sunshine. So, the scale of colour is held within the fullness of sunlight, which is forever breaking apart, revealing its diverse hues, contrasts and affinities and then closing again upon this scale in the oneness of white light.

Further, the colour depends not only upon the quality and quantity of the source of light, but upon the capacity of our human eyes to receive that colour. We do not know whether the eyes of one individual see the same colour as the eyes of another individual, and we have no means of ever knowing this. It has been thought that the eyes of primitive man saw only the bright colours at the base of the spectrum, reds and oranges, and that only as our civilization advanced our eyes came to see the range of colour we now see. Whether this be so or not it is certain that at moments of low vitality, however bright the sunlight may be, one sees only dimly the differentiation of colour, one sees light and its

58

degrees but not colour. At moments of high vitality and keen perception the differentiation deepens with intensive power.

We know that there are many rays in light whose chemical action is powerful, but which are not visible as colour to our eyes as they are tuned at present. It may be that in the future our eyes will develop to see ultra-violet and infra-red, but in the meantime we have to take them into account in our scale without seeing them. That is to say, that in thinking of the circle of colours, red, orange, yellow, green, blue, violet, we must not think of it as a finite circle, but as one where there is a gap of unknown, unseen colour, which comes in between the violet and the red, and is necessary to their harmony. Violet is the colour of highest tension, the colour only visible in its beauty at moments of high vitality and clearest sunlight. It is the difficult colour to use, and those artists whose primary interest is form always remain within the safe precincts of the lower notes of the scale, vermilion and blue with browns and neutrals. Those artists who have been interested in the potency of colour have always investigated violet—though they have rarely used more than a little of its suspicious magic. We have not yet learnt to correlate it to its unseen neighbour and beyond that to fire past the gap in the circle of our scale. We have then somewhat felt our scale situated somewhere between the orb of the sun and the retina within our eyes, closing and opening—closed it is white light, open it is the prismatic play of pristine colours.

How has this scale been used? Hardly at all—as such. Colour was used as architecture by the old masters, as melody by the Easterns.

The post-Impressionists started to think scientifically. They separated colour into two halves as with a knife, and taking the two complementaries, red and green, or orange and blue, or yellow and violet and contrasting them one against the other, thereby very simply made light and darkness.

Since then the development has been towards clarity in colour.

The Neoplastic artists have taken the simplest colours that they could, the three primaries, red, blue, yellow—used them as fixed points and only them. Used their treble accord in counterpoint against the pairs of opposites in the art of shape—horizontal against vertical—mass against line—elevation against plan, etc., etc. The colours wait to be used further. The nature of abstract colour is utter purity—but colours wish to fly, to merge, to change each other by their juxtapositions, to radiate, to shine, to withdraw deep within themselves.

For a long time they have been nailed down like carpets.

Some people think that other mediums than paint will be discovered for

the expression of colour—and this is probable—but the one that is offered of artificial light is not sufficient—for artificial light is transitory, and we seek something free, but stable, calculated in clearness.

Meanwhile as the eyes of man have seen more colour, more precise paint pigments have been invented. After the Impressionists had seen gold glory the Cadmiums were invented. After abstract freedom was seen the celestial Monastral Blue was invented. We need a violet paint. But if we had that we should have a range of pigments capable of conveying the tension of sunlight and could go ahead with our investigations. What these will be is the secret of the living present.

Into words they can not be put, and will never be put. They will be colour, and colours alone will state them. But just as in music, the most abstract music, there are abstract states of human emotion which correspond to the music, so there is in colour.

If I should wish to convey an impression of a piece of music to another person there is no way other than music of doing this—but I can give some slight indication of the kind of music it is by giving an emotional analogy. I can say that the music was solemn—or that it expressed joy.

So with colour we can say by analogy with human feeling the type of territory of the human spirit to which we are taken by colour—and very roughly, for we are at the very beginning of our investigations—we know that these will not be intellectual, for colour is not intellectual.

We know also that they will not be dramatic, for colour is not concerned with the clash of opposites and their movements. Very, very tentatively one may speculate that the research of colour may investigate into the territory of the abstract quality of our emotions, that quality of which we know hardly anything, and in the direction of states of being—and being itself. What makes one suggest this to oneself is that those words which evoke colour out of blindness are such words as freedom, wonder, deep content.

THE FACULTY OF ABSTRACTION
By Herbert Read

ALL who have given any careful or consistent thought to the subject of so-called abstract or non-objective art know that it leads to problems of psychology and philosophy of the subtlest difficulty. These problems cannot be discussed in the normal course of art criticism, because in general they depend on the use of a philosophical terminology with which the general public cannot be expected to be familiar. The present essay, while not pretending to treat the subject in a manner satisfactory to the professional philosopher, will carry art criticism on to a plane which it generally avoids in this country. Indeed, I would say that the discussion of this subject, abstract art, has reached a condition of deadlock which can only be liberated by the use of ampler philosophical terms.

We must begin with certain assumptions about the development of consciousness in mankind. There is no space for a critical review of the various theories which have been advanced by anthropologists and psychologists, but I would venture to say that there is a general agreement on certain broad lines which will suffice for our present purpose. What we now know as intellection or abstract reasoning is peculiar to man, and only becomes evident in man at a relatively late stage of evolution. We do not deny that reasoning of a kind takes place even in animals, but such reasoning is always particular and concrete. 'It seems as evident to me', wrote Locke, 'that they do, some of them, in certain instances, reason, as that they have sense, but it is only in particular ideas, just as they received them from their senses. They are, the best of them, tied up within these narrow bounds, and have not (as I think) the faculty to enlarge them by any kind of abstraction.' (*An Essay concerning Human Understanding*, Book II, Ch. xi, s. 11.)

This subject, as I have already warned the reader, bristles with all the classical problems of philosophy, and it is only by the nimble use of certain

stepping-stones that we shall avoid getting bogged. Those stepping-stones are of a solid materialistic or empirical nature, but I cannot stop to describe them. But, in brief, the theory I would support regards this faculty of abstraction as due to progressive stages in the use of classification. Man, as an animal, is presented through his senses with a mass of phenomena. Merely to carry on the business of life, to exist, he is compelled to arrange these phenomena in a certain order. At first that order will be determined by affective (emotional) reactions, and such is the classification of phenomena we find in primitive man. Everything at this stage of development is fused into one view, and superstition and fear dominate existence. Phenomena which we as civilized human beings regard as discrete and, if connected, connected by explicable links, are for the primitive mind inextricably interpenetrated. Levy-Bruhl has called this state of mind in the primitive: 'collective representation'. 'Their mental activity', he says, 'is too little differentiated for it to be possible to consider ideas or images of objects by themselves apart from the emotions and passions which evoke these ideas or are evoked by them. Just because our mental activity is more differentiated, and we are more accustomed to analysing its functions, it is difficult for us to realize by any effort of imagination, more complex states in which emotional or motor elements are *integral parts* of the representation.' (*How Natives Think*, p. 36.)

The evolution of reasoning we may regard as the progressive attempt to divorce this emotional element from the process of representation. Over a long period of trial and error, and ever driven on by the necessities of combating natural forces (the so-called struggle for existence) mankind was led to make, first a utilitarian or technical classification of phenomena, and then, as the need for connecting or explaining such a pragmatic classification became apparent, a conceptual or scientific classification. We have to imagine mankind as first forming a vast structure of pigeon-holes, into which he sorted the confusing mass of phenomena presented by his senses; then as giving to the contents of each pigeon-hole a general name or 'concept' by means of which he could refer to the contents. This name or concept is, in effect, a symbol which saves us the trouble of doing the sorting and pigeon-holing every time we want to speak about or think about the phenomena in question. We must leave aside the very interesting problem of why a particular word should become the symbol representing a particular set of phenomena.

The further, and final, stage of development comes when man acquires the ability to manipulate these symbols or concepts without reference back to the actual objects or phenomena which they denote. He 'reasons' with the symbols

62

as abstractions: obviously, as in mathematical reasoning, but no less abstractly in dialectical or metaphysical reasoning. To see how extensively and with what almost dizzy prestidigitation this can be done one has only to look at the metaphysical systems of German philosophers like Kant and Hegel—systems which, long after they have been discredited as true deductions from experience, will be admired as abstract works of art.

This process of development so briefly and inadequately described must now be related to the parallel development of art. Art begins, so far as we can trace its beginnings in the Old Stone Age, with the reproduction of eidetic images—that is to say, of images of objects (actually almost invariably animals) which for mystical or emotional reasons have been vividly impressed on the memory of the artist. Art begins as a purely affective or emotive activity, and as such it remains among the most primitive types of mankind still existing (the Bushmen of South Africa, for example). It begins to change when, with the growth of classification, man requires a symbol to express a particular group of phenomena. We have already seen how a word or concept may be chosen to express such a group of phenomena. But alternatively a sign or graphic symbol may be selected. At first such a sign or symbol will be based on the vividness of the eidetic imagery in the mind of the artist, but in time the sign will be reproduced with increasing carelessness, with less and less reference to the memory of actual phenomena, and eventually will become divorced from reality. In this way most alphabets arose and developed, and in some of them we may still find traces of their pictorial origins.

In my recent book, *Art and Society*, I have argued that such symbolic art, gradually divorced from immediate imagery and from the emotional associations of the object, inevitably loses its vitality and declines. I will not repeat the overwhelming evidence which the history of art offers in support of this contention. I think it would be well to note here, however, an apparent exception, best represented in Byzantine art. I should be the last to deny the supreme aesthetic appeal of certain symbolic representations of Christ or the Madonna which we find in the mosaics and illuminated manuscripts of this period. But here I would contend that the artist was in no sense using a symbol as the representative of a generic concept. He was actually trying to represent, with all the emotional awe which such a daring attempt implied, the actual form and features of the godhead. We have only to observe how the representation of the Madonna degenerates at the hands of a more rational or more commercial type of artist to have this truth confirmed.

63

THE FACULTY OF ABSTRACTION

With the growth of rationality and a logical type of mind, art tended to become more and more differentiated as an activity. It was no longer, as in primitive times, an activity integral with life itself—as accepted and as natural as any other practical activity. It became a specialized activity, appealing only to a minority. In the same way, reasoning or intellectual activity developed apart from the normal life of mankind, and became a specialized activity appealing to a minority. By the nineteenth century it was possible for a philosopher like Hegel to regard art and intellect as two distinct and incompatible elements in human life; and as an intellectual, an exponent of the idea, to treat art as an obsolescent feature of life. And from his particular point of view, Hegel was right. This incompatibility between art and intellect does exist; art cannot become conceptual, an affair of symbols, an activity conducted without relation to objects. Art is always a perceptual activity, an activity of the senses in relation to plastic materials.

That is to say, art must now as ever rely on what Levy-Bruhl calls 'the laws of participation'. For the artist as for primitive man there always exists a 'mystic community of substance', a 'pre-logical' identification of thought and object, of concept and percept. But this does not imply that the artist must revert to the primitive stage of mentality. The identification which is now required of him lies *beyond* the concept. That is to say, he must now reclothe the concept in visible and vital raiment. He must accept the orderly universe of philosophy, the pigeon-holes of science. But he must make them real and vivid. In the place of the single concept, he must now put the single phenomenon, the work of art.

I do not pretend that there is any one way of doing this. It seems to me, on the contrary, that we are at a stage of experimentation, trying in various ways to discover a new law of identification. I believe that surrealism, no less than abstract art, is engaged on this all-absorbing and all-important task.

The surrealist believes, or acts as if he believed, that parallel to the development of a *conscious* method of reasoning, there has taken place, below the conscious level of the mind, an organization of latent perceptions (images), and that what is required of the artist is the materialization of this unconscious activity. He would argue that consciousness, intellection and reasoning generally have not developed without unconscious compensations; that against the transcendental edifices of a Kant or a Hegel we must balance the subliminal fantasies of a Lautréamont or a Picasso—just as, in another age, the theological system of a Thomas Aquinas was balanced by the imaginative structure of a

64

Gothic cathedral. The only problem is to discover methods of circumventing the intellect—of releasing the compensatory images of the unconscious in plastic and poetic form.

The method of the abstract artist is more direct. His aim is, in effect, to construct a plastic object appealing immediately to the senses and in no way departing from the affective basis of art, which shall nevertheless be the plastic equivalent of the concept—or, to use the dialectical term, its antithesis. Indeed we may go further and say that he accepts the position of absolute opposition between art and idea declared by Hegel, and proceeds to resolve the contradiction by creating the synthesis—the work of art which translates the concept back again into perceptual form, but retaining the unity of the original concept.

'Space', for example, is a typical concept. As a concept it is very evident in the work of a surrealist painter like Dali; Dali contradicts the rational concept of space in a fantastic manner, giving to his picture what we might call 'a dream perspective'. This very contradiction of space makes us vividly aware of its reality. But an abstract artist like Mondrian attacks the same concept frontally. He presents us with a bare arrangement of lines and two or three pure colours which create and affirm the concept 'space' in the most direct and unequivocal manner. The purer and more fundamental the elements which are used, the acuter and purer is our *emotional* awareness of 'space'. The very fact that naturalistic motives are excluded, and that a naturalistic quality like shading is not imitated, makes our physical awareness of the concept more direct, more exact.

I do not suggest that all concepts can be treated in this manner. The word 'dog' is a concept. If we picture a dog, it is always a particular breed of a dog, and perhaps only a surrealist could paint a conceptual dog, or give an adequate plastic equivalent of all that is implied when we use the symbolic word 'dog'. But actually we do not need such a plastic equivalent; it would, as we say, serve no useful purpose. The activity which modern art is engaged on, of translating concepts into plastic percepts (plastic objects which can be perceived), is determined by necessity—the necessity of our social evolution. At any stage in history (since the appearance of human consciousness) certain concepts are created or preferred, which concepts form the typical ideology of a period. If we are dialectical materialists we regard them as the reflection of that particular state of economic development. But essential to the creative life and development of each period is the translation of these concepts into objects of

65

aesthetic contemplation. The Greek temple, the Gothic cathedral, the Renaissance palace, are but the major types of such translations. Today we are in the process of creating such another type in architecture. But subordinate to these major types are thousands of minor types, all illustrating the ideological concepts of each period. The difference in our own period is that we have become more conscious of these historical processes, *and can attack directly what other ages could only discover accidentally.* Just as surrealism makes use of, or rather proceeds on the assumption of, the knowledge embodied in psycho-analysis, so abstract art makes use of, or proceeds on the basis of, the abstract concepts of physics and dynamics, geometry and mathematics. It is not necessary for the abstract artist to have a knowledge of these sciences (nor is it necessary for the surrealist to have a knowledge of psycho-analysis); such concepts are part of our mental ambience, and the artist is precisely the individual who can make this ambience actual. He can make it actual in detached and non-utilitarian works of art; or he can make it actual in architecture and the industrial arts. In either case he is serving the highest interests of humanity, which is never to halt in a static deadlock, never to revert to an easier path, never to acknowledge defeat when confronted with a contradiction; but ever to negate the negation, to proceed to fresh syntheses, to new paths, to whatever new awareness his evolving consciousness shall lead.

THE QUARREL WITH REALISM
THE DESTINY OF PAINTING *
By Le Corbusier

Is it painting itself which concerns us today, among the anxieties which surround us everywhere, or the fate of the painters who are out of work?

I think that, in this discussion, we are concerned with painting. The question to be answered is: realism or not realism, and by that it would seem that we mean the life or the death of painting. Words perhaps! for in reality the discussion only admits of nuances extending from one extreme to the other.

The painting which has been transmitted to us by history is, in part, figurative or documentary painting. It was right that it should have been documentary because no specialized organization, no mechanism could improve on what the dexterity of the brush could produce.

Painting played a very important part for thousands of years. On the one hand, it constituted documentary archives or perpetuated a sermon, a speech, or recorded in forms more or less cryptic a thought or a doctrine. It transformed a fleeting event into a permanent fact. But, while doing all this and quite independent of these utilitarian tasks, painting—and this is its real vocation, its destiny—recorded forms conveying lyricism. When painting was good, this lyricism was specifically that of the forms. Plastic harmony, infinitely variable and varied. It could then touch sensitive and sane spirits, and evoke poetry —the definite aim of painting and the arts.

Today—as Fernand Léger has said—we are inundated with images. The objective, impassive machine has outstripped the human retina; a machine fears neither heat nor cold; it is never tired; it thus has the advantage of ex-

*This article is a translation of an address given at a discussion on 'Painting and Reality', in which Le Corbusier, Léger and Aragon took part.

ceptional sight, so that its productions are a revelation to us. It permits us to penetrate the mysteries of the cosmos by means of investigations to which our human capacities could never aspire.

We are, then, inundated with images—in the cinema, the magazine, the daily paper. Is not therefore a great part of the tasks of painting accomplished? When a period is almost at an end, when a common incentive no longer animates it, men indulge in soft intimacy and tenderness. It is natural that, at such a time, painting should reap a rich harvest, and innumerable painters should find employment and good remuneration. But this page has been turned—it had to happen one day, and it has happened now—we are entering a collective period; painting has lost some of its *raison-d'être*, and the painters have lost their patrons. That is their tragedy at the present time—the anguish of being useless and unemployable. Times have changed; the great army of painters, with their public and their patrons, with tasks to accomplish, are now without employment. Before considering whether it is possible to save them, let us try to decide whether the fate which has overtaken painting is retrograde or progressive.

When a period becomes collectivized or acquires undeniable common needs, such as those to which the last hundred years have led up, suitable systems must be established, both social and authoritative—with new ideas and, above all, new equipment.

It is useless to try to imagine what the mechanical revolution of the last hundred years really is; it has invaded the whole world; it has upset everything, disturbed everything, battered everything, but, at least for those capable of reading between the lines, it brings also the certainty of speedy deliverance from these misfortunes and crises.

With the wonderful tool which in future will replace the toil of our hands and the sweat of our brow—the machine—we will be able to equip ourselves adequately, not only for comfort—a wide and healthy comfort—but also, this new époque of machine-made civilization will give us happiness and a greater individual liberty, combined with the most complete greatness and collective vitality.

I refer to impending works—the equipment of the country, of all countries, of the world—towns, roads, villages, farms, ports, everything where men live or pass through, whether on the earth, or braving the perils of the seas or the air. A vast animation has seized on the whole world and has placed us face to face with tasks never before contemplated.

For architecture, this equipment opens up a new field. The word is with the architects, if I may be pardoned for saying so. The other day, my friend Elie Faure could state that, from an historical standpoint, in the time of stress the last word was with the architects. I think this is clear.

Thus, in this era of construction, it is architecture which concerns us most. It will not bring us the delight of an intimate nature such as easel-painting could bring us; but it will put us in the way of a new life in which the chief factor will be the sun, nature, the cultivation of the body, the cultivation of the mind—a kind of new selection intervening in the human race. A new life—just imagine it—a life of splendour and physical and intellectual beauty. Another field open in world-consciousness.

But what will become of painting and sculpture? It would seem that these two major arts should accompany architecture; there is room for them there. Let me describe what architecture really is in these modern times: it does not consist only of our own works published in reviews; these are merely the expression of a *carte-forcée*, programmes of doubtful interest which, nevertheless, have allowed us to approach the study of man, his spiritual and physical needs. A new start from the very beginning—a sweeping away of ballast full of errors, deformities, academic sloth. What modern architects have accomplished hitherto is but trifling. It has been all the same a successful revolution.

If we attempt to visualize the great enterprises of modern times, we will find that certain aesthetic pursuits are out of date. Other tasks on a new plane are apparent. We are entering an epic cycle which makes its appeal to the spirit of art, of course, and for this reason, to intelligent artists; but of what transcending quality!

Certain painters and sculptors are speaking of it. In order that the significance which I attach to these considerations should not be misunderstood, I would mention that my best friends are among them, not by force of circumstances only, but because my ideas are fully in accord with theirs. Rather because I extend my ideas of architecture to the phenomena of general culture—to those who express the spirit of a period. And the higher arts are the revealers.

I know painters and sculptors well. I am not an iconoclast, as some would have it. I know the paintings and sculpture of the world because I have travelled everywhere in order to study them. I love them at heart and I live only by the comfort which they give me. This being so, I must confess that I speak here of a certain quality in pictorial and plastic art which alone has the right to intervene in the great architectural symphony of the new era.

69

THE QUARREL WITH REALISM

In order to feed this emotion, will we evoke only the Gothic or the Egyptians? Should we not rejoice—all who are present here, that we have been able to participate in the terrific expansion of the most liberating movement in painting which has taken place for a long time—a movement in art which has re-united us with the great periods of thought and art across countries and ages —which brings unequalled possibilities for the future, at the very moment when painting and sculpture had lost all style and had sunk into bourgeois stagnation—a decadent art, nationalized by Ministries of Fine Arts and Academies.

I refer here to the cubist movement which, with its droll title, burst on us like a liberation. This deliverance was so powerful that I would see in it a great and spontaneous explosion taking place somewhere in the world when, all of a sudden, by some means and in some place, the safety-valve opens and the thing happens.

This revolutionary event was produced with clarity and with vision. It was the artists who started it, like a shell at the end of its trajectory. I do not think that, when a discussion has begun so high, we should let it descend to mean considerations or money interests or vanity. We must realize what the advent of cubism meant, twenty years ago; the result, let it be understood, of the labour of our predecessors, perhaps the direct work of a few great seekers of the nineteenth century. A great historical event unquestionably.

It is suggested today that we should repudiate this event, renounce the greatness of this conquest! This art which is called abstract through a disquieting misunderstanding of its meaning (when a name has to be given to anything in art, idiotic terms are dug out—it is always enemies who give them), this art is concrete and not abstract. In France, this concrete quality could not escape the fate of the spirituality of the country, that is to say, a fundamental objectivity.

At the basis of international production is French art, which, abstract in name, is really concrete. It is essentially concrete. It contains realism. It proceeds in deep layers towards an organic equilibrium. The origin, the roots, the key is to be found in each of its elements. Perhaps the Nordic races—the Anglo-Saxons or the Germanic peoples—allowed themselves to indulge in abstractions. It is of little consequence, however; others will decide one day. We are now in a position to use this art. In what synthesis will it be possible? Here I will again make a confession. I am an architect, but I am just as much a painter—a painter by trade. I have two hearts, as in the song, two home-lands. As architect and painter, every day I find myself absorbed in this problem;

70

can the plastic arts be accommodated harmoniously in the architecture of today with a sufficient understanding of present reality?

The question is important. It is a phenomenon profoundly organic. It is no longer a matter of combining painting and sculpture with architecture, as has been done quite happily sometimes at certain periods, principally in times of pomp and frivolity, from the Renaissance to our own day (you have a bad example in this hall—poor remnant of an art which is, moreover, full of ambiguity).

I believe that we are entering on a period infinitely more serious, when we shall no longer have the right to stick things on something, but when the pure, regenerating spirit of modern times will be expressed by organisms with a mathematical interior, comprising precise and inherent places where the work of art will be given its full value in exact accord with the potential forces in the architecture.

Let me—as an architect—affirm this: architecture is an event in itself. It can exist quite independently. It has no need either of sculpture or of painting. Architecture provides shelters. These shelters supply a human need, from the dwelling to the building erected for civic, intellectual or mystic purposes, etc.

It has been customary for the last twenty years to assert that our houses require art and artists. Some would like to see a dining-room decorated with a basket of fruit painted or carved on a beam. I think that a good leg of mutton on the table would supply this want better. And here I stop short in the discussion. Give me your attention; do not let us bring the commercial system into this debate. The house requires lots of other things more urgently. I refer to the tradition handed down to us in prints or by other witnesses of the past; they show us life in the home at the time of the kings and of a luxury said to have been general. There was no decoration in the houses; people lived with a robust simplicity—proof of their moral wholesomeness. As to the luxury, it was often composed of very bad elements. The lapse of time and the patina alone have obscured things. After the revolution of '89, they wanted to create a bourgeois king; then a workman-king. Léger has spoken truly. It was not the fault of the artists; it is their education which was wrong.

I think that painting and sculpture will find a place in architecture, starting again at zero, organizing everything anew, from the skeleton to the flesh. Loving this skeleton—architecture, which has raised up a real symphony by means of light and the way in which this light illumines the walls, whose lyricism is composed of things intensely real, psycho-physiological—this architec-

71

ture, the result of mathematics—and here mathematics are invoked as beauty and not as an imposition—this architecture, the hub of which is proportion, the human race is ready to accept, and to listen to carefully chosen discourses in places perfectly in harmony with them. We shall have the desire to call in the painter or the sculptor.

When we arrange matters so as to collaborate with the painter and the sculptor, we have no intention of asking only trifles of them. When we invite into our house a worthy, dignified and able guest, whom we respect, we do not make a noise near him; we listen, and he speaks amid silence because he has something to say. In the collaboration of the major arts and of architecture, dignity is not an empty claim.

The conclusion becomes clear. Such an art requires elevation of character and of temperament. Who is ready for this immediate task? Excuse me if I speak frankly. I will not hesitate to do so, for it is necessary. I fear this immense artistic production which is quite indifferent to the advent of contemporary architecture. I love walls beautifully proportioned and I dread to see them given over to minds unprepared. For, if a wall is spoilt, if it is soiled, if the clear, sane language of the architecture is ruined by the introduction of inappropriate painting or sculpture, if the artist is unable to enter into its spirit or goes against its spirit, it is like so many crimes of deceit.

There are two methods of applying painting. There is the purely utilitarian method; I was years before I discovered it. I have gradually observed that the great change in the modern technique of building has produced houses whose interior is surprisingly complex. This complexity of modern planning brings us into conflict with the classic square room of the past. Sometimes, because of the biological necessities of the plan, wall-surfaces, curved or oblique partitions are necessary, even if contrary to our desire for plastic purity—intrusive presences in the architectural whole.

Léger has evoked the formidable dynamic power of colour. It is by means of polychromy that a thrill of excitement may be introduced into the house, a coloured epic, soft or violent. I have been engaged for a long time in defining the wonderful resources of colour; and taking advantage of the organic necessities of the modern plan, I saw that we could restrain confusion by colour, create lyrical spaces, bring out its order, increase its dimensions and make the spirit of architecture rejoice.

This is not yet painting. It is not necessary. It is architectural polychromy. I can, then, when a wall or a partition presses down on me, burst them open by

72

means of an appropriate colour. But I can also, if the place is suitable, call in a painter and ask him to register here his plastic thoughts and at one blow open all the doors to the deep land of dreams—especially there, where there is no real depth.

Here, then, is an exceptionally favourable opportunity to collaborate with the painter. It is camouflage placed at the service of thought. With the same object in view, recourse may also be made to photography—photographic setting.

The second method of association with painting admits of a more preconceived intention. The architect can arrange his plans with the desire—at a given moment—of introducing the note of plastic lyricism. It is then a combination of deep harmony. But there is always the danger of the dualism of two plastic arts out of tune with one another: heterogeneous architecture and painting.

In the collaboration visualized here, mural painting and sculpture with the architecture, restraint is necessary, special qualities of monumentalism and careful preparation. In this—because the dinner plate is the architecture of modern times—I do not see that we can go back to anything in the past, neither to Rembrandt or Rubens, nor to the Quattrocento or the Gothic.

I said before that cubism had opened the gates to the universality of the great periods of art. We must see in this fact only encouragement to go forward. What they expressed was the strength of geometry, symbolism, anthropocentric powers, and their expression was pushed to the limits of clarity.

I have finished. I would close on this note: if we are misjudged now in our manifestations of renewal, if the contemporary arts, painting, sculpture and even architecture are only tolerated with a certain reserve, it is that we have never had the opportunity to create anything—I mean just as much a small house as a part of a town—or the surroundings have been unsuitable. We have always been pushed to one side because the ground was occupied by vestiges of the past—good or bad. We are in the proportion of 1 per cent. modern spirit to 99 per cent. ancient environment. Nothing was elevated, everything was against harmony, and our part was always to appear like boors, our feet covered with mud or manure, appearing to state our views in an elegant and tranquil society. Our manners have, therefore, sometimes been insolent, in spite of ourselves. When harmony will have attained sufficient dimensions, the emotions of the people, of the masses, will be stirred. And, as Léger has said, in very welcome, very optimistic words, at that moment the people will not be wrong. They will say: 'It is well.'

73

THE QUARREL WITH REALISM

It will not be necessary for them to know the paths which have led to this result; but they will feel the harmony, the power and the clarity which we have introduced.

When circumstances are at length favourable to the shaking off of depressing reversals, now in fashion; when people stop looking behind them and leaning on the Renaissance and the splendours of the past—many of which are doubtful—but instead go forward to construct something whole and entire, then we are certain to meet with unanimous approval.

74

QUOTATIONS
Ben Nicholson

1. It must be understood that a good idea is exactly as good as it can be universally applied, that no idea can have a universal application which is not solved in its own terms and if any extraneous elements are introduced the application ceases to be universal. 'Realism' has been abandoned in the search for reality: the 'principal objective' of abstract art is precisely this reality.

2. A different painting, a different sculpture are different experiences just as walking in a field or over a mountain are different experiences and it is only at the point at which a painting becomes an actual experience in the artist's life, more or less profound and more or less capable of universal application according to the artists' capacity to live, that it is capable of becoming a part, also, of the lives of other people and that it can take its place in the structure of the world, in everyday life.

3. 'Painting' and 'religious experience' are the same thing. It is a question of the perpetual motion of a right idea.

4. You cannot ask an explorer to explain what a country is like which he is about to explore for the first time: it is more interesting to investigate the vitality of the present movement than to predict its precise future development; a living present necessarily contains its own future and two things are indisputable—that the present constructive movement is a living force and that life gives birth to life.

75

II. SCULPTURE

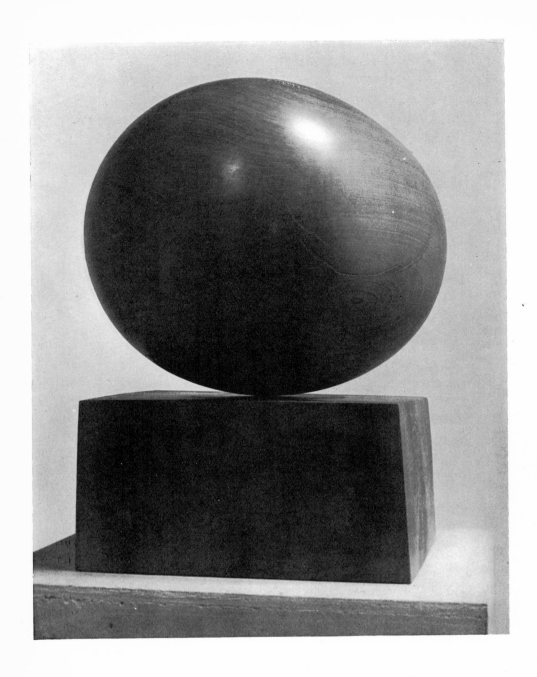

I. HEPWORTH 1935

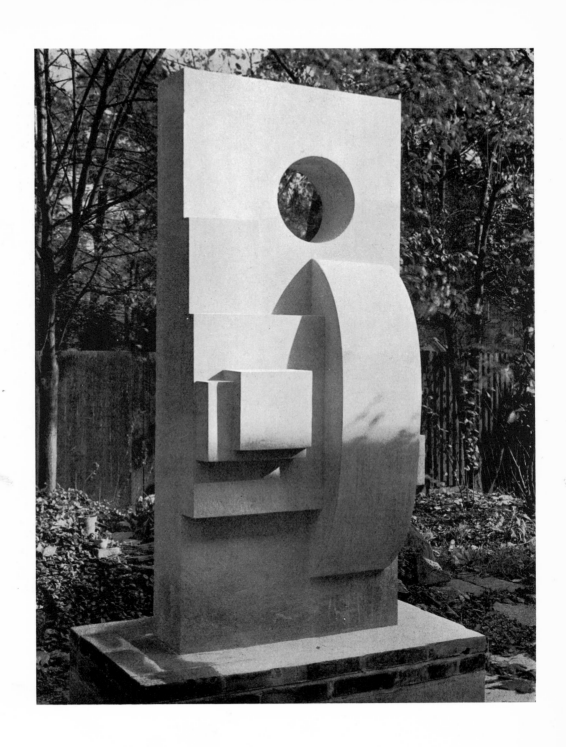

2. HEPWORTH 1936

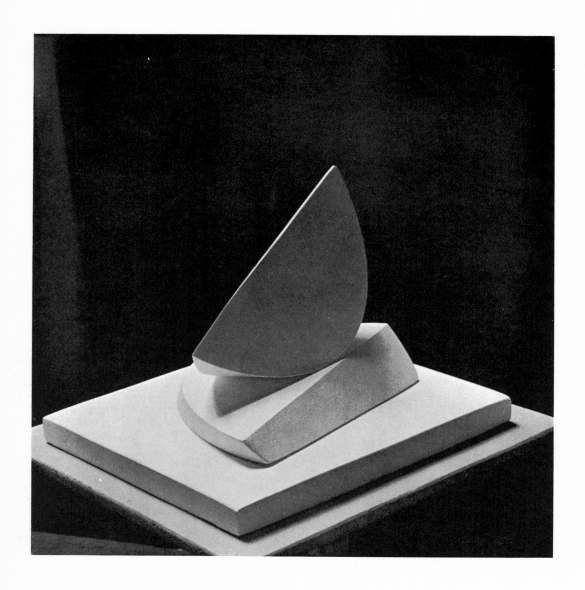

3. HEPWORTH 1936

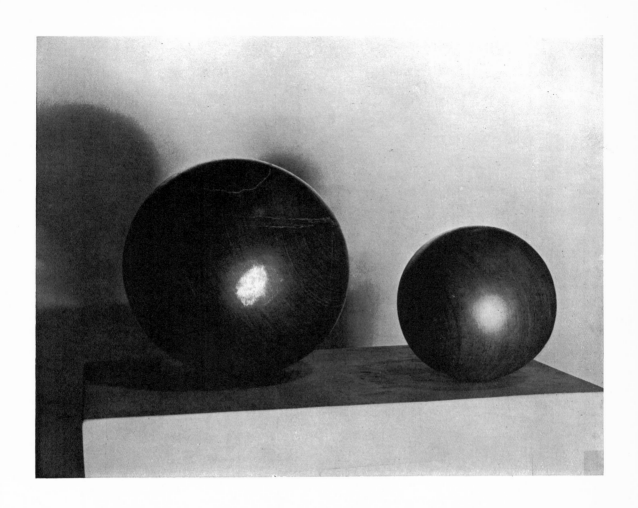

4. HEPWORTH 1936

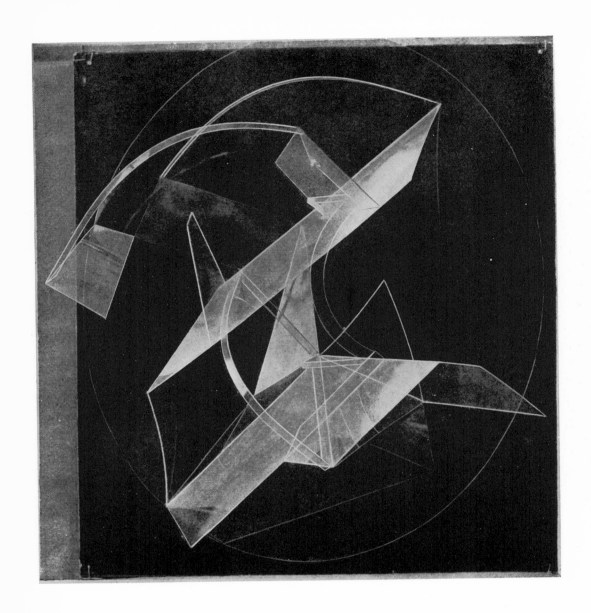

5. GABO 1920

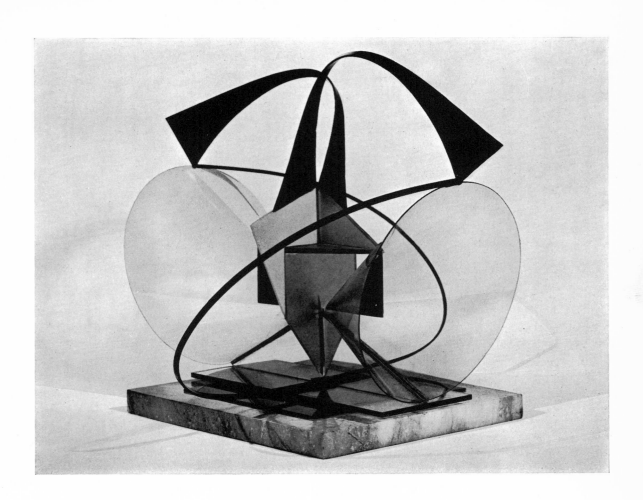

6. GABO 1928

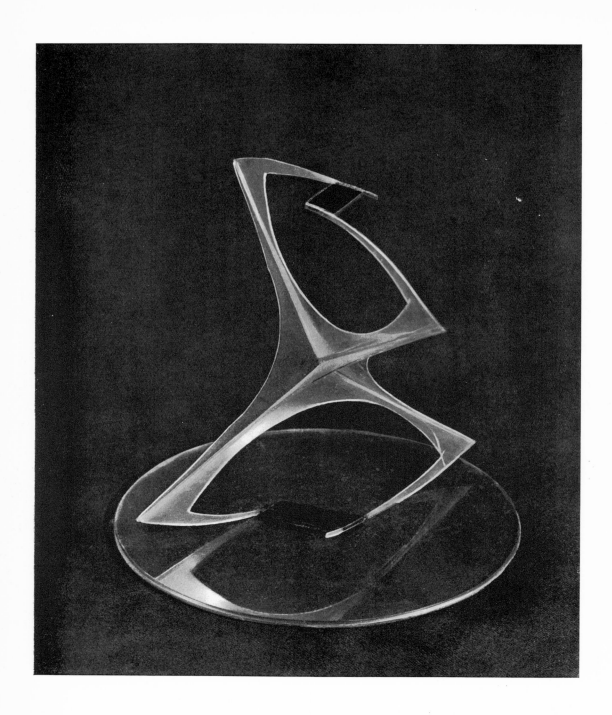

7. GABO 1929

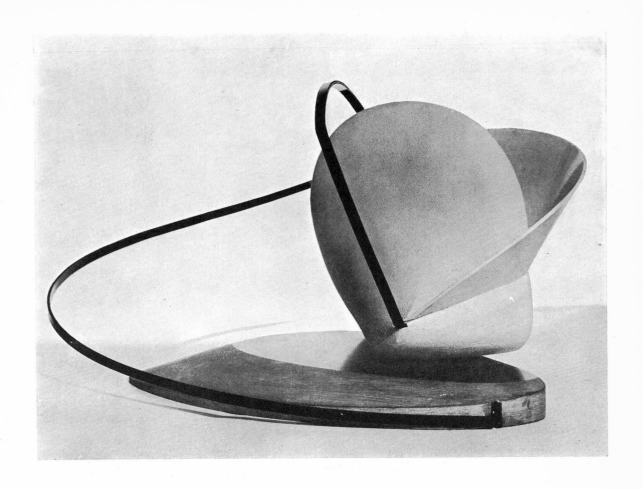

8. GABO 1933

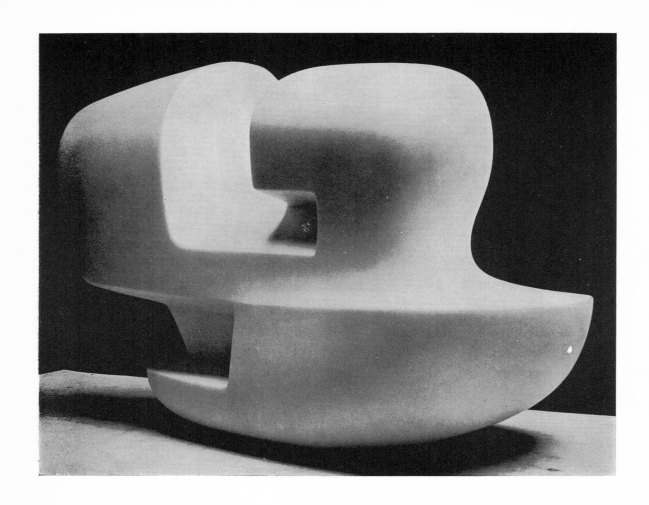

9. MOORE 1936

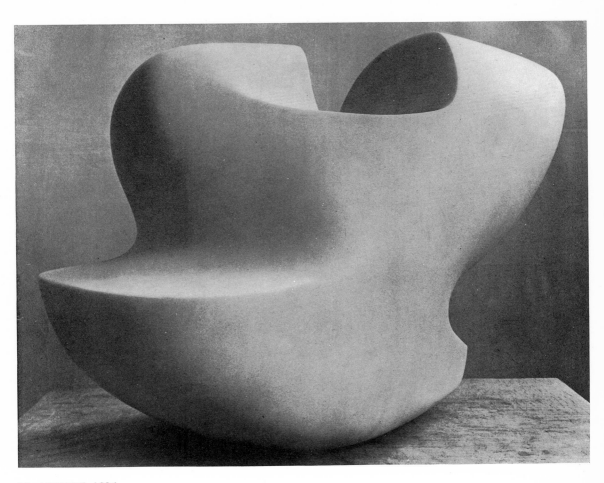

10. MOORE 1936

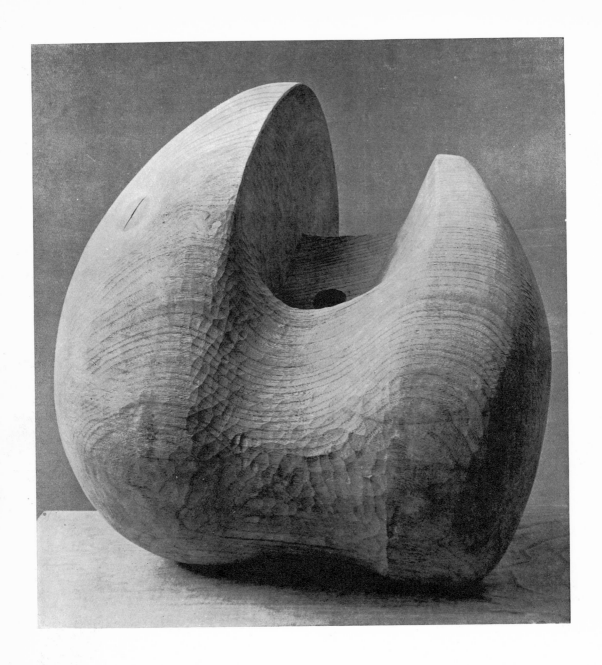

11. MOORE 1936

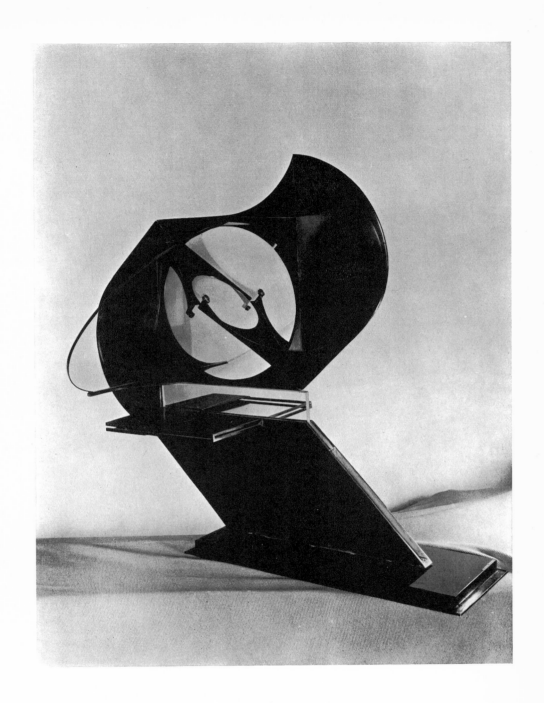

12. PEVSNER 1934

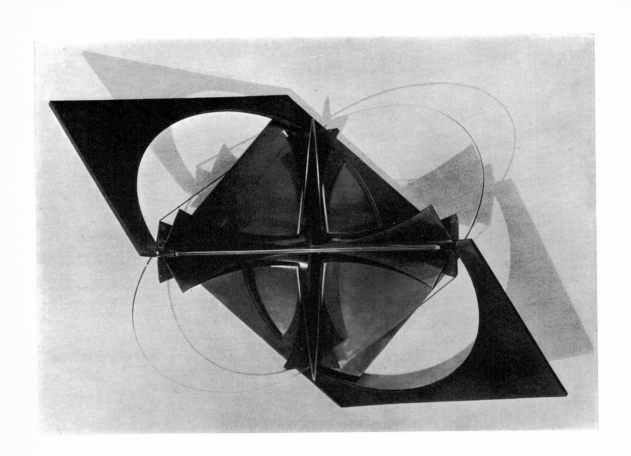

13. PEVSNER 1934

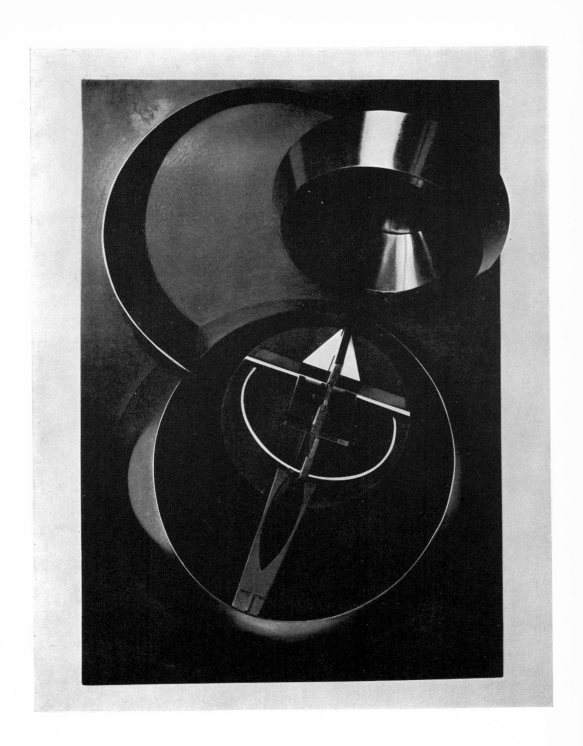

14. PEVSNER 1936

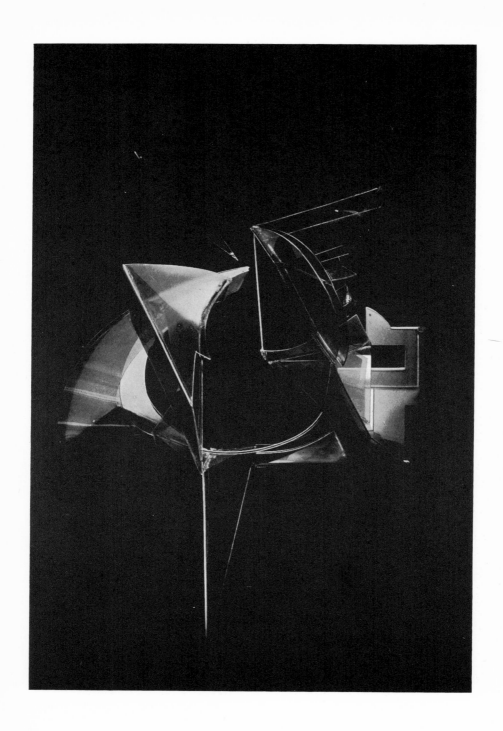

15. PEVSNER 1930

16. HOLDING 1936

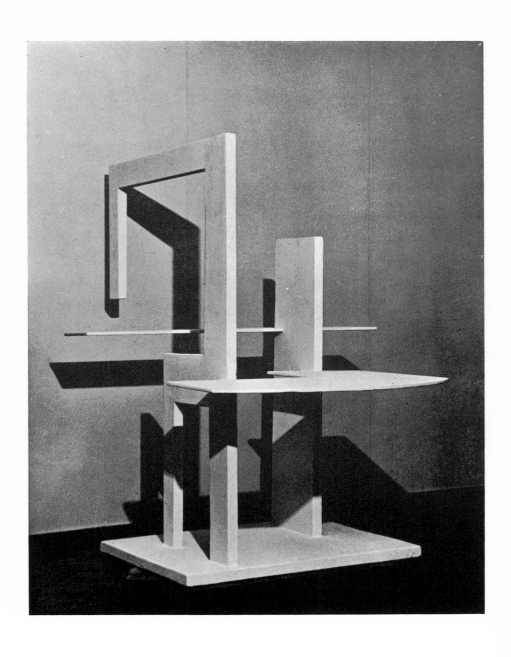

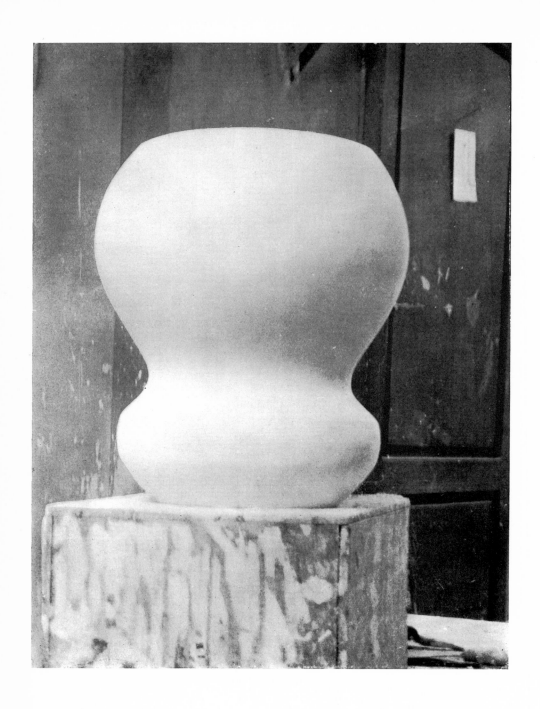

17. GIACOMETTI 1936

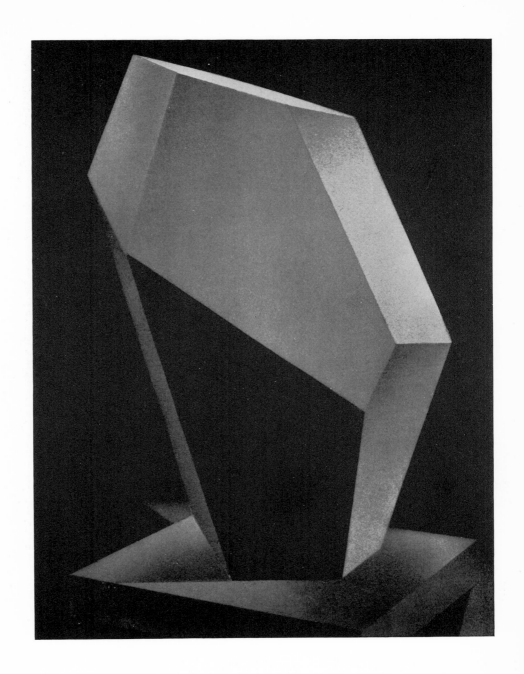

18. GIACOMETTI 1933-34

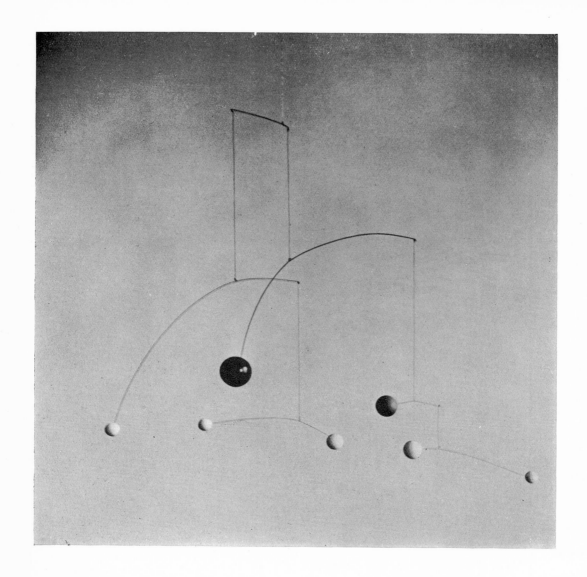

19. CALDER 1936

20. CALDER 1935

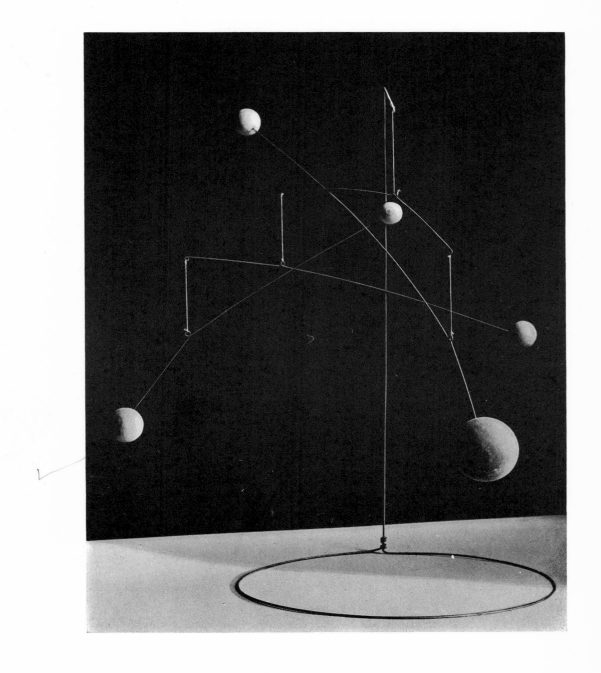

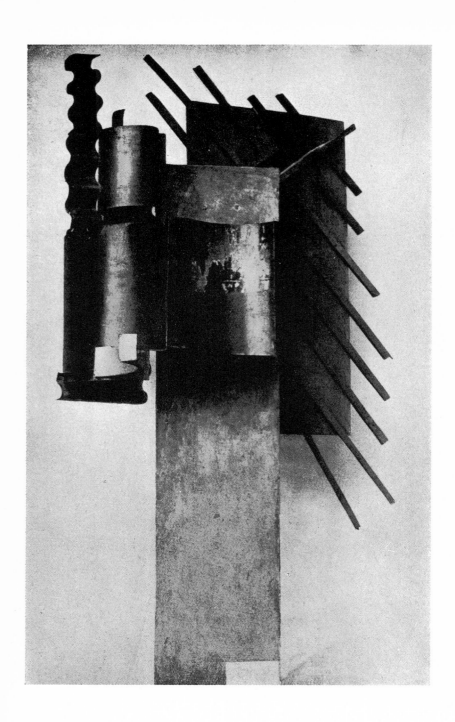

21. TATLIN 1917

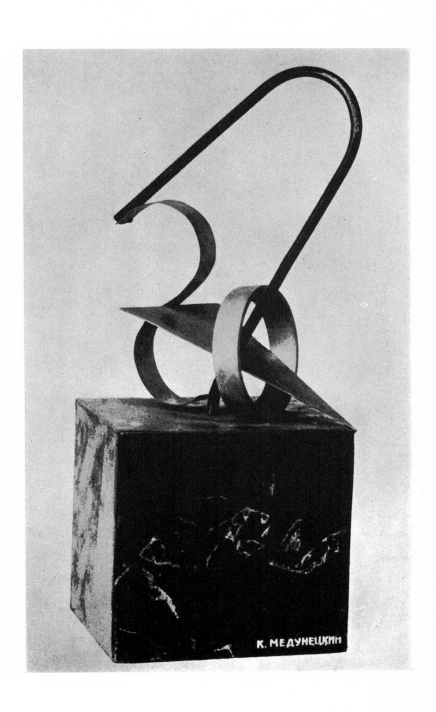

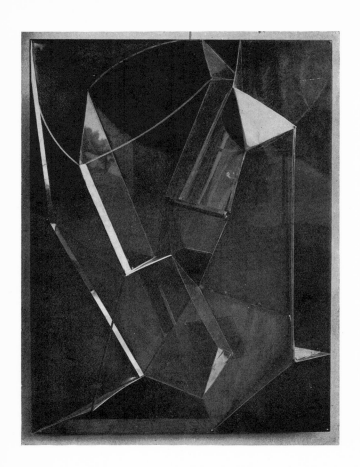

23. GABO 1920

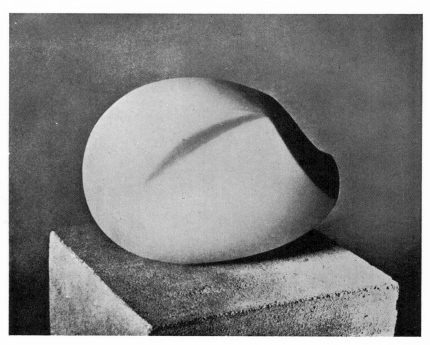

24. BRANCUSI 1915

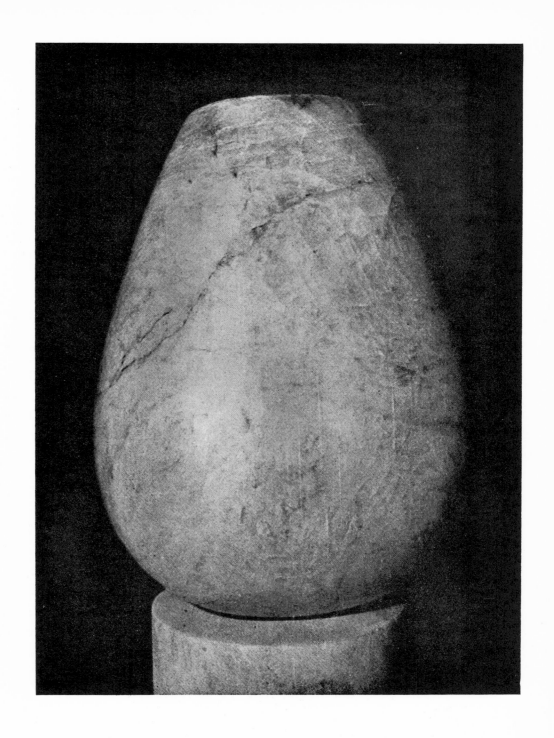

25. BRANCUSI 1922

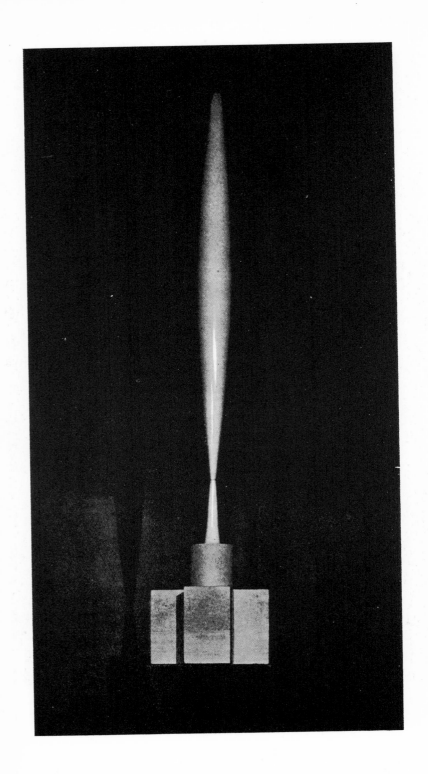

26. BRANCUSI 1925

SCULPTURE: CARVING AND CONSTRUCTION IN SPACE
by N. Gabo

I. I II

THE growth of new ideas is the more difficult and lengthy the deeper they are rooted in life. Resistance to them is the more obstinate and exasperated the more persistent their growth is. Their destiny and their history are always the same. Whenever and wherever new ideas appeared they have always been victorious if they had in themselves enough life-giving energy. No idea has ever died a violent death. Every idea is born naturally and dies naturally. An organic or spiritual force which could exterminate the growth of any new idea by violence does not exist. This fact is not realized by those who are all too keen to fight against any new idea the moment it appears on the horizon of their inter-

103

ests. The method of their fight is always the same. At the beginning they try to prove that the new idea is nonsensical, impossible or wicked. When this fails they try to prove that the new idea is not at all new or original and therefore of no interest. When this also does not work they have recourse to the last and most effective means: the method of isolation; that is to say, they start to assert that the new idea, even if it is new and original, does not belong to the domain of ideas which it is trying to complete. So, for instance, if it belongs to science, they say it has nothing to do with science; if it belongs to art, they say it has nothing to do with art. This is exactly the method used by our adversaries, who have been saying ever since the beginning of the new art, and especially the Constructive Art, that our painting has nothing to do with painting and our sculpture has nothing to do with sculpture. At this point I leave it to my friends the painters to explain the principles of a constructive and absolute painting and will only try to clarify the problems in my own domain of sculpture.

According to the assertions of our adversaries, two symptoms deprive constructive sculpture of its sculptural character. First, that we are abstract in our carving as well as in our constructions, and second that we insert a new principle, the so-called construction in space, which kills the whole essential basis of sculpture as being the art of solid masses.

A detailed examination of this slander seems to be necessary.

What are the characteristics which make a work of art a sculpture? Is the Egyptian Sphinx a sculpture? Certainly, yes. Why? It cannot be only for the reason that it consists of stone or that it is an accumulation of solid masses, for if it were so, then why is not any house a sculpture, and why are the Himalayan Mountains not a sculpture? Thus there must be some other characteristics which distinguish a sculpture from any other solid object. I think they could be easily established by considering that every sculpture has the following attributes:—

I. It consists of concrete material bounded by forms.

II. It is intentionally built up by mankind in three-dimensional space.

III. It is created for this purpose only, to make visible the emotions which the artist wishes to communicate to others.

These are the main attributes which we find in every sculptural work since the art of sculpture began, and which distinguish a sculptural work from any other object. Any other attributes which appear are of a secondary and temporary nature and do not belong to the basic substance of sculpture. In so far as these main attributes are present in some of our surroundings we have al-

104

ways the right to speak about them as things with a sculptural character. I will carefully try to consider these three main attributes to see if a constructive sculpture lacks any of them.

I. Materials and Forms.

Materials in sculpture play one of the fundamental roles. The genesis of a sculpture is determined by its material. Materials establish the emotional foundations of a sculpture, give it basic accent and determine the limits of its aesthetical action. The source of this fact lies hidden deep in the heart of human psychology. It has an utilitarian and aesthetical nature. Our attachment to materials is grounded in our organic similarity to them. On this akinness is based our whole connection with Nature. Materials and Mankind are both derivatives of Matter. Without this tight attachment to materials and without this interest in their existence the rise of our whole culture and civilization would have been impossible. We love materials because we love ourselves. By using materials sculptural art has always gone hand in hand with technique. Technics does not banish any material from being used in some way or for some constructive purpose. For technique as a whole, any material is good and useful. This utility is only limited by its own qualities and properties. The technician knows that one cannot impose on material those functions which are not proper to its substance. The appearance of a new material in the technique determines always a new method in the system of construction. It would be naïve and unreasonable to build a steel bridge with the same methods as those used in their stone bridges by the Romans. Similarly, technicians are now searching for new methods in construction for reinforced concrete since they know the properties of this material are different from the properties of steel. So much for technics.

In the art of sculpture every material has its own aesthetical properties. The emotions aroused by materials are caused by their intrinsic properties and are as universal as any other psychological reaction determined by nature. In sculpture as well as in technics every material is good and worthy and useful, because every single material has its own aesthetical value. In sculpture as well as in technics the method of working is set by the material itself.

There is no limit to the variety of materials suitable for sculpture. If a sculptor sometimes prefers one material to another he does it only for the sake of its superior tractability. Our century has been enriched by the invention of many new materials. Technical knowledge has elaborated methods of working with many of the older ones which could never before be used without diffi-

culty. There is no aesthetical prohibition against a sculptor using any kind of material for the purpose of his plastic theme depending on how much his work accords with the properties of the chosen one. The technical treatment of materials is a mechanical question and does not alter the basic attributes of a sculpture. Carved or cast, moulded or constructed, a sculpture does not cease to be a sculpture as long as the aesthetical qualities remain in accord with the substantial properties of the material. (So, for instance, it would be a false use of glass if the sculptor neglected the essential property of this material, namely, its transparency.) That is the only thing our aesthetical emotions are looking for as far as the materials of a sculpture are concerned. The new Absolute or Constructive sculpture is intending to enrich its emotional language, and it could only be considered as an evidence of spiritual blindness or an act of deliberate malice to reproach an artistic discipline for enriching its scale of expression.

The character of the new materials which we employ certainly influences the sculptural technique, but the new constructive technique which we employ in addition to the carving does not determine the emotional content of our sculptures. This constructive technique is justified on the one hand by the technical development of building in space and on the other hand by the large increase in our contemplative knowledge.

The constructive technique is also justified by another reason which can be clarified when we examine the content of the 'space problem in sculpture'. At the head of this article there are photographs of two cubes which illustrate the main distinction between the two kinds of representation of the same object, one corresponding to carving and the other to construction. The main points which distinguish them lie in the different methods of execution and in the different centres of interest. The first represents a volume of mass; the second represents the space in which the mass exists made visible. Volume of mass and volume of space are sculpturally not the same thing. Indeed, they are two different materials. It must be emphasized that I do not use these two terms in their high philosophical sense. I mean two very concrete things with which we come in contact every day. Two such obvious things as mass and space, both concrete and measurable.

Up to now, the sculptors have preferred the mass and neglected or paid very little attention to such an important component of mass as space. Space interested them only in so far as it was a spot in which volumes could be placed or projected. It had to surround masses. We consider space from an entirely

different point of view. We consider it as an absolute sculptural element, released from any closed volume, and we represent it from inside with its own specific properties.

I do not hesitate to affirm that the perception of space is a primary natural sense which belongs to the basic senses of our psychology. The scientist will probably find in this affirmation of mine a large field for argument and will surely suspect me of ignorance. I do not grudge him this pleasure. But the artist, who is dealing with the domain of visual art, will understand me when I say we experience this sense as a reality, both internal and external. Our task is to penetrate deeper into its substance and bring it closer to our consciousness; so that the sensation of space will become for us a more elementary and every-day emotion the same as the sensation of light or the sensation of sound.

In our sculpture space has ceased to be for us a logical abstraction or a transcendental idea and has become a malleable material element. It has become a reality of the same sensuous value as velocity or tranquillity and is incorporated in the general family of sculptural emotions where up to date only the weight and the volume of mass have been predominant. It is clear that this new sculptural emotion demands a new method of expression different from those which have been used and should be used to express the emotions of mass, weight and solid volume. It demands also a new method of execution.

The stereometrical method in which Cube II is executed shows elementarily the constructive principle of a sculptural space expression. This principle goes through all sculptural constructions in space, manifesting all its varieties according to the demands of the sculptural work itself.

At this place I find it necessary to point those too hasty conclusions which some followers of the constructive movements in art have arrived at in their anxiety not to be left in the rear. Snatching at the idea of space they hasten to assume that this space-idea is the only one which characterizes a constructive work. This assumption is as wrong an interpretation of the constructive idea in sculpture as it is harmful for their own work. From my first affirmation of the space-idea in the *Realistic Manifesto*, 1920, I have not ceased to emphasize that in using the spacial element in sculpture I do not intend to deny the other sculptural elements; that by saying, 'We cannot measure or define space with solid masses, we can only define space by space', I did not mean to say that massive volumes do not define anything at all, and are therefore useless for sculpture. On the contrary, I have left volume its own property to measure and define—masses. Thus volume still remains one of the fundamental at-

tributes of sculpture, and we still use it in our sculptures as often as the theme demands an expression of solidity.

We are not at all intending to dematerialize a sculptural work, making it non-existent; we are realists, bound to earthly matters, and we do not neglect any of those psychological emotions which belong to the basic group of our perceptions of the world. On the contrary, adding Space perception to the perception of Masses, emphasizing it and forming it, we enrich the expression of Mass making it more essential through the contrast between them whereby Mass retains its solidity and Space its extension.

Closely related to the space problem in sculpture is the problem of Time. There is an affinity between them although the satisfactory solution of the latter still remains unsolved, being complex and obstructed by many obstacles. The definite solution is still handicapped by its technical difficulties. Nevertheless, the idea and the way for its solution is already traced in its main outlines by the constructive art. I find it essential for the completion of the discussion of the whole problem of our sculpture to sketch here in general terms the question of Time.

My first definition, formulated in the *Realistic Manifesto*, was: 'We deny the thousand-year-old Egyptian prejudice that static rhythms are the only possible bases for a sculpture. We proclaim the kinetic rhythms as a new and essential part of our sculptural work, because they are the only possible real expressions of Time emotions.' It follows from this definition that the problem of Time in sculpture is synonymous with the problem of motion. It would not be difficult to prove that the proclamation of this new element is not the product of the idle fancy of an efficient mind. The constructive artists are not the first and will, I hope, not be the last, to exert themselves in the effort to solve this problem. We can find traces of these efforts in almost too many examples of ancient sculpture. It was only presented in illusory forms which made it difficult for the observer to recognize it. For instance, who has not admired in the Victory of Samothrace, the so-called dynamic rhythms, the imaginary forward movement incorporated in this sculpture? The expression of motion is the main purpose of the composition of the lines and masses of this work. But in this sculpture the feeling of motion is an illusion and exists only in our minds. The real Time does not participate in this emotion; in fact, it is timeless. To bring Time as a reality into our consciousness, to make it active and perceivable we need the real movement of substantial masses removable in space.

The existence of the arts of Music and Choreography proves that the

108

human mind desires the sensation of real kinetic rhythms passing in space. Theoretically there is nothing to prevent the use of the Time element, that is to say, real motions, in painting or sculpture. For painting the film technique offers ample opportunity for this whenever a work of art wishes to express this kind of emotion. In sculpture there is no such opportunity and the problem is more difficult. Mechanics has not yet reached that stage of absolute perfection where it can produce real motion in a sculptural work without killing, through the mechanical parts, the pure sculptural content; because the motion is of importance and not the mechanism which produces it. Thus the solution of this problem becomes a task for future generations.

I have tried to demonstrate in the kinetic construction* in space photographed here the primary elements of a realization of kinetic rhythms in sculpture. But I hold it my artistic duty to repeat in this place what I said in 1920, that these constructions do not accomplish the task; they are to be considered as examples of primary kinetic elements for use in a completed kinetic composition. The design* is more an explanation of the idea of a kinetic sculpture than a kinetic sculpture itself.

Returning to the definition of sculpture in general, it is always stated as a reproach that we form our materials in abstract shapes. The word 'abstract' has no sense, since a materialized form is already concrete, so the reproach of abstraction is more a criticism of the whole trend of the constructive idea in art than a criticism of sculpture alone. It is time to say that the use of the weapon 'abstract' against our art is indeed only the shadow of a weapon. It is time for the advocates of naturalistic art to realize that any work of art, even those representing natural forms, is, in itself, an act of abstraction, as no material form and no natural event can be re-realized. Any work of art in its real existence, being a sensation perceived by any of our five senses, is concrete. I think it will be a great help to our common understanding when this unhappy word 'abstract' is cancelled from our theoretic lexicon.

The shapes we are creating are not abstract, they are absolute. They are released from any already existent thing in nature and their content lies in themselves. We do not know which Bible imposes on the art of sculpture only a certain number of permissible forms. Form is not an edict from heaven, form is a product of Mankind, a means of expression. They choose them deliberately and change them deliberately, depending on how far one form or another re-

*See illustrations 2 and 3, page 112.

109

SCULPTURE: CARVING AND

sponds to their emotional impulses. Every single shape made 'absolute' acquires a life of its own, speaks its own language and represents one single emotional impact attached only to itself. Shapes act, shapes influence our psyche, shapes are events and Beings. Our perception of shapes is tied up with our perception of existence itself. The emotional content of an absolute shape is unique and not replaceable by any other means at the command of our spiritual faculties. The emotional force of an absolute shape is immediate, irresistible and universal. It is impossible to comprehend the content of an absolute shape by reason alone. Our emotions are the real manifestation of this content. By the influence of an absolute form the human psyche can be broken or moulded. Shapes exult and shapes depress, they elate and make desperate; they order and confuse, they are able to harmonize our psychical forces or to disturb them. They possess a constructive faculty or a destructive danger. In short, absolute shapes manifest all the properties of a real force having a positive and a negative direction.

The constructive mind which animates our creative impulses enables us to draw on this inexhaustible source of expression and to dedicate it to the service of sculpture, at the moment when sculpture was in a state of complete exhaustion. I dare to state, with complete confidence in the truth of my assertion, that only through the efforts of the Constructive Idea to make sculpture absolute did sculpture recover and acquire the new force necessary for it to undertake the task which the new epoch is going to impose on it.

The critical condition in which sculpture found itself at the end of the last century is obvious from the fact that even the rise of naturalism through the growth of the impressionist movement was not able to awaken sculpture from its lethargy. The death of sculpture seemed to everybody inevitable. It is not so any more. Sculpture is entering on a period of renaissance. It again assumes the role which it formerly played in the family of the arts and in the culture of peoples. Let us not forget that all the great epochs at the moment of their spiritual apogee manifested their spiritual tension in sculpture. In all great epochs when a creative idea became dominant and inspired the masses it was sculpture which embodied the spirit of the idea. It was in sculpture that the demoniac cosmology of the primitive man was personified; it was sculpture which gave the masses of Egypt confidence and certainty in the truth and the omnipotence of their King of Kings, the Sun; it was in sculpture that the Hellenes manifested their idea of the manifold harmony of the world and their optimistic acceptance of all its contradictory laws. And do we not find completed

110

in the impetuous verticals of the Gothic sculpture the image of the Christian idea?

Sculpture personifies and inspires the ideas of all great epochs. It manifests the spiritual rhythm and directs it. All these faculties were lost in the declining period of our culture of the last century. The Constructive idea has given back to sculpture its old forces and faculties, the most powerful of which is its capacity to act architectonically. This capacity was what enabled sculpture to keep pace with architecture and to guide it. In the new architecture of today we again see an evidence of this influence. This proves that the constructive sculpture has started a sound growth, because architecture is the queen of all the arts, architecture is the axis and the embodiment of human culture. By architecture I mean not only the building of houses but the whole edifice of our everyday existence.

Those who try to retard the growth of the constructive sculpture are making a mistake when they say that constructive sculpture is not sculpture at all. On the contrary, it is the old glorious and powerful art re-born in its absolute form ready to lead us into the future.

2. KINETIC SCULPTURE—GABO

3. DESIGN—GABO

SCULPTURE
By Barbara Hepworth

I

FULL sculptural expression is spatial—it is the three-dimensional realization of an idea, either by mass or by space construction. The materials for sculpture are unlimited in their variety of quality, tenseness and aliveness. But for the imaginative idea to be fully and freely projected into stone, wood or any plastic substance, a complete sensibility to material—an understanding of its inherent quality and character—is required. There must be a perfect unity between the idea, the substance and the dimension : this unity gives scale. The idea—the imaginative concept—actually *is* the giving of life and vitality to material ; but when we come to define these qualities we find that they have very little to do with the physical aspect of the sculpture. When we say that a great sculpture has vision, power, vitality, scale, poise, form or beauty, we are not speaking of physical attributes. Vitality is not a physical, organic attribute of sculpture—it is a spiritual inner life. Power is not man power or physical capacity—it is an inner force and energy. Form realization is not just any three-dimensional mass—it is the chosen perfected form, of perfect size and shape, for the sculptural embodiment of the idea. Vision is not sight—it is the perception of the mind. It is the discernment of the reality of life, a piercing of the superficial surfaces of material existence, that gives a work of art its own life and purpose and significant power.

One of the most profound qualities of sculpture is scale—it can only be perceived intuitively because it is entirely a quality of thought and vision. Sculpture does not gain or lose spiritual significance by having more or less of physical attributes. A vital work has perfect co-ordination between conception and realization; but actual physical contours do not limit a perfected idea.

It does not matter whether a sculpture is asymmetrical or symmetrical—it

113

SCULPTURE

does not lose or gain by being either: for instance, it can be said that an asymmetrical sculpture has more points of view. But this is only one aspect of the sculptural entity—asymmetry can be found in the tension, balance, inner vital impact with space and in the scale.

The fact that a plastic projection of thought can only live by its inner power and not by physical content, means that the range for its choice of form is free and unlimited—the range of many forms to one form, surprising depths and juxtapositions to the most subtle, very small to very large. All are equal, and capable of the maximum of life according to the intensity of the vision.

Scale is not physical size, because a very small thing can have good scale or a very large thing poor scale—though often large sculptures achieve good scale because the artist approaches their conception with a greater seriousness and thought. Size can be emphasized by the juxtaposition of the very large to the very small; but this is only one side of sculptural relationships. There is the sculpture which has magnificent scale because of its precise and exact relationship between dimension and idea—it creates space for itself by its own vitality. There are two main sculptural identities—one which comes within the embrace of our hands and arms, and the other which stands free and unrelated to our sense of touch. Both have their distinct and individual quality of scale which makes an expansion and spaciousness in everything surrounding them. Scale is connected with our whole life—perhaps it is even our whole intuitive capacity to feel life.

II

The most difficult and complicated form relationships do not necessarily give a sculpture the fullest spiritual content. Very often, as the thought becomes more free the line is purified, and as principles—the laws which contain lesser laws—are comprehended, the forms become simplified and strengthened. In the physical world we can discover in the endless variations of the same form, the one particular form which demonstrates the power and robustness of the simplified structure—the form is clear and every part of it in precise unity with the whole. It is not the accidental or casual, but the regular irregularity, the perfect sequence which gives the maximum expression of individual life. In the three-dimensional realization there is always this exact form, or sequence of form—which can most fully and freely convey the idea. But there is no formula that can reveal the sequence; the premise is individual and the logical sequence purely intuitive—the result of equilibrium between thought and medium.

114

The perception of these differences, imperfections and perfections help us to understand the language the sculptor uses to convey the whole feeling and thought of his experience. It is the sculptor's work fully to comprehend the world of space and form, to project his individual understanding of his own life and time as it is related universally in this particular plastic extension of thought, and to keep alive this special side of existence. A clear social solution can only be achieved when there is a full consciousness in the realm of thought and when every section constitutes an inherent part of the whole.

The sculptural elements have long been neglected and unconsidered, the form consciousness of people has become atrophied; but now much is being done by a more balanced and free education—a greater co-ordination between hand and head—that will keep alive the intuitive form perceptions of the child. A world without form consciousness would scarcely be alive at all. The consciousness and understanding of volume and mass, laws of gravity, contour of the earth under our feet, thrusts and stresses of internal structure, space displacement and space volume, the relation of man to a mountain and man's eye to the horizon, and all laws of movement and equilibrium—these are surely the very essence of life, the principles and laws which are the vitalization of our experience, and sculpture a vehicle for projecting our sensibility to the whole of existence.

III

The whole life force is in the vision which includes all phantasy, all intuitive imagination, and all conscious selection from experience. Ideas are born through a perfect balance of our conscious and unconscious life and they are realized through this same fusion and equilibrium. The choice of one idea from several, and the capacity to relate the whole of our past experience to the present idea is our conscious mind: our sensitivity to the unfolding of the idea in substance, in relation to the very act of breathing, is our unconscious intuition.

'Abstract' is a word which is now most frequently used to express only the type of the outer form of a work of art; this makes it difficult to use it in relation to the spiritual vitality or inner life which is the real sculpture. Abstract sculptural qualities are found in good sculpture of all time, but it is significant that contemporary sculpture and painting have become abstract in thought and concept. As the sculptural idea is in itself unfettered and unlimited and can choose its own forms, the vital concept selects the form and substance of its expression quite unconsciously.

SCULPTURE

Contemporary constructive work does not lose by not having particular human interest, drama, fear or religious emotion. It moves us profoundly because it represents the whole of the artist's experience and vision, his whole sensibility to enduring ideas, his whole desire for a realization of these ideas in life and a complete rejection of the transitory and local forces of destruction. It is an absolute belief in man, in landscape and in the universal relationship of constructive ideas. The abstract forms of his work are now unconscious and intuitive—his individual manner of expression. His conscious life is bent on discovering a solution to human difficulties by solving his own thought permanently, and in relation to his medium. If we had lived at a time when animals, fire worship, myth or religion were the deepest emotional aspects of life, sculpture would have taken the form, unconsciously, of a recognizable god; and the formal abstract relationships in the representation would have been the conscious way of vitalizing these ideas; but now, these formal relationships have become our thought, our faith, waking or sleeping—they can be the solution to life and to living. This is no escapism, no ivory tower, no isolated pleasure in proportion and space—it is an unconscious manner of expressing our belief in a possible life. The language of colour and form is universal and not one for a special class (though this may have been in the past)—it is a thought which gives the same life, the same expansion, the same universal freedom to everyone.

The artist rebels against the world as he finds it because his sensibility reveals to him the vision of a world that could be possible—a world idealistic, but practical—idealistic, inclusive of all vitality and serenity, harmony and dynamic movement—a concept of a freedom of ideas which is all-inclusive except to that which causes death to ideas. In his rebellion he can take either of two courses—he can give way to despair and wildly try to overthrow all those things which seem to stand between the world as it appears to be and the world as it could be—or he can passionately affirm and re-affirm and demonstrate in his plastic medium his faith that this world of ideas does exist. He can demonstrate constructively, believing that the plastic embodiment of a free idea—a universal truth of spiritual power—can do more, say more and be more vividly potent, because it puts no pressure on anything.

A constructive work is an embodiment of freedom itself and is unconsciously perceived even by those who are consciously against it. The desire to live is the strongest universal emotion, it springs from the depths of our unconscious sensibility—and the desire to give life is our most potent, constructive, conscious expression of this intuition.

116

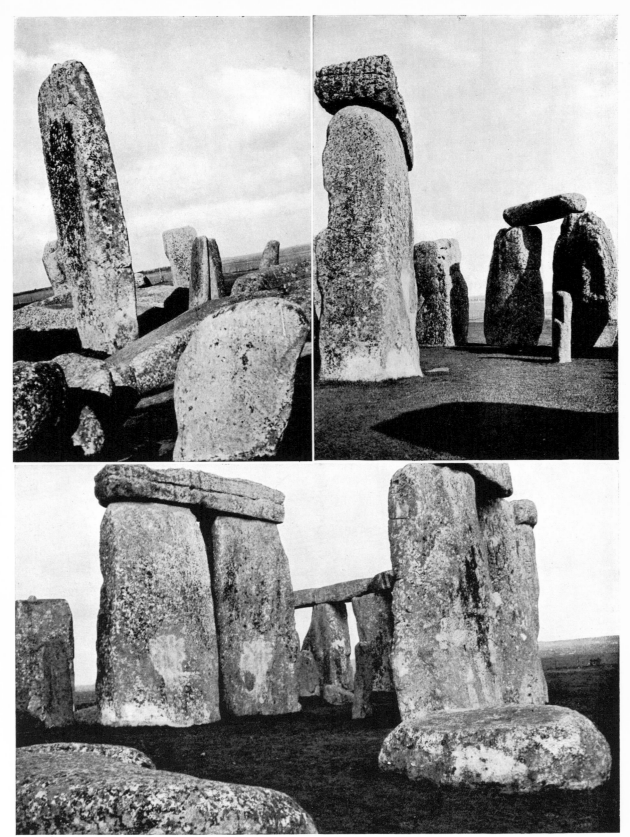

STONEHENGE

QUOTATIONS
Henry Moore

1. I DISLIKE the idea that contemporary art is an escape from life. Because a work does not aim at reproducing the natural appearance it is not therefore an escape from life—it may be a penetrating into reality; not a sedative or drug, not just the exercise of good taste, the provision of pleasant shapes and colours in a pleasing combination, not a decoration to life—but an expression of the significance of life, a stimulation to greater effort in living.

2. Architecture and sculpture are both dealing with the relationship of masses. In practice architecture is not pure expression but has a functional or utilitarian purpose, which limits it as an art of pure expression. And sculpture, more naturally than architecture, can use organic rhythms. Aesthetically architecture is the abstract relationship of masses. If sculpture is limited to this, then in the field of scale and size architecture has the advantage; but sculpture, not being tied to a functional and utilitarian purpose, can attempt much more freely the exploration of the world of pure form.

ART AND THE SCIENTIST
By J. D. Bernal

ONE of the features of the civilization out of which we are now passing was its rigid separation of human functions into different spheres. Every man tended to have a job, to be a specialist in something. The great branches of human culture seemed to move further and further apart. In particular, art and science became two entirely separate spheres which did not even touch at any point. The last official link was the annual reviews of the Royal Academy which used to be given in *Nature*, and in which the academicians were chided for putting the moon the wrong way up in the sky or for painting a flower with too many petals. But even these have now been discontinued, and for the official scientist a picture or statue might just as well not exist. It had not always been so. In the great creative periods of science the artists and the scientists worked very closely together and were in many cases the same people. It was to the interest in the visual arts that we owe the birth of accurate observation of nature. It was the problems of architecture that gave rise to the science of mechanics. Leonardo da Vinci, though the greatest, was only typical of whole schools of artist-scientists. Gradually, however, with the development of bourgeois culture the useful and the ornamental were piously separated. Science was used to make the money, art simply as a means of spending it. The result of this separation has been the most incredible mutual ignorance. The scientist totally ignores art, the artist works as if science had never existed. Yet, particularly at the present day, both have to learn from one another enormously. The whole modern movement in art did, in fact, originate not only from the revulsion of the artists to the lavish and aimless materialism of nineteenth-century painting and sculpture, but also from a slight inkling that the problems of perspective and natural colouring which they had inherited from the artist-scientists of the Renaissance were not the only problems for the artist and that the more recent

developments of science, particularly the new theories of vision, demanded new art to go with them. In the Impressionists, and particularly Seurat, this tendency was manifest, but the contact there made was not renewed until our own time, and then it was not with science but with technics. Through the Constructivist school and the Functionalist architects, the artist began to see new and more rigid harmonies which the necessities of engineering and economics had imposed on the technician. Even this contact, however, was casual and imperfect. There has been no attempt to think out the full implications of modern science for art, and indeed it is doubtful if there is anyone yet capable of doing it. What follows are rather notes and suggestions of the lines along which such an analysis might be made.

We can consider the different aspects of art for this purpose as the formal or modal, the content of art, and its direction or intention. One of the earliest and most marked tendencies of the new development in art has been its insistence on its formal character, whether this betrays itself nakedly as a purely formal or abstract art, or implicitly underlying more elaborate and realistic representations. What is so particularly interesting about this development is, however, that in many ways it represents a recapitulation of the progress of mathematical and physical thought over the period from the Renaissance to the present day. Early art was elementary in its geometry though still below the intricacies of the hyper-geometries of the modern mathematicians. The artist has discovered by intuition and practice many of the stages of this geometrical development. Take for example symmetry. Classical art knew only the simplest bilateral symmetry. Modern art, on the other hand, while ostensibly rejecting symmetry altogether is effectively reintroducing it in more complex forms. These forms have been known, but outside the classical tradition, particularly in the art of savage races, where the sense of rhythm is far more highly developed. The basic concepts of the three-dimensional symmetry are those of rotation, such as the symmetry of a flower; of inversion, as in the difference between the right hand and the left hand; and the combination of these with each other and with direct movements in space (see Fig. 1). This can be done only in a limited number of ways: 230 for three dimensions, 17 for two (see Fig. 2), but this is only for regular figures. By altering the scale a far larger number of internal harmonies, depending essentially on symmetry, can be introduced. Some of the more abstract artists have produced intuitively many of these complex rhythms (see Fig. 3). Architecture in particular gives great opportunities for symmetrical rhythms.

The question arises as to whether an actual knowledge of what the artist is doing would add or detract from his own production or our appreciation of it. Only the event can decide, but the analogy of music may here be helpful. In music the relations of tone and rhythm are for physiological and physical reasons particularly simple. They were realized in practice long before there was any theory, but the advent of theory, far from stifling musical originality, gave it an enormous impetus—the rules of harmony and counterpoint worked as liberating restrictions, and the same might be true in the visual and constructive arts. A picture of a building might be conceived in a certain symmetry combination, much as a musical composition is written in a key.

Another aspect of modern art which recapitulates mathematical forms is the development of line and surface. Here again, classical art was limited to a small number of curves and surfaces, circles, wave forms, spheres and cylinders. Modern art has evolved many more subtle forms, especially sculpture, which now depends on far more complex curves and surfaces. Negative curvature (saddle or hour-glass shape) is characteristic of much modern work (Fig. 4), as are the subtle inflections and the use of nodal points. There is an extraordinary intuitive grasp of the unity of a surface even extending to surfaces which though separated in space and apparently disconnected yet belong together both to the mathematicians and the sculptor (Fig. 5). The stages of this evolution are interesting. Originally surfaces are chosen as presenting the most easily executed representation of a natural surface, the dome of a head, or the curve of a torso. In this nature is always pulling back and tends in the end to destroy the original simplicity in accurate but insignificant detail. By becoming abstract these restrictions are removed and the study of the forms themselves, moved only by subconscious strivings to representation, can be developed. At a later stage the two may come together again in a realism informed by the previous analytic study.

The Cubist school exemplify another attempt at the solution of the problem of surfaces, here resolving them more usually by their principal tangent planes, or occasionally, as in the work of Pevsner, by normal planes (Fig. 6), but in either case carrying out an algebraic discontinuous decomposition as a prelude to a more complex and understanding synthesis.

To this purely geometric aspect of form has been added in tradition another more mechanical aspect. Every building, and ultimately every picture, is anthropomorphized in some inner way so that the effort of lifting and supporting its various parts is instinctively felt on seeing it. The conception of balance

and composition in art is a mixture of appreciation of geometrical symmetry and static compensation. To this must be added the quite different dynamic balance which occurs only for movements, the balance of the bicycle rider or the wheeling bird. How representational art, even in its most abstract form, can suggest this balance and through it the implicit stillness or motion of its parts, is still an unexplored field in the psychology of sensation. Here again the artist has been busy solving problems in practice for which the theoretical formulation is yet largely wanted.

The problem of content is a much more serious one for modern art. In the earlier stages of revolt from nineteenth-century art, content was explicitly neglected in favour of form. A certain choice of content was still made but it was formal objects, and particularly surfaces whose forms gave rise to problems, that were specially selected. The human figure remained because of the richness of forms which it could present, and, though not explicitly, because of its traditional psychological implications. Musical instruments, fruit, houses, machinery were all taken up from this point of view. Another way in which the content could be formalized was presented by Constructivism, where what was represented was essentially between forms such as occur in modern engineering practice, but with a strong tendency to geometricization and abstraction. Finally, in the later developments of purely abstract art the content is reduced to the simplest geometric forms, rectangles, spheres, cylinders and their positive and negative aspect, of which the abstract bas-reliefs of Ben Nicholson (Fig. 7), curiously reminiscent of the equally formal stonework of the Tiahuanaco culture, may stand as a fitting example.

Against this tendency two different streams of reaction have grown up, both concerned with the apparent contentual poverty of abstract art. The surrealist movement depends essentially on introducing literary or psychological content into formal compositions, but it is one in which the rules of composition themselves are no longer mathematical but psychologically guided. Surrealism also significantly draws on a field of content new to art, that of biological structure. Although for the most part it uses the cruder, more accessible, and consequently more emotive dissections of man or the higher animals, it does in principle open the field of biological science as a new source of pictorial content.

The other type of reaction is sociological rather than psychological. The earlier stages of the revolution of the arts were essentially occupied in solving certain problems of presentation, but this modern artists are finding increasing-

ly unsatisfactory. Problems have to be solved, but the solving of problems is not enough. The artist no more than the scientist can occupy himself in permanent satisfaction with the contemplative and analytic sides of his work. Socially art is not complete unless it passes from the solution of problems to something of more immediate social utility. It is true that the artist can as citizen and particularly among other artists, express and carry out political activities. The question, which is one for artists and scientists alike, is: can he do so as artist or scientist? Can the discoveries which have been made in the last thirty years in the field of much more conscious and less tradition-ridden presentation of form be used to produce painting and sculpture which is a powerful part of the social movements of the time? Clearly to do so may involve a return to representation, but it should be a return on a different level of experience. The artist at the moment is in his work necessarily divorced from organic social expression, simply because in our civilization there is practically no vehicle for such expression. Paintings and sculptures are purchasable objects, not parts of well-conceived social construction. As long as this remains so, there can be no satisfactory solution, but this does not mean that nothing can be done. Even a civilization in a state of transition must be able to find expression through its arts for the struggles that are going on. The expression need not, in fact should not, take the obvious and hackneyed forms of revolutionary art. Nor, on the other hand, can it be left to the artists in isolation to discover what form it should take. Scientists and artists suffer not only from being cut off from one another but being cut off from the most vital part of the life of their times. How to end this isolation and at the same time preserve the integrity of their own work is the main problem of the artist of today. There are no ready-made solutions, but if the goal can be seen the way to it will be found.

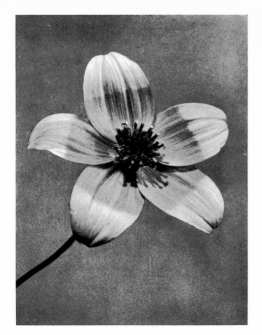

1.

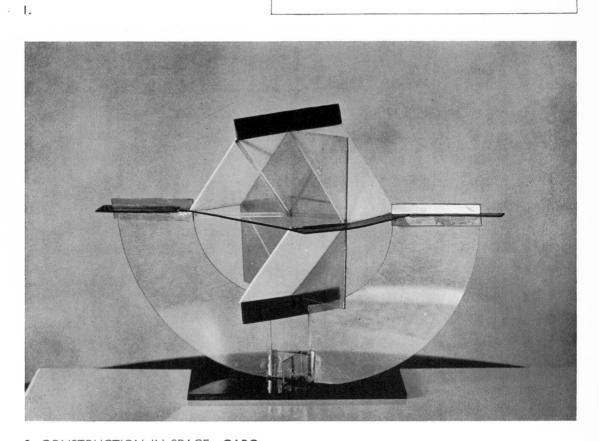

3. CONSTRUCTION IN SPACE—GABO

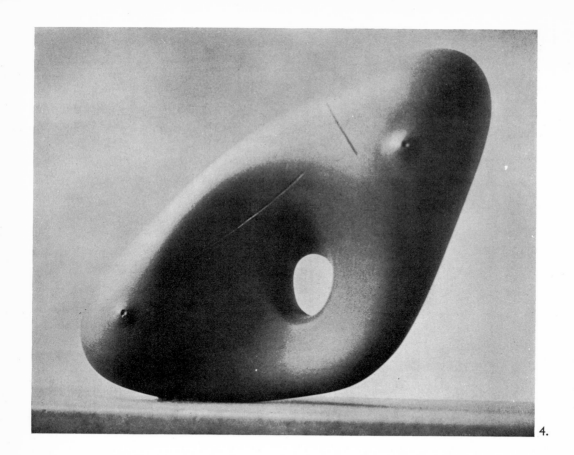

4.

4. SCULPTURE—MOORE
5a. EQUI-POTENTIAL SURFACE OF TWO LIKE CHARGES
5b. SCULPTURE—HEPWORTH

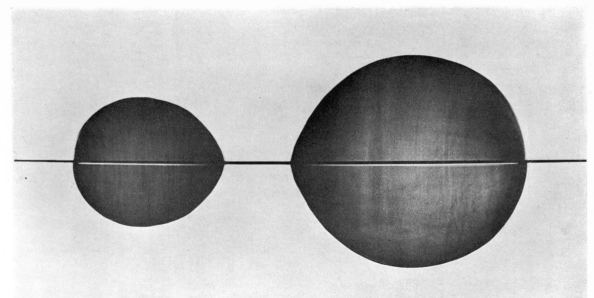

5a.

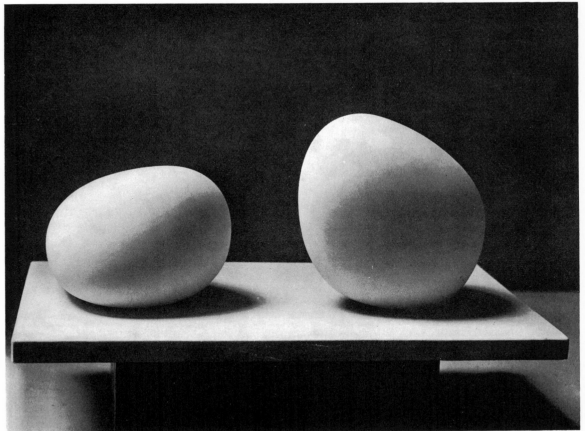

5b.

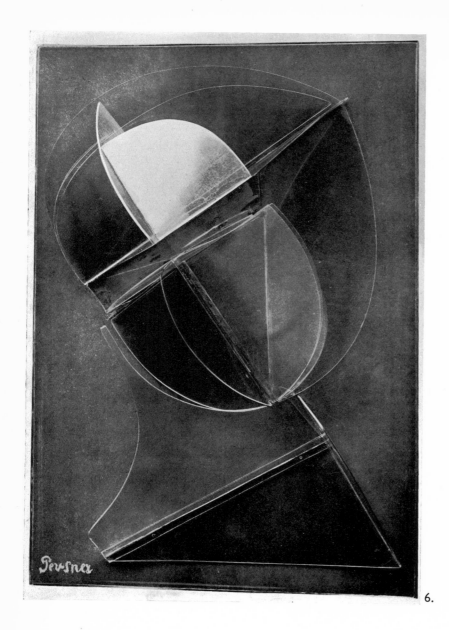

6.

6. RELIEF—PEVSNER
7a. RELIEF—NICHOLSON
7b. STONECARVING FROM TIAHUANACO (PERU)

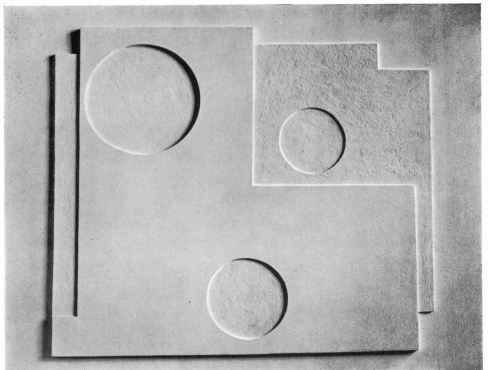

7a.

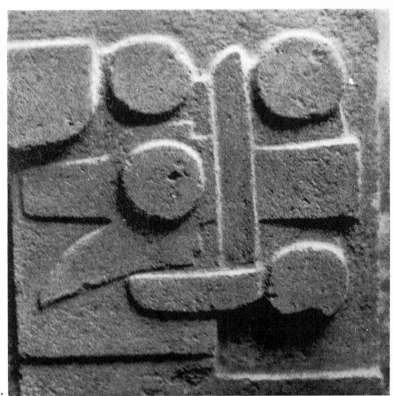

7b.

III. ARCHITECTURE

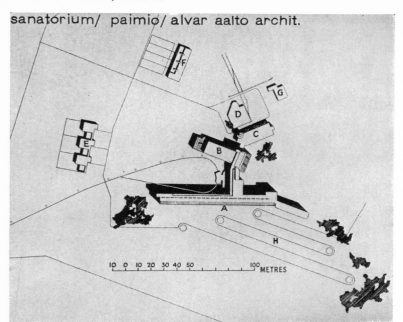

sanatorium/ paimio/ alvar aalto archit.

PAIMIO, FINLAND. THE
TUBERCULOSIS SANATORIUM

KEY PLAN.
Wing A. Two patient wards and sun
terraces. Wing B. Doctors' Quarters,
clinics, operating theatres, adminis-
tration, recreation, dining. Wing C.
General service and nursing staff.
Wing D. Power Station. Wing F.
Employees' Houses. G. Garages.
H. Gardens.

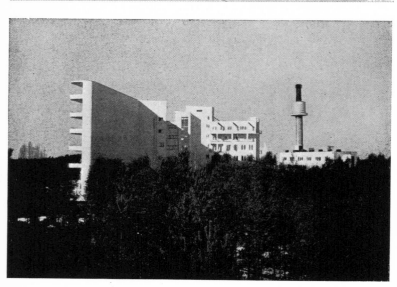

General View.

Sun Terrace Wing A.

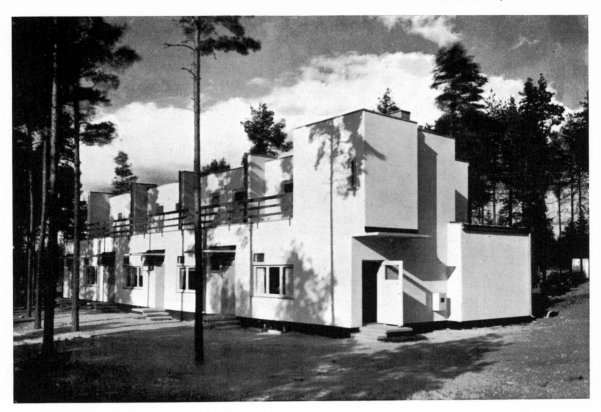

PAIMO, FINLAND
THE EMPLOYEES' HOUSES

WATER TOWER OF THE TOPPILA
CELLULOSE FACTORY IN THE ARCTIC
REGION OF FINLAND

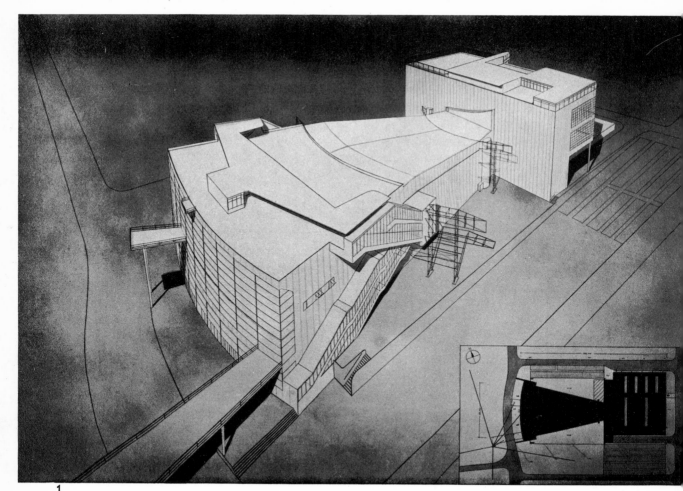

1

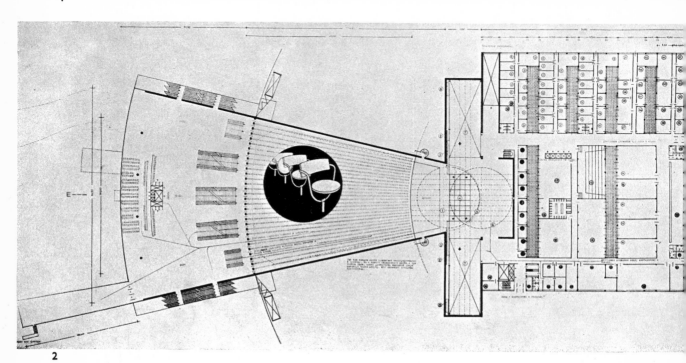

2

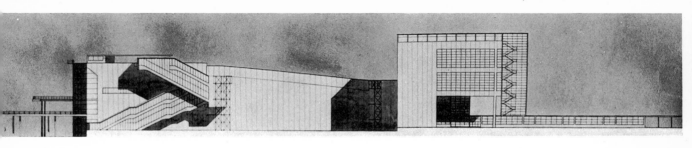

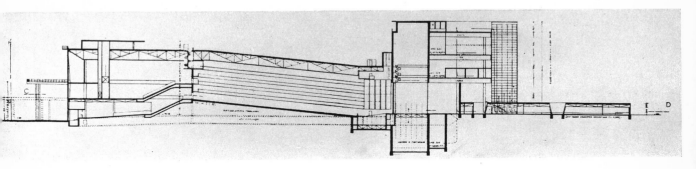

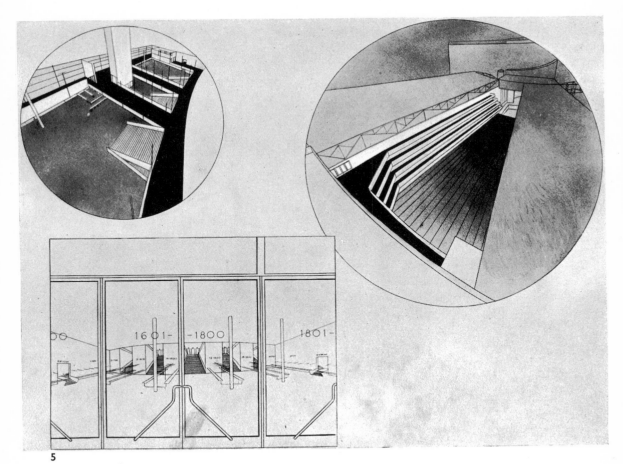

PROJECT FOR A THEATRE IN KHARKOV TO SEAT 4000 SPECTATORS
1. General view. 2. Plan. 3. Side elevation. 4. Longitudinal section.
5. Diagrams of entrance hall and sliding auditorium roof.

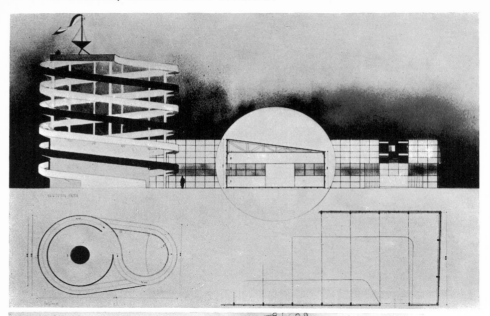

1

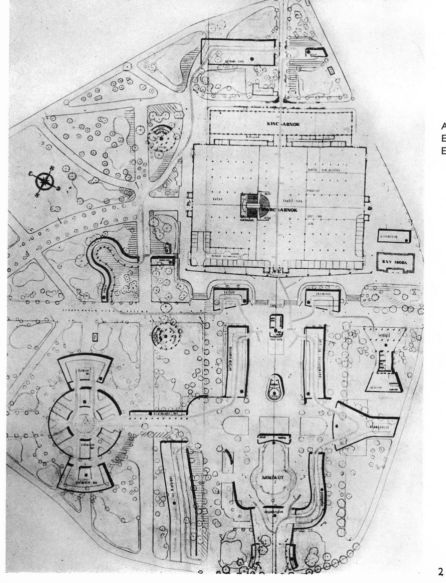

A LAY-OUT FOR AN
EXHIBITION IN AN
EXISTING PARK, 1935

2

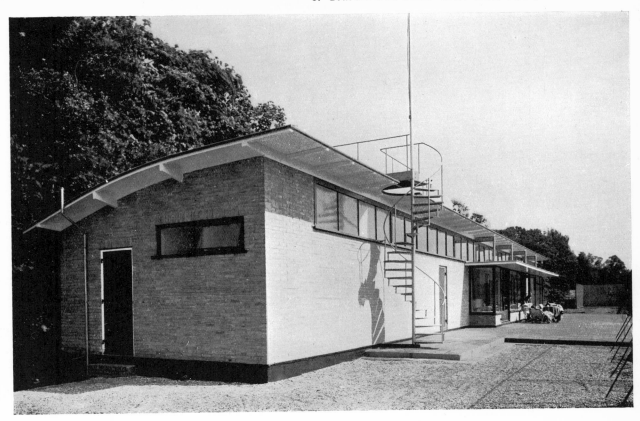

1. TENNIS CLUB HOUSE IN
ROTTERDAM 1936

2, 3 and 4. SMALL HOUSE AT
NOORDWIJK

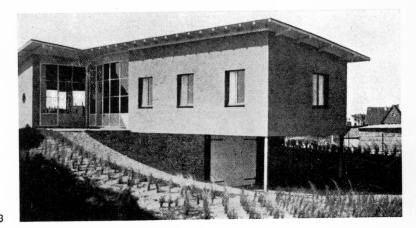

2

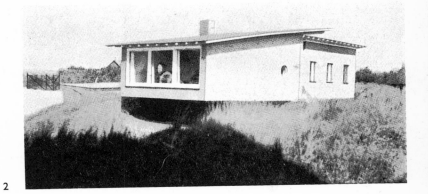

4. 3

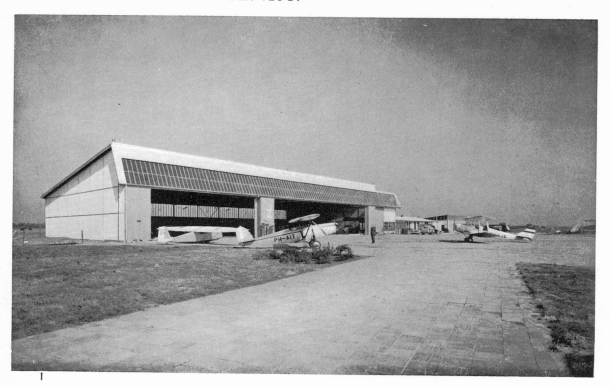

1

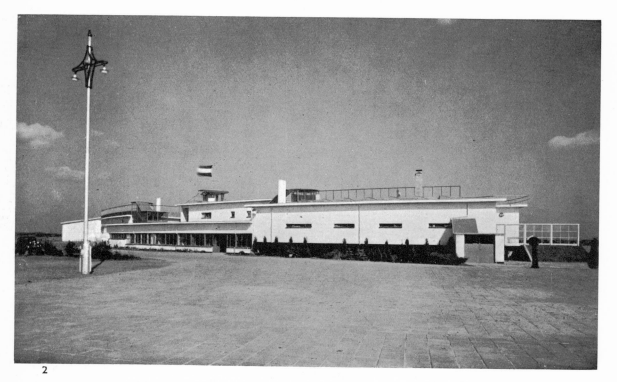

2

YPENBURG, HOLLAND. NEW AERODROME BUILDINGS
1. View of the Hangars.
2. South front as seen from the road.

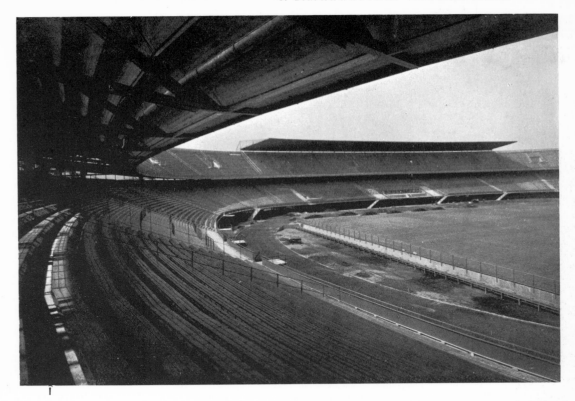

1

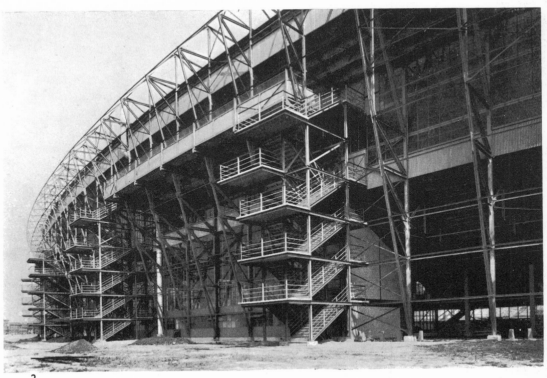

2

ROTTERDAM. THE FEYENOORD FOOTBALL STADIUM

Designed to hold 65,000 spectators in two tiers of seats, one tier cantilevered above the other. (1) Interior view looking towards the official stand. (2) Exterior view showing the general construction, staircases and elevated promenade gallery.

NEW OFFICES AT CAMDEN TOWN 1937

This office block is placed at the corner of two cobbled streets which serve an adjacent goods yard. The problem finally resolved itself into one of noise elimination from two sources:

1. Structure borne sound, *i.e.* transmission of vibration from roadway through building;

2. air-borne sound, *i.e.* street noise entering directly through windows or being reflected from adjacent buildings through windows.

These considerations have governed the entire design and have been dealt with as follows:

1. Elimination of structure borne sound. The reinforced concrete structure stands on a cork bed (A) and is insulated internally with Heraklith slab (B). The foundations are in addition isolated by an air duct by means of an anti-vibration wall (C) on the street side of the building. This vibration wall and the intermediary floor slabs are themselves isolated one from another by expansion joints filled either with bitumen or cork.

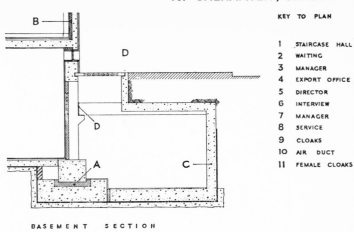

BASEMENT SECTION

KEY TO PLAN

1 STAIRCASE HALL
2 WAITING
3 MANAGER
4 EXPORT OFFICE
5 DIRECTOR
6 INTERVIEW
7 MANAGER
8 SERVICE
9 CLOAKS
10 AIR DUCT
11 FEMALE CLOAKS

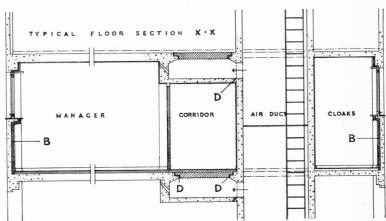

TYPICAL FLOOR SECTION X·X

(D). The working portion of the building, lifts, cloaks, staircase, service, etc., is isolated from the office area, see section 1. Vertical pipes are interrupted with rubber joints. Floor slabs are hollow tile and slag concrete screed, *i.e.* cellular, sound insulating with cork floors for noise elimination at source.

2. Elimination of air borne sound. The whole building has been sealed and is air conditioned from a plenum plant in the basement. Windows open with coach keys for cleaning purposes only: windows are double glazed with two different thicknesses of glass of different vibration periods; teak frames are used to make them more inert, sound resisting and rattleproof. Window areas have been reduced as far as possible without light loss. All ceilings in offices facing the street are in addition acoustically treated with absorbent acoustic plaster to prevent noise reflection.

Board rooms are on the sixth floor. The Canteen where silence is not an essential factor, has been placed on the ground floor where the various preventative measures are in any case likely to be less effective.

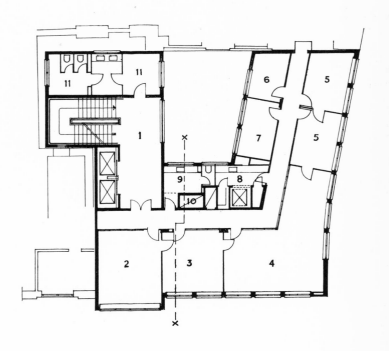

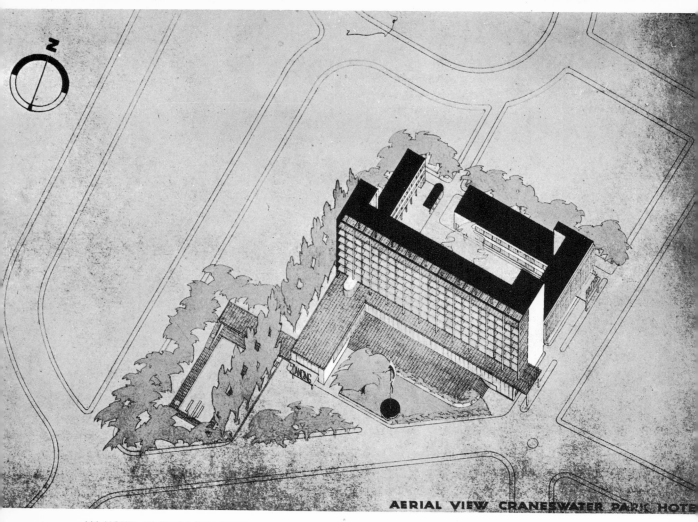

AERIAL VIEW CRANESWATER PARK HOTEL

AN HOTEL PROJECT FOR SOUTHSEA

The project incorporates the following distinct sections:
1. Hotel.
2. Large Assembly rooms accessible both from the Hotel and independently, direct from the street with a view to sub-letting.
3. A number of flats for permanent or semi-permanent residents.
4. Medicinal baths for various treatments.
5. Open Air Swimming Pool, etc.

The main hotel block runs east west, so that all bedrooms, entertainment rooms and terraces face south, and command an uninterrupted view of the sea. The main entrance to the hotel is situated at the east end of the block near the intersection of the main roads. Running to the north of this, and forming a separate wing is the medicinal bath installation, accessible both from the street and from the hotel. Over this wing is the flat accommodation. The assembly room block is placed at the west end of the hotel and projects in front of this, its flat roof being used as a sun terrace. The bathing pool is 120 feet by 48 feet with changing room accommodation for 1,000 bathers. The ground and mezzanine floors are shown opposite.

The first floor of the hotel block includes the writing room and lounge, Men's library, Ladies' drawing room and card room all opening on to terraces facing south.

On the second to the sixth floors there are 108 hotel bedrooms, each approximately 15 feet by 12 feet 6 ins., and having a large balcony with ample space for couches and deck chairs. Altogether 15 flats are provided, each containing a large living room, kitchenette, bathroom, w.c. and two bedrooms.

The entire structural frame of the building is of reinforced concrete designed on a unit system which will permit the greatest saving of cost and complete freedom of subdivision into the various internal elements of the building.

Ground floor.

A. Entrance hall.
B. Reception hall.
C. Cloaks.
D. Shops and barber.
E. Cellars.
F. Kitchens.
G. Service entrance.
H. Tea lounge.
J. Band.
K. Dance floor.
L. Foyer.
M. Ballroom entrance.
N. To terrace.
O. Changing rooms.
P. Swimming pool.
Q. Garages.
R. To staff rooms.
S. Petrol station.
T. Squash courts.
U. Baths entrance.
V. Waiting room.
W. Hydro therapy.
X. Flats entrance.
Y. Offices.

Mezzanine floor.

A. Tea lounge.
B. Bar.
C. Grill room.
D. Restaurant.
E. Wines.
F. Cold kitchen.
G. Service.
H. Sun bathing.
J. Pavilion.
K. Upper part of
 ballroom.
L. Staff rooms (men).
M. Flats.
N. Terraces.
O. Electro therapy.
P. Upper part of
 squash courts.
Q. Gallery.

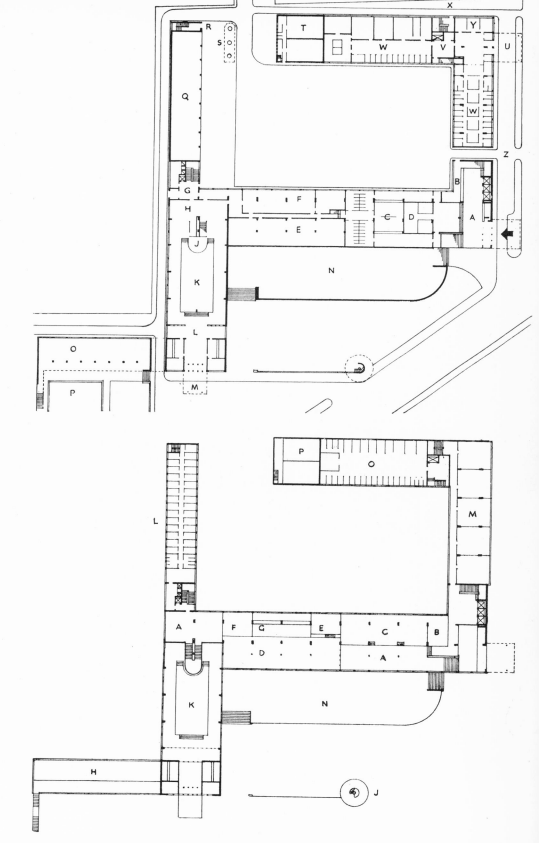

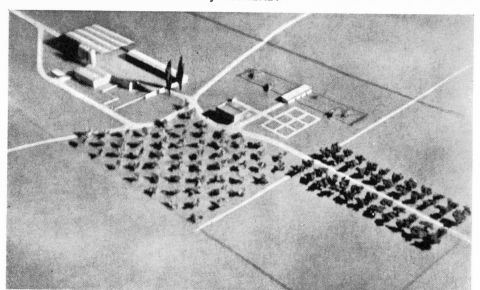

1. GENERAL VIEW OF THE FARM

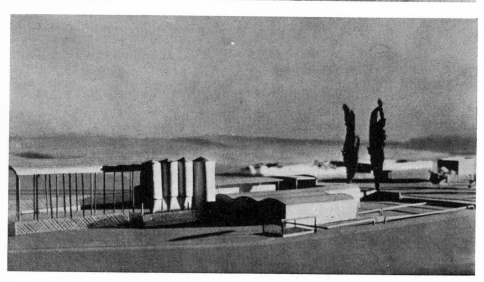

2. THE SILOS, BARNS, ETC. WITH THE HOUSE ON THE EXTREME RIGHT

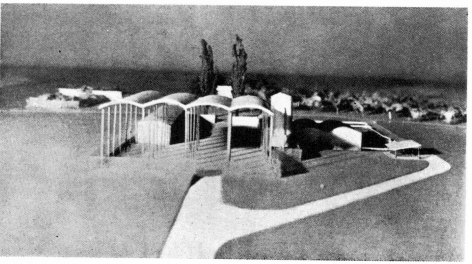

3. VIEW OF THE BARN. Built as a steel frame. The vaults are filled in with light concrete and covered over with earth.

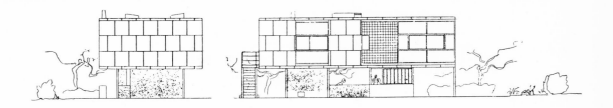

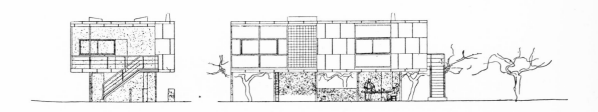

THE FARM HOUSE

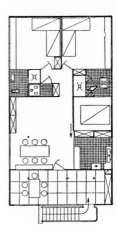

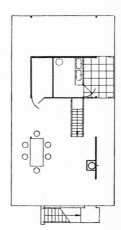

AGRARIAN REORGANIZATION, 1934

The scheme is a practical attempt to make a systematic study of agrarian reform without which town reorganization cannot be complete. Town inhabitants cannot be attracted to country life if this remains in its present condition. The co-operative village with its repair shops, stores, housing, educational and cultural centres, is as necessary as the new type of farm. The farm illustrated is therefore part of a large scheme of reorganization and is in itself not an isolated example, but a type form. Its units are standardized but will allow a variety of arrangements according to situation, aspect, etc.

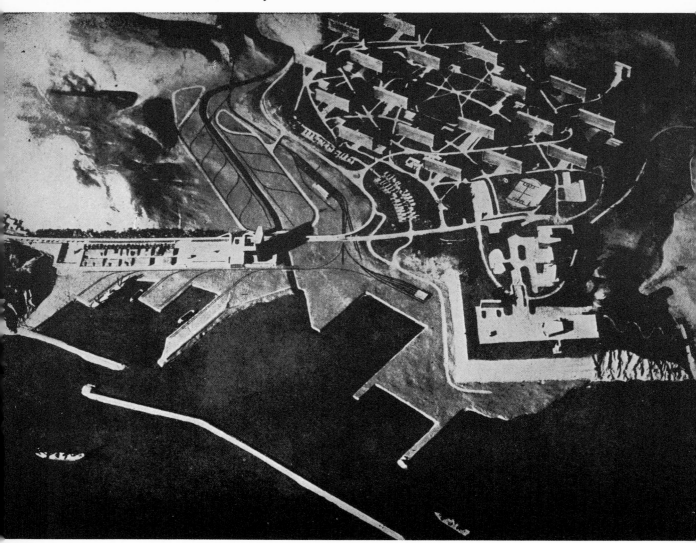

1. THE COMPLETE PROJECT: rational disposition and harmonious development.

THE TOWN PLAN FOR NEMOURS, NORTH AFRICA, 1934
The scheme controls the entire development of the new town for a population of 38,000 European inhabitants and ensures rational and healthy future extension.

2. THE COMPLETE SCHEME
OF CIRCULATION

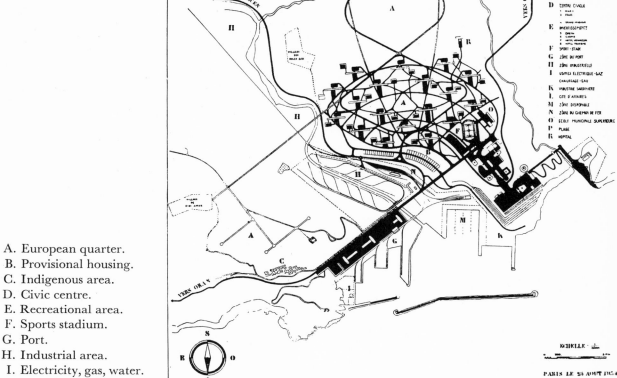

A. European quarter.
B. Provisional housing.
C. Indigenous area.
D. Civic centre.
E. Recreational area.
F. Sports stadium.
G. Port.
H. Industrial area.
 I. Electricity, gas, water.
K. Sardine industry.
L. Administration.
M. Free space.
N. Railway.
O. School area.
P. Bathing.
R. Hospital.
CO. Communal land.

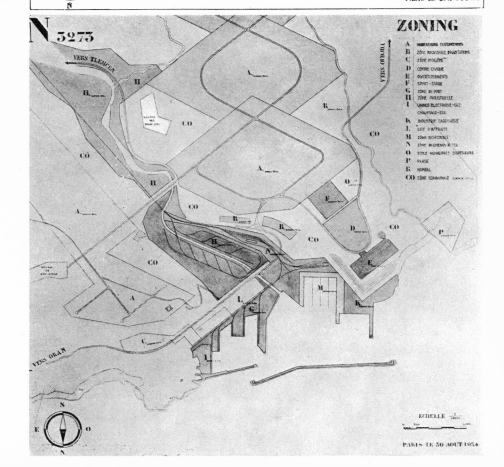

3. THE ZONING PLAN

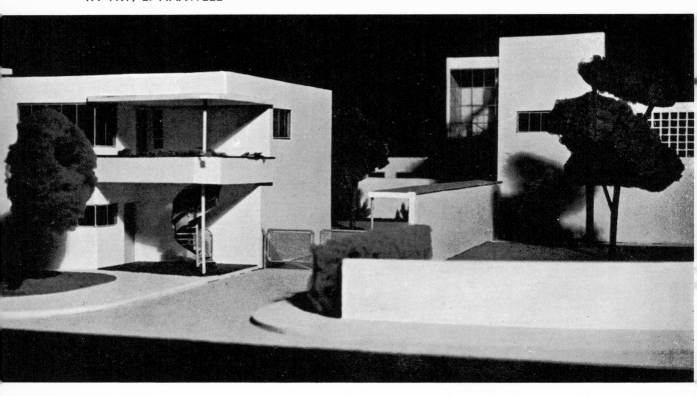

A HOUSE AT COOMBE SURREY, 1936-1937

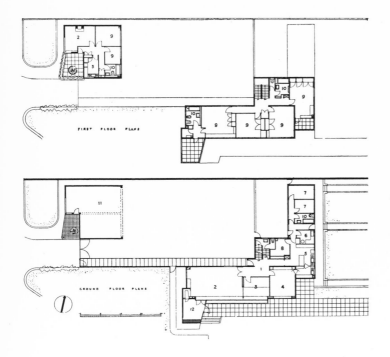

1. Hall.
2. Living room.
3. Study.
4. Dining room.
5. Kitchen.
6. Wash house.
7. Maids' bedrooms.
8. Maids' room.
9. Bedrooms.
10. Bathroom.
11. Garage.
12. Sun room.

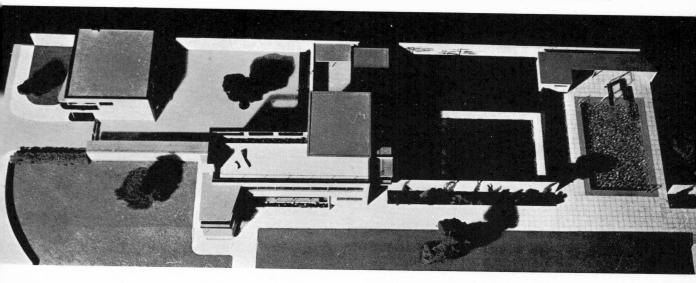

General view.

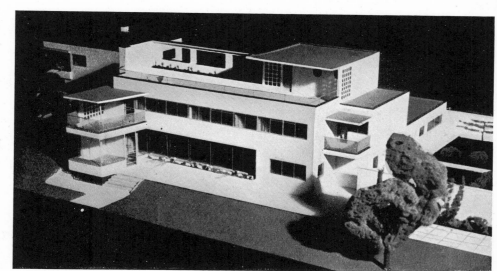

View from the south.

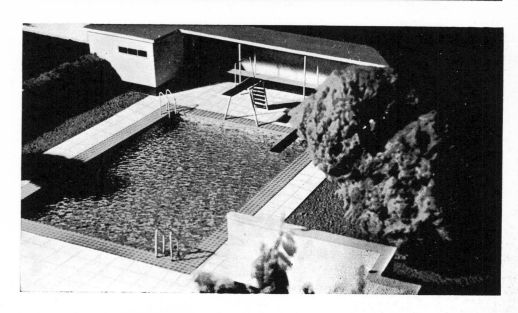

The swimming pool.

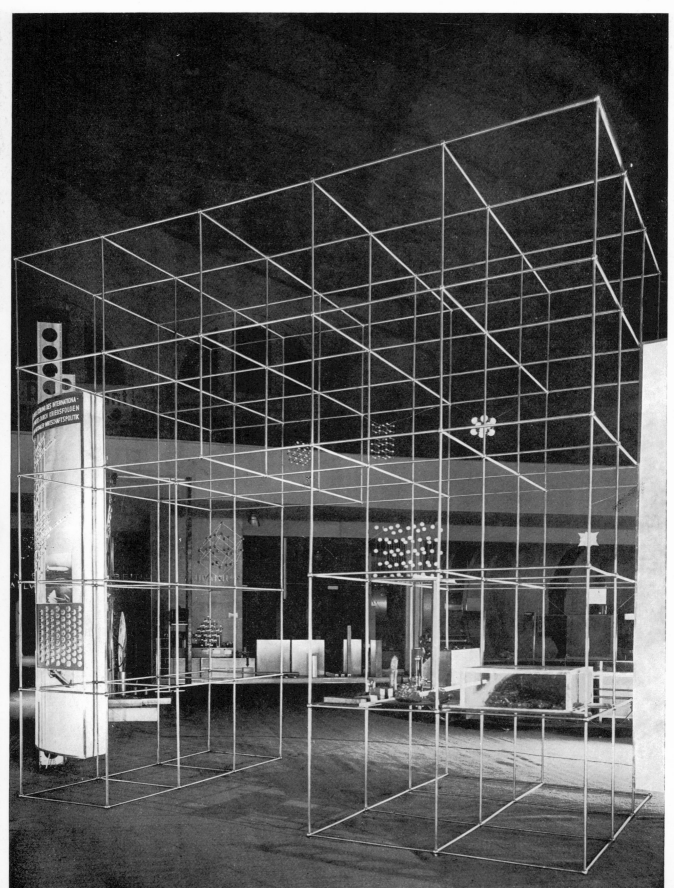

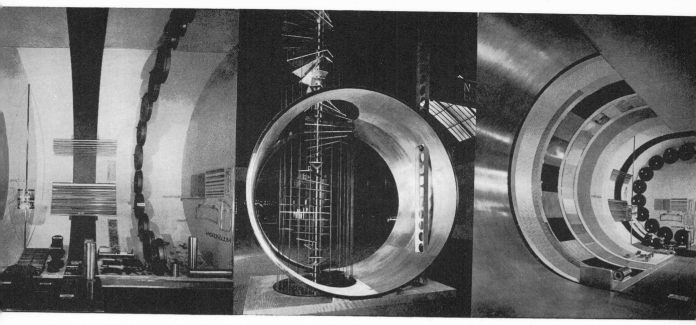

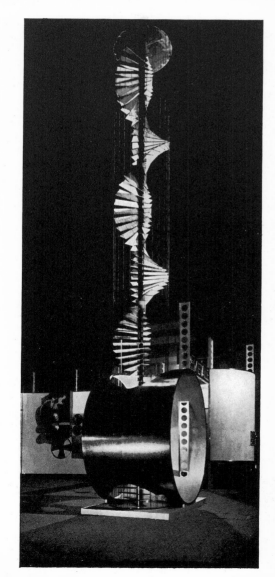

5 VIEWS OF THE DISPLAY UNITS OF THE NON-FERRO METALS SECTION OF THE " DEUTSCHES VOLK, DEUTSCHE ARBEIT " EXHIBITION, BERLIN

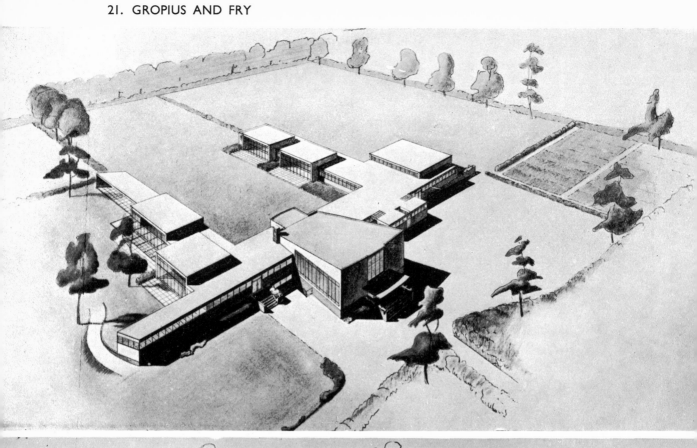

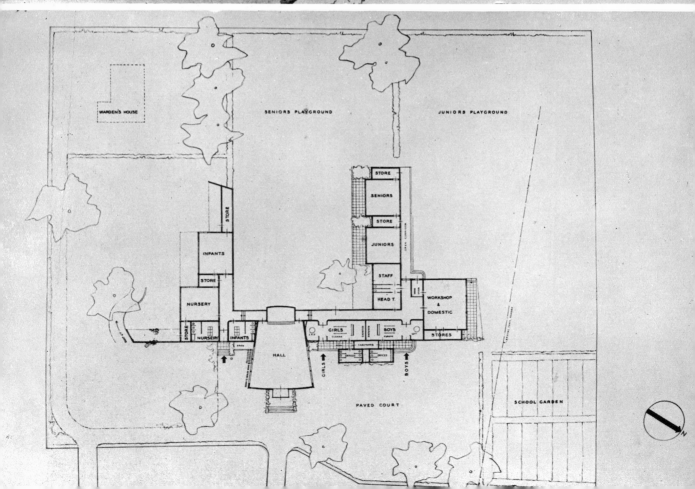

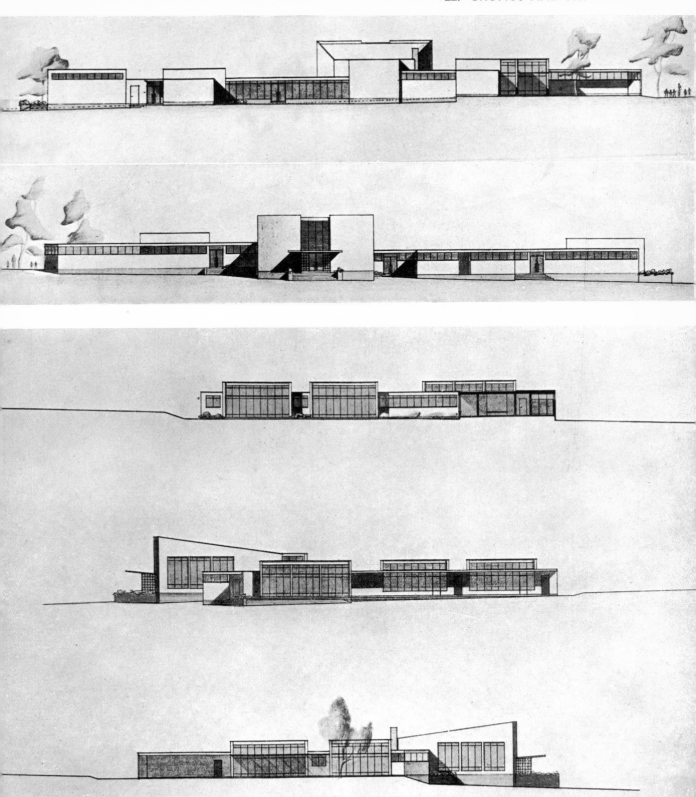

PROJECT FOR A SCHOOL AT PAPWORTH, 1937

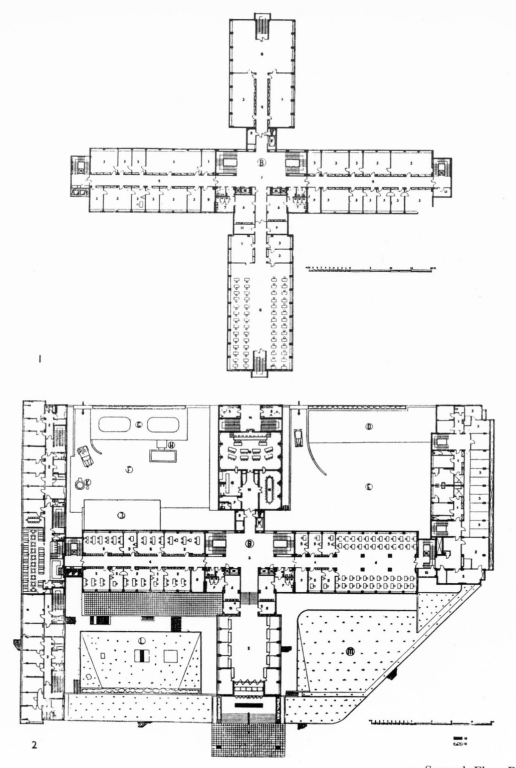

1. Seventh Floor Plan.
2. Ground Floor Plan.

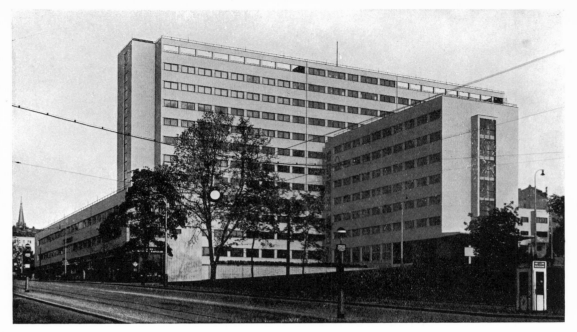

3

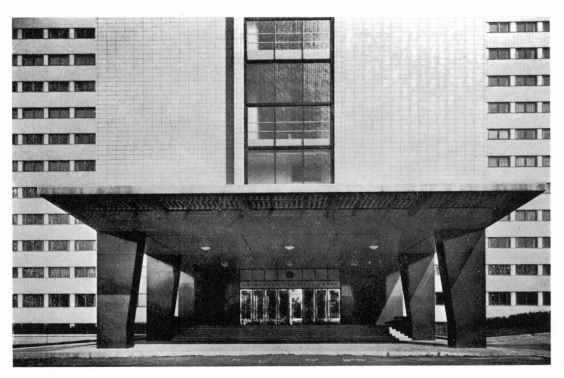

4

3. The West Front.
4. The Main Entrance.

THE NATIONAL PENSIONS BUILDING, PRAGUE

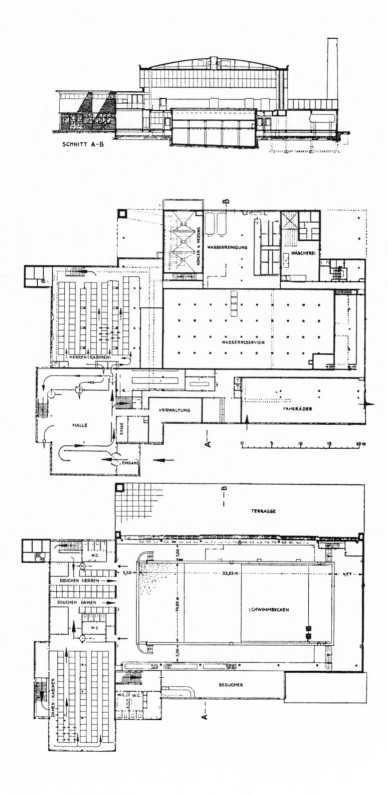

SCHNITT A-B

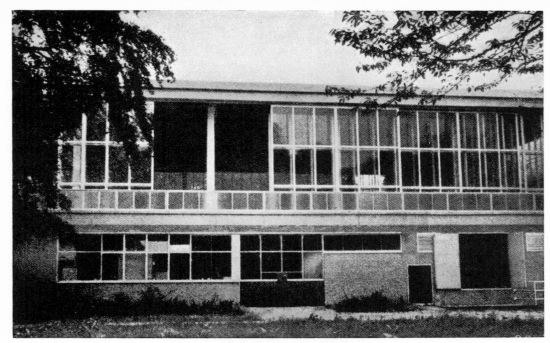

terior view.

E NEW COVERED SWIMMING
TH AT HAARLEM, HOLLAND

Staircase and dressing
room block.

Interior view across
the bath looking to-
wards the terrace.

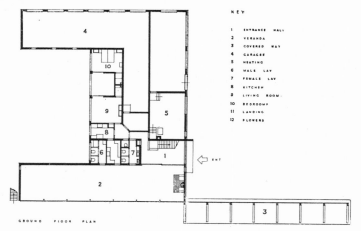

KEY

1 ENTRANCE HALL
2 VERANDA
3 COVERED WAY
4 GARAGE
5 HEATING
6 MALE LAV
7 FEMALE LAV
8 KITCHEN
9 LIVING ROOM
10 BEDROOMS
11 LANDING
12 FLOWERS

GROUND FLOOR PLAN

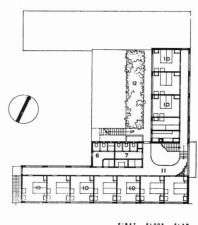

FIRST FLOOR PLAN

A RECREATION HOME
FOR LABOURERS AT
ELLECOM, HOLLAND

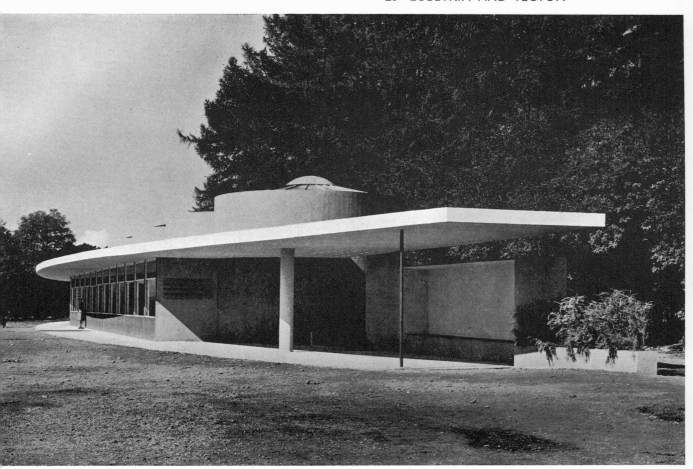

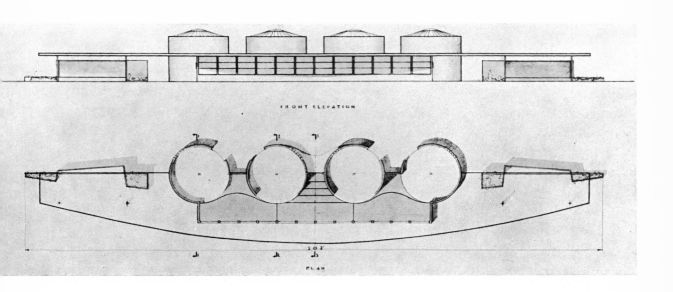

FRONT ELEVATION

PLAN

THE ELEPHANT HOUSE, WHIPSNADE ZOO

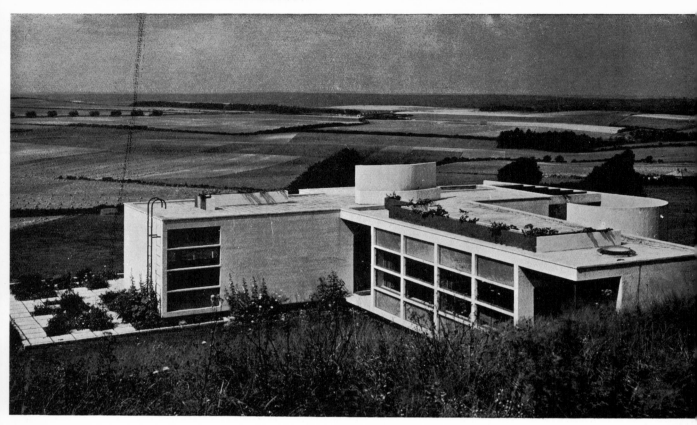

A BUNGALOW AT
WHIPSNADE, 1936

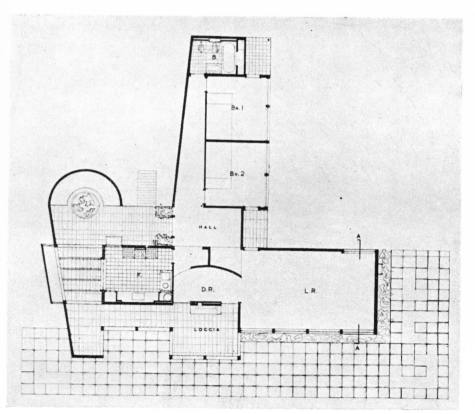

Ground Floor Plan.

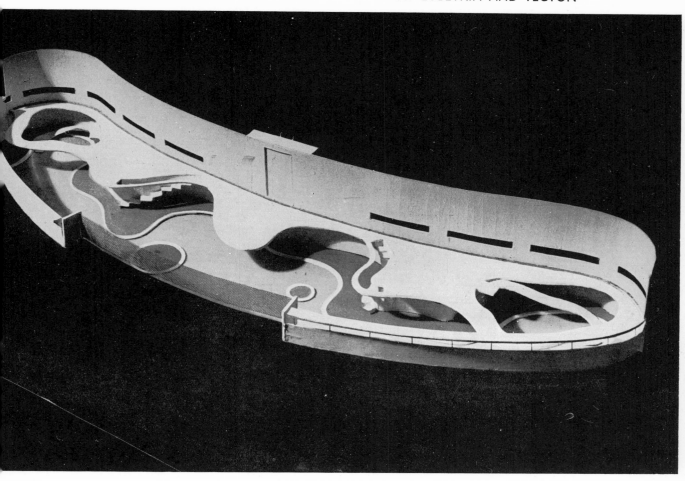

PENGUIN POOL AT THE BIRMINGHAM ZOO, 1936-37

31. MARTIN, J. L.

A

① 8 UNITS
 2 BUNKS

② 10 UNITS
 2 BUNKS

③ 12 UNITS
 2 BUNKS

④ 15 UNITS
 3 BUNKS

⑤ 15 UNITS
 3 BUNKS

⑥ 15 UNITS
 4 BUNKS

⑦ 18 UNITS
 4 BUNKS

⑧ 18 UNITS
 4 BUNKS

⑨ 16 UNITS
 4 BUNKS

⑩ 20 UNITS
 4 BUNKS

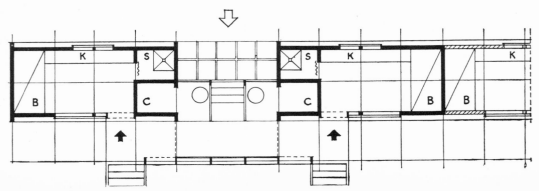

These unit houses, intended for week-end or summer use, are entirely built up from a series of standardized sections. Wall sections consist of a timber frame, plybestos face, wallboard inner lining, and aluminium foil insulation. Roof and floor sections are also prefabricated. Window and wall sections are built separately to allow a greater number of arrangements of plan to suit various aspects; the floor area in each case being necessarily a multiple of 4 feet square (1 unit). Examples of 10 to 20 unit types are shown on the opposite page.

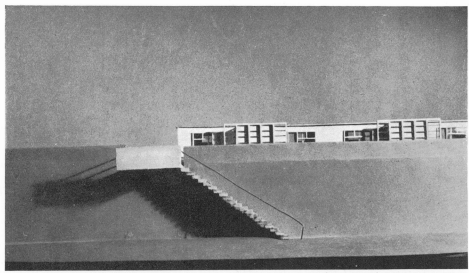

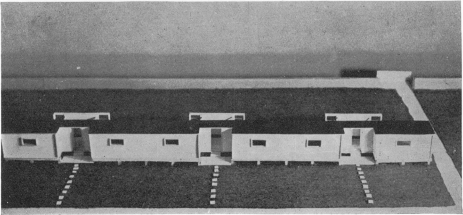

Each house is equipped with bunk beds (B), kitchen sink and cupboard unit (K), chemical closet (C), and shower (S). By means of movable screens of stretched canvas the plans can be adjusted to suit a day (B) or night (A) arrangement. The cost of an average type (No. 9) is £64 at the workshop, *i.e.* approximately £4 per unit. This price includes the cost of a terrace for single houses or a proportion of terrace costs for grouped plans. The erection cost is about £15. Houses are raised off the ground and are therefore easily adjusted to fit sloping sites. Each terrace is provided with exercise bars and racks for drying bathing suits and towels.

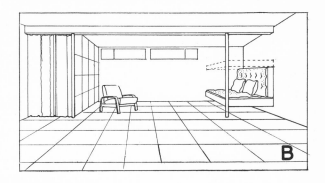

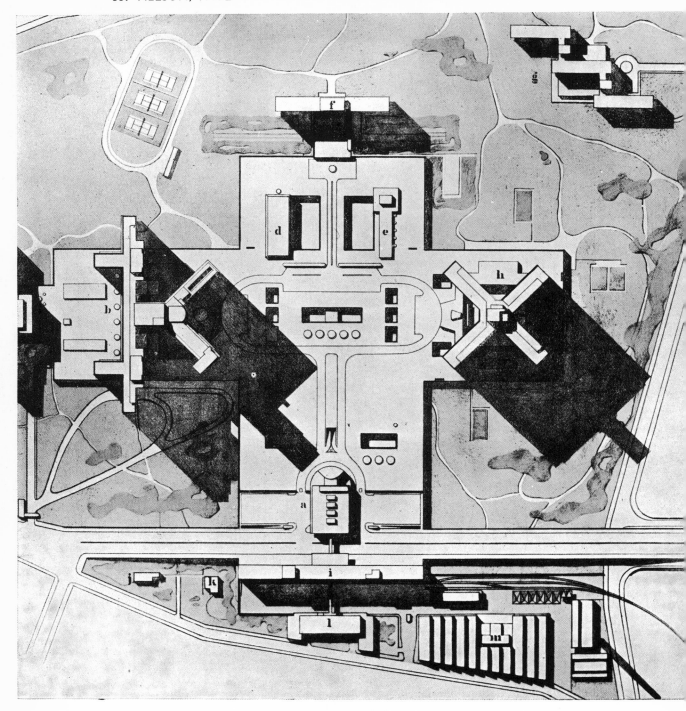

PROPOSED HOSPITAL CITY AT LILLE, 1933

a. administration building; *b.* medical centre; *c.* private patients' pavilion; *d.* congress hall and theatre; *e.* cult; *f.* nurses' home and school; *g.* home for the pensioned ; *h.* hospices for the aged, incurables and convalescents; *i.* servants' quarters and central stores; *j.* assistant director's home; *k.* director's home; *l.* mortuary service; *m.* service buildings.

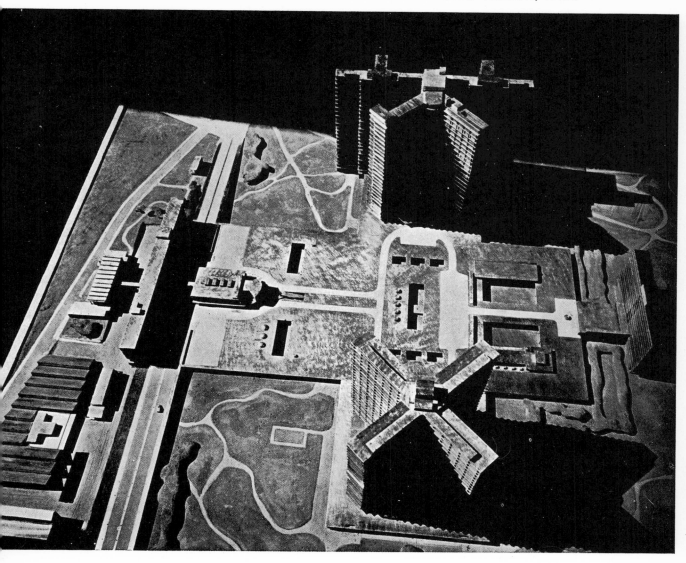

VIEW FROM THE NORTH

The project illustrates a health city planned on 72 acres of land and situated ten minutes journey from the centre of Lille. In this city the patient will find all the elements necessary for his cure and will be taught to preserve his health. The architect has attempted to concentrate within a single group the hospital service of the city and to reconstruct out-of-date buildings in this single centre. The centralization involves economy of administration and closer general co-operation. Within the various buildings in this group the interior planning allows complete flexibility and ease of adaptation for all new needs and scientific developments. By rationalizing movements and needs economy and ease of working are assured: in this respect great attention has been paid to height, express lifts connect the most distant services in 30 seconds.

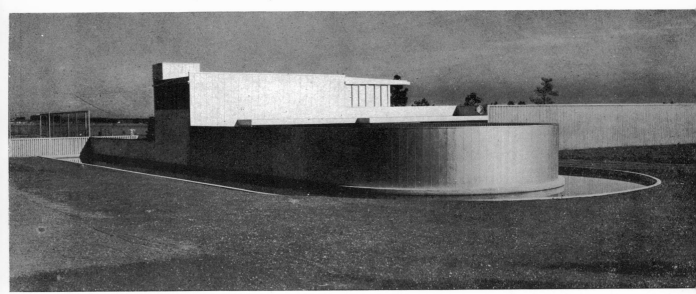

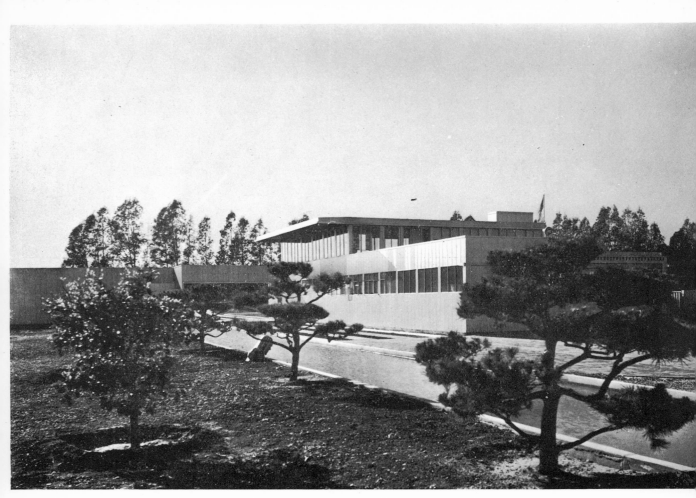

ALL STEEL RESIDENCE IN THE SAN FERNANDO VALLEY

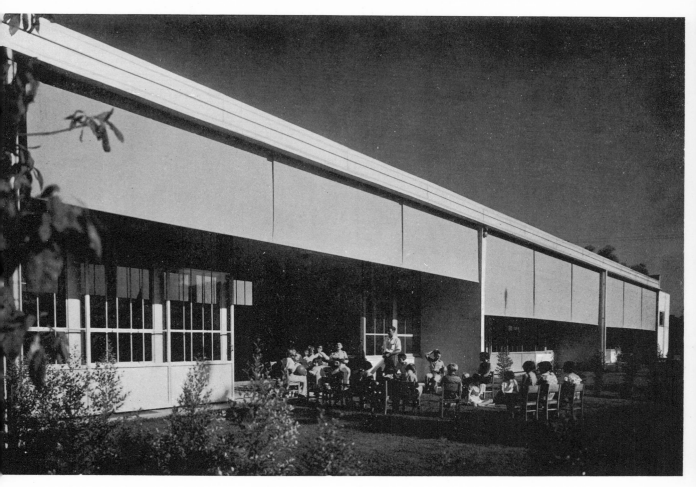

The classrooms open into the garden by 16 feet wide glass partitions with awnings mechanically operated. G. Ain, P. Pfisterer and H. Smith collaborated with the architect.

EXPERIMENTAL SCHOOL, LOS ANGELES BOARD OF EDUCATION

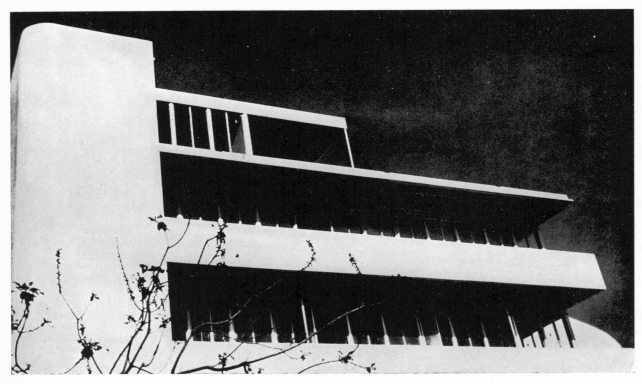

ALL ELECTRIC HOUSE IN HOLLYWOOD, CALIFORNIA, IN COLLABORATION WITH GREGORY AIN

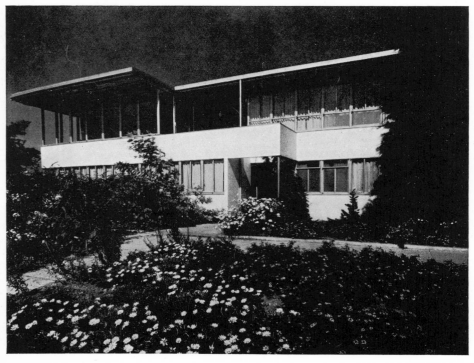

WEST FRONT OF V.D.L. RESEARCH HOUSE OVERLOOKING SILVER LAKE, LOS ANGELES, CALIFORNIA

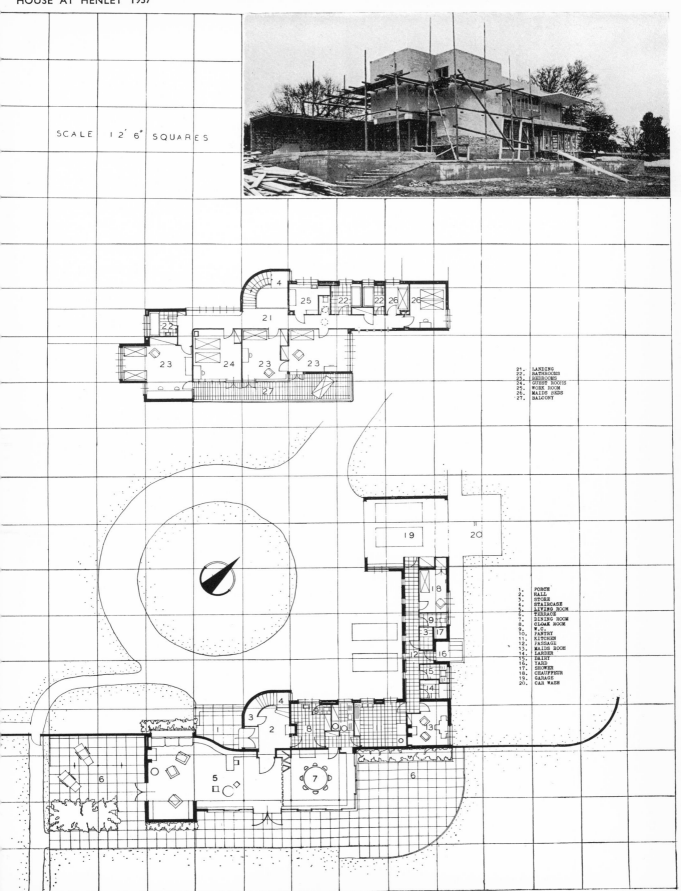

SCALE 12' 6" SQUARES

21. LANDING
22. BATHROOMS
23. BEDROOMS
24. GUEST ROOMS
25. WORK ROOM
26. MAIDS BEDS
27. BALCONY

1. PORCH
2. HALL
3. STORE
4. STAIRCASE
5. LIVING ROOM
6. TERRACE
7. DINING ROOM
8. CLOAK ROOM
9. W.C.
10. PANTRY
11. KITCHEN
12. PASSAGE
13. MAIDS ROOM
14. LARDER
15. DAIRY
16. YARD
17. SHOWER
18. CHAUFFEUR
19. GARAGE
20. CAR WASH

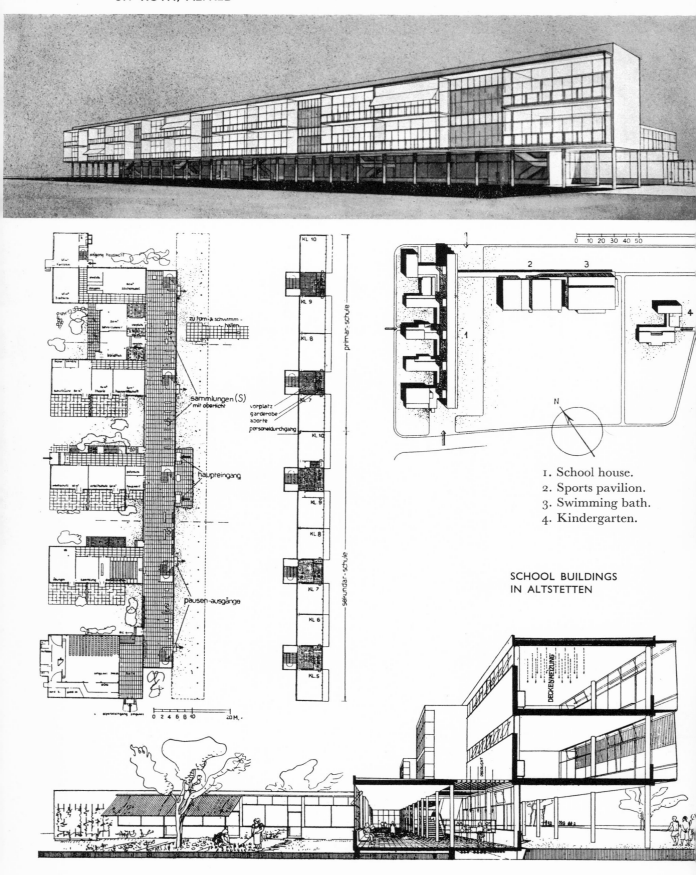

1. School house.
2. Sports pavilion.
3. Swimming bath.
4. Kindergarten.

SCHOOL BUILDINGS
IN ALTSTETTEN

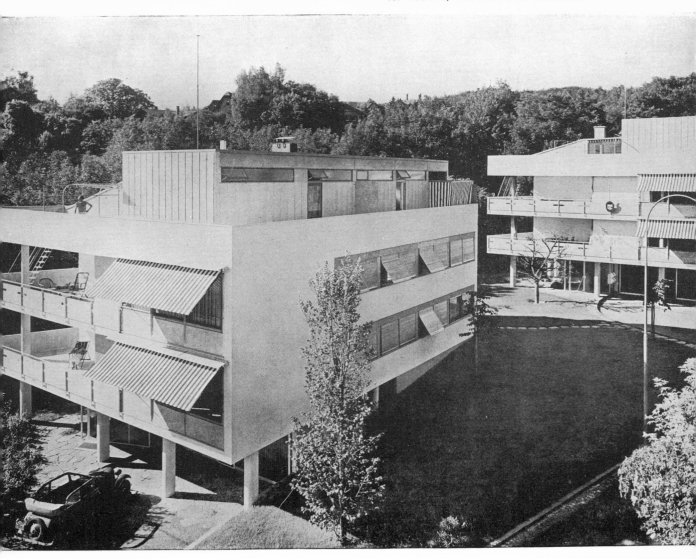

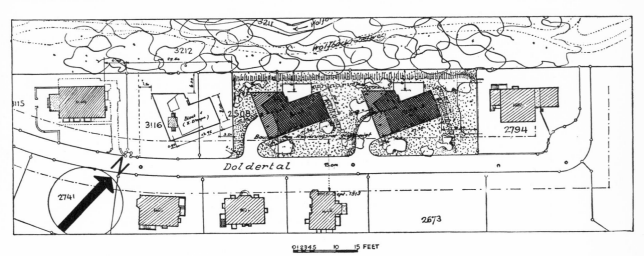

FLATS IN THE DOLDERTAL, ZURICH, 1936

41. ROTH, ROTH AND BREUER

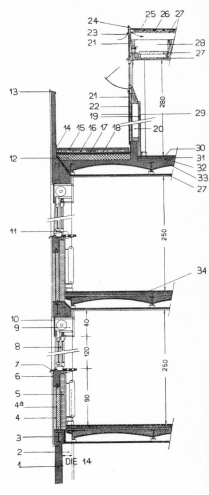

KEY TO DETAIL SECTION

1. Foundation wall.
2. Steel columns.
3. Girder.
4. Hollow tile 4 in.
4a. Reinforcement.
5. Gypsum block 2¾
6. Stucco.
7. Zinc coated sill.
8. Sliding windows.
9. Awning.
10. Plate cover.
11. Slate sill.
12. Concrete.
13. Copper.
14. Flashings.
15. 2 in. concrete
16. Sand and gravel.
17. Building paper.
18. Cork insulation.
19. Sheathing.
20. Air space.
21. Spun glass insulation.
22. Facing.
23. Ventilation.
24. Copper capping.
25. Tar and gravel.
26. Sheathing.
27. Slab roof.
28. Air space.
29. Birch veneer.
30. Linoleum.
31. Floating 2 in.
32. Cork.
33. Aerated concrete.
34. Wood flooring.

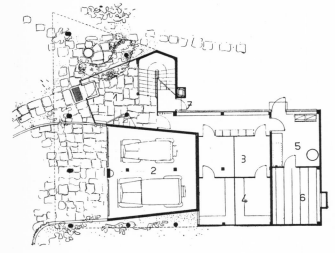

LOWER GROUND FLOOR

1. Glazed lobby.
2. Garage.
3. Store.
4. Store.
5. Laundry.
6. Drying.
7. Service entrance.

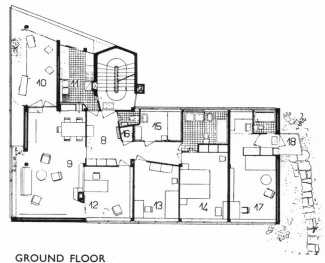

GROUND FLOOR

8. Hall.
9. Living room.
10. Terrace.
11. Kitchen.
12. Library.
13. 14. Bedrooms.
15. Bath.
16. Linen.
17. Bedroom.
18. Balcony.
19. Hall.

The architects' studio, room 31 on plan.

FLATS IN THE DOLDERTAL
ZURICH

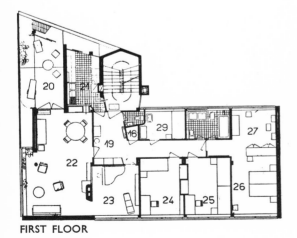

FIRST FLOOR

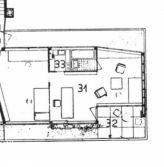

SECOND FLOOR

20. Sun terrace.	24. Bedroom.	27. Dressing	29. Servants'	32. Porch.	36. Kitchenette.
21. Kitchen.	25. Bedroom.	room.	room.	33. Kitchenette.	37. Sun terrace.
22. Living room.	26. Bedroom.	28. Bathroom.	30. Hall.	34. Hall.	38. Terrace.
23. Music room.			31. Studio.	35. Living room.	39. Store.

A BLOCK OF FLATS AND SHOPS
AT GENOA, ITALY, 1936-1937

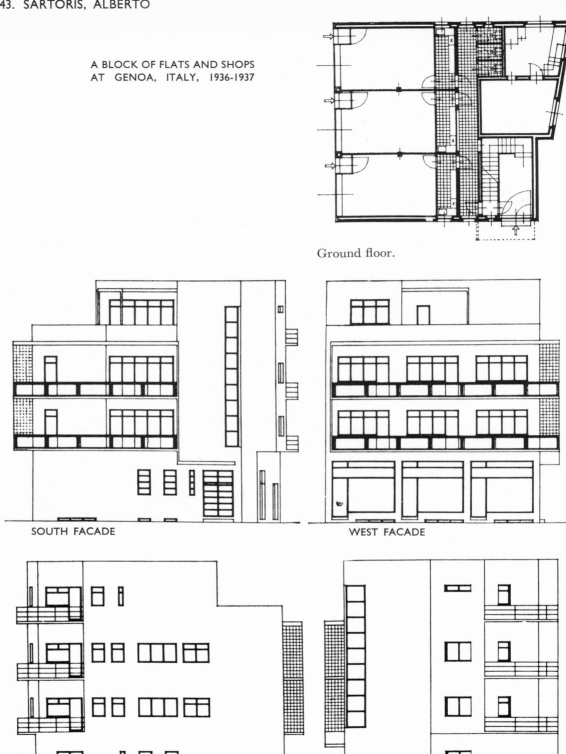

Ground floor.

SOUTH FACADE

WEST FACADE

NORTH FACADE

EAST FACADE

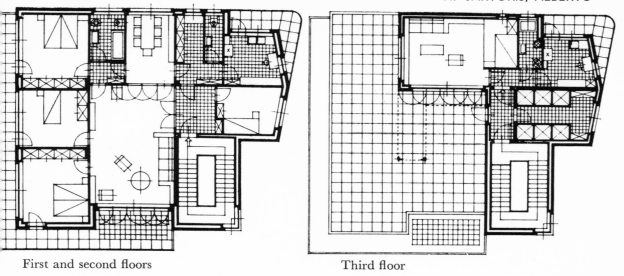

First and second floors Third floor

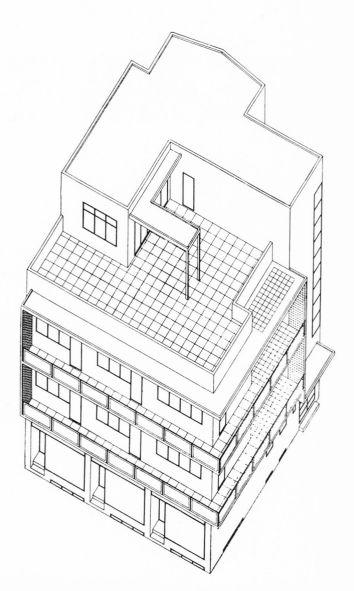

On the ground floor this building contains three shops with small offices and lavatories, the first and second floors consist of one flat each with sun and service terraces and on the third floor is a studio flat with service and lounge sun terrace.

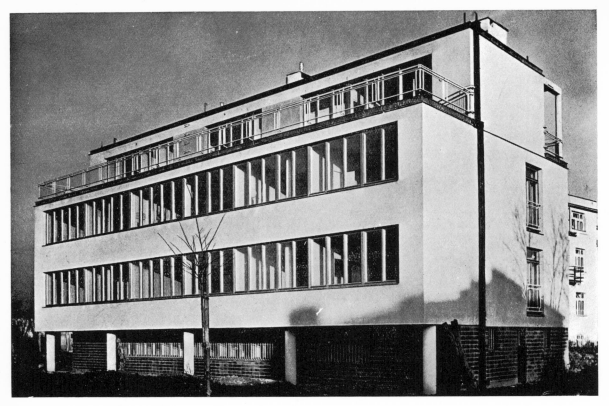

A SMALL BLOCK OF FLATS
IN WARSAW 1936

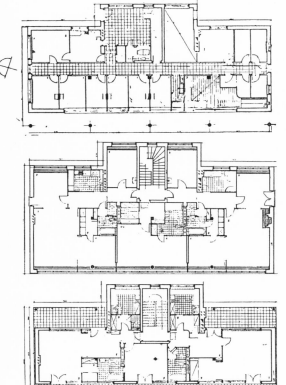

Ground floor plan.

First and second floor plan.

Third floor plan.

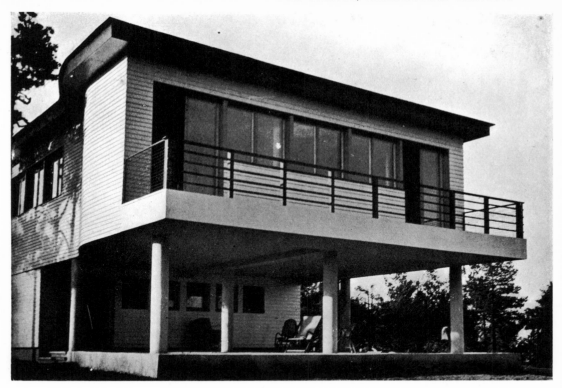

A COUNTRY HOUSE BUILT IN WOOD ON THE EASTERN FRONTIER OF POLAND

1. Ground floor plan.
2. First floor plan.

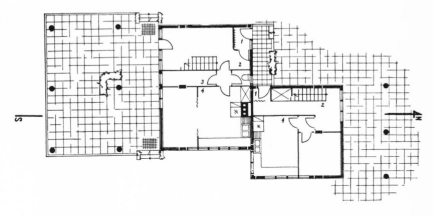

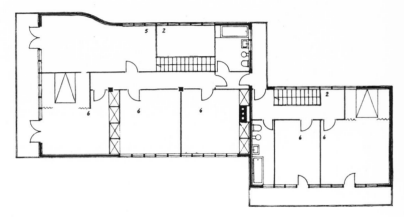

1. Entrance.
2. Hall.
3. Cloaks.
4. Kitchen.
5. Living room.
6. Bedroom.

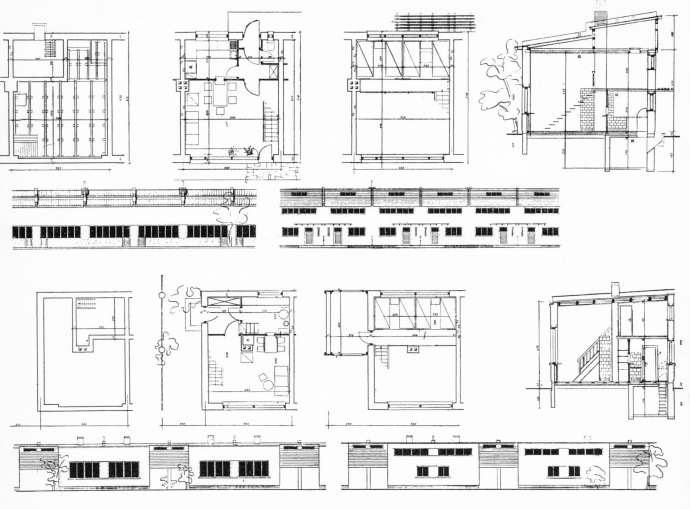

1. Typical plans, elevations and sections.
2. Variations of plan.
3. Interior of a typical house.

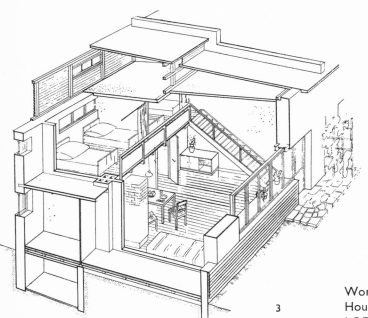

3

Workers' houses constructed by the Workers' Housing Society (T.O.R.) at GRUDZIADZ and at LODZ 1936.

WORKERS' CITY, RAKOWIEC

(Société Cooperative d'Habitations de Varsovie).

Blocks A, B, C, D built 1935.
 Architects Praesens Group.

Blocks E, F, G in construction.
 Architects H. & S. Syrkus.

I. LAYOUT.

Building areas.	sq. metres
Blocks (A, B, C, D, E, F) -	4,450
Collective Services (G) -	350
Total - - - -	4,800
Yards, roads, etc. - -	7,700
Workers' gardens - -	10,000
Children's gardens and play space - - - -	8,000
Total - - - -	25,700

I. HOUSING

Blocks A, B, C, D (1935), 192 flats each with 31.5 sq. metres of useful area.

Blocks E, F (in construction) 96 flats each with 33 sq. metres of useful area.

Volume A, B, C, D, E, F = about 50,000 cub. metres.

Price per cub. metre = 27 zlotys (22.5 mason's hrs.).

Monthly wages of a worker = 120 zlotys (100 mason's hrs.).

Flats are available only for workers receiving less than 240 zlotys per month.

Monthly rent for a flat with 32-33 sq. metres of useful area = 22 zlotys (18 mason's hrs.).

(For the purpose of calculation 25 zlotys equal 1 pound sterling.)

I. COLLECTIVE SERVICES (G).

Volume = 4,200 cub. metres.	sq. metres
Underground Laundry, etc. - -	145
Ground level: maternity clinic -	170
baths - - -	110
1st and 2nd floors Meeting Hall -	115
Lecture rooms clubs - - -	315

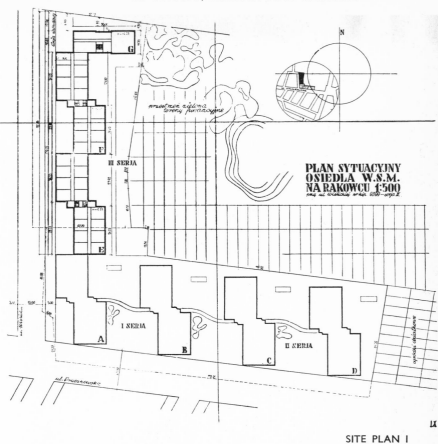

SITE PLAN I

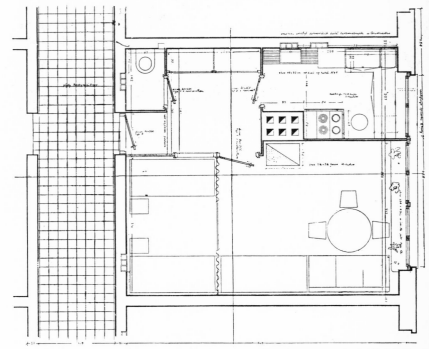

TYPICAL FLAT BLOCK E-F II

A HOUSE AT ESHER 1936

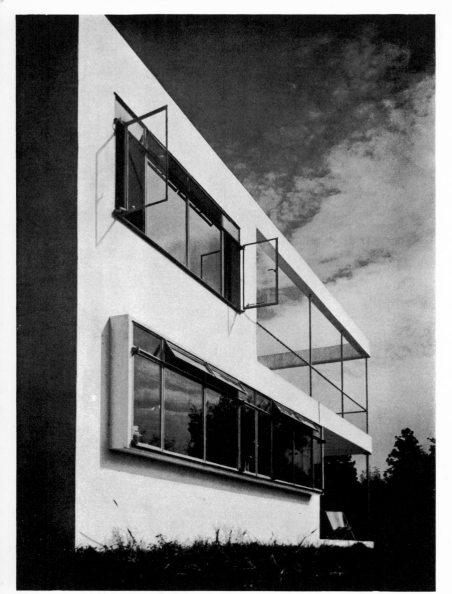

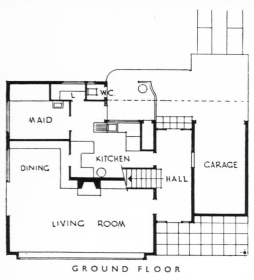

GROUND FLOOR

MAID

DINING

KITCHEN

W.C.

LIVING ROOM

HALL

GARAGE

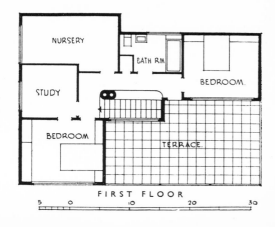

NURSERY

STUDY

BEDROOM

BATH RM

BEDROOM.

TERRACE.

FIRST FLOOR

5 0 10 20 30

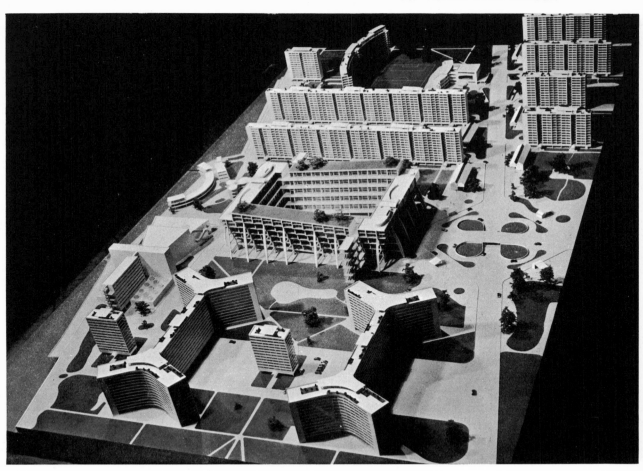

A GARDEN CITY OF THE FUTURE, general view and plan (description overleaf.)

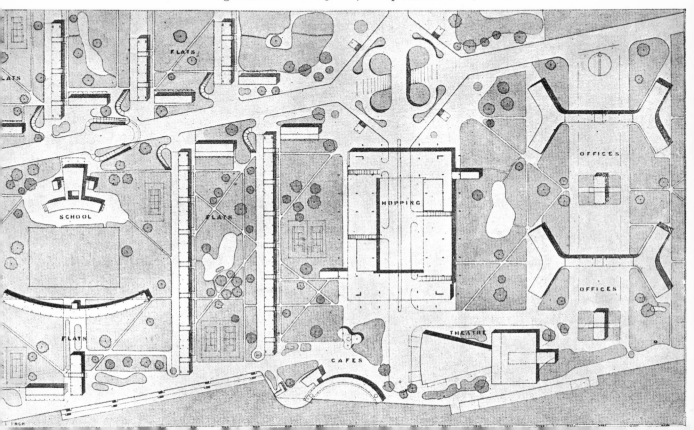

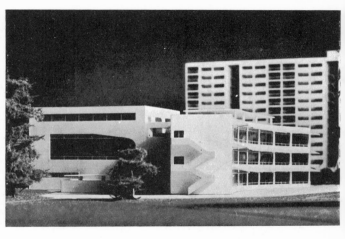

The school The school and housing

A GARDEN CITY OF THE FUTURE

This model is an attempt to embody a visual presentation of an entirely new or 'ideal' city. One of its chief values lies in its demonstration of principle, and the data it provides in regard to the size and shape of a city, its building density, the situation and structural form of its various quarters, and its particular system of urban transport. The maximum superficial dimensions of the model base (9 feet 6 inches by 5 feet 6 inches) provided a certain limitation. To a scale of 1/20th of an inch to the foot these dimensions represent an area approximately half a mile long by a quarter of a mile deep, which must be supposed to stretch along the north shore of a lake or river. As only a relatively small slice of the centre of the city could be included in the model, the designers confined themselves to a few typical quarters—a residential district with its local school to the west, the shopping district occupies the middle of the plan with a theatre, cafés and bathing place (the recreational area) along the water front to the south of this, to the east is the business district with its blocks of offices and administration buildings.

The city must be imagined as extending westwards over further residential districts with their own schools and playing fields eastwards, over an industrial area towards the port, and northwards continuing the general planning disposition prevailing to the east and west. Arterial roads are kept away from the waterfront, which is segregated for public recreation; the main east-west thoroughfare lies inland. At the point where this crosses the great North road there is a tube station with non-stop services of trains eastwards to the harbour, and northwards to the airport, both of which lie outside the range of the model.

In order to produce a maximum of air and light the buildings are designed as large blocks widely spaced, the open spaces being reserved for parks, playing fields and traffic facilities. A uniform height of twelve storeys is adopted as calculations have shown that this height provides the most rational utilisation of site area. If three storey development is compared with the twelve storeyed type adopted in the model, and if the intervals between the blocks are assumed to be twice the height of the blocks in each case, the reduction of built up area that is achieved by the latter amounts to no less than 40 per cent. It follows that, in using the higher building, there was no intention to crowd the city or to encourage an unnaturally intensive utilisation of ground area; with proper restrictions (such as the imposition of a minimum angle of light for all windows) all the only too manifest evils of existing American cities can be avoided, while the adoption of higher buildings ensures a type of garden city planning in which the distances from point to point are reduced to a minimum. With this type of plan too, the simplification of traffic conditions becomes automatic, there are fewer house doors, fewer

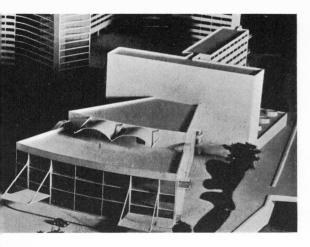

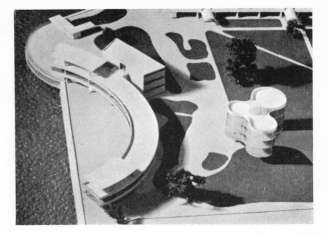

The theatre The amusement centre

streets, and above all, fewer street intersections. It may, however, be noted in passing that the acceptance of the vertical type of development in this model does not imply that all buildings in any town should be skyscrapers. Apart from such considerations as different local requirements it should be remembered that the architects are concerned in this case with the inner centre of the city. In this model for example the only type of dwelling shown is the block of flats. The private house in the centre of the city complicates immediately the traffic problem, the architects propose to place houses of this class to the outskirts, as an intermediate stage between town and country. These private houses would be arranged so as to allow a rational future town development; the roads which serve them could, if necessary, be adapted to the street plan of the central area. The rows of flats run north to south with windows facing east and west. There are no shadowed corners, each flat has a balcony garden open to east and west and the flat roof to the block provides a communal roof garden. The distance from the windows of one block to those of the block opposite is 240 feet; this space is either given over to playing fields or is planted with trees and laid out with lawns. All blocks are supported on concrete stilts, the space so gained provides a parking place for cars, below these parking places are subterranean garages. Thus the flats lie immediately over the parking places and the garages below, all three being directly interconnected by lifts and stairs.

Daily purchases can be made in the long rows of shops placed at the ends of the blocks of flats; the windows of these shops face the gardens instead of the main road which is intended purely for vehicular traffic. Schools, with their playing fields, are centrally grouped between the blocks of dwellings; specially ramped subways under streets enable the children to reach and leave school without having to negotiate a street crossing. The main shopping centre forms a group of five double-storeyed premises facing on to a large public square. Its streets are a succession of terraces partly covered over and connected by sloping ramps. Escalators are placed at either end and the roof accommodates gardens, cafés, restaurants and places of entertainment. The office buildings and administrative blocks are again 'island' structures separated by parkland. Two different structural types are demonstrated, the smaller office block with central staircase and the larger block with forked ends. Along the waterfront there is an open grouping of bathing places, cafés and a theatre partly situated on the slope down to the shore so as not to impede the view over the water. The model incorporates a new solution of an urgent traffic problem which allows street intersections to be crossed without periodic hold-ups by crossing traffic. An over bridge in one direction, forming an under bridge in the other, carries crossing streams over and under each other without interruption.

THE CONDITION OF ARCHITECTURE
AND THE PRINCIPLE OF ANONYMITY
By J. M. Richards

THE cause of the decay in architecture* in the nineteenth century was not a decay in *taste*—a mysterious criterion that is actually not a quality but a symptom —nor was it wholly the incomplete assimilation of the industrial revolution. The industrial revolution began half-way through the eighteenth century, as did the onset of eclecticism; whereas the latter was not widespread until the thirties, at the earliest, of the nineteenth. Moreover, the rapid acceleration of technological advance that we speak of as the industrial revolution was again only the occasion of the cultural disturbance whose exact nature it is important to define.

The more immediate cause of decay was a cultural—a socio-psychological one; a phenomenon that may be summarized as a diffusion of purpose, manifested in a divorce of art as an individual achievement from art as a vernacular expression.

The bane of the nineteenth century was the celebrity-architect: the Renaissance idea of the individual glorified over the Renaissance sense of artistic unity. And architecture cannot afford to be an affair of the individual. It is only when the individual innovation becomes assimilated into a regional tradition that it can be regarded as culturally valid.

In the technical sphere, certainly, revolution is architecture's life-blood, but even this new blood must circulate through the whole system, must become a regenerative part of the evolving but, at any given moment, universal architectural vocabulary. Further, technical progress, though its impetus may be

*In architecture labelled as such, not in building, whose condition was vigorous; *vide* the experimental tradition of structural engineering, referred to later.

184

revolutionary, adapts itself architecturally by means of the progressive modi-fication of type forms: a process that is essentially impersonal.

The vital link that the nineteenth century lost was that between working and creating. (William Morris was right even if his remedy was wrong.) When this link is missing, as in the architects' architecture of that period, the import-ant quality of inevitability disappears: the capacity of *thinking architecturally*. Instead of the application of a universal idiom we find a mere eclectic practice of connoisseurship; a capricious variation of style for no other reason than for the sake of variation, and—to emphasize my point—for the sake of the ex-ploitation of personality. We find, as Lethaby phrased it, a battle of the styles that indicates that true style is absent.

I have defined the malady from which the architect-ridden Victorian period suffered, as a diffusion of purpose. Periods productive of good architec-ture, on the other hand—good architecture in the sense of a live universal lan-guage, not in the sense of isolated good architectural monuments—can be said to owe this fortunate condition to a *unity* of purpose, not only pervading the specialized spheres of architectural and industrial design, but existing in these spheres as the echo or reflection of a unity of social and cultural purpose per-vading the whole of life.

Such a unity of purpose allows the establishment of a unity of cultural lan-guage—the widespread vernacular, in the case of architecture, already referred to. The existence of this vernacular might be alternatively described as the acceptance of a settled anonymity in architectural design; and it is worth while examining the occurrence of an anonymous tradition in the periods of live architecture. We may prove to ourselves the necessity of recovering some such anonymous tradition (deriving from a greater unity of purpose) in this age, if we are to establish an architecture of cultural value.

The significance of the architectural development in the eighteenth cen-tury was that that period's social stability, combined with its intellectual capa-city for the absorption of new ideas and for steady development in a single direction, allowed the establishment of an accepted style of building (which, because it was accepted universally, was not a style in the Victorian sense) that ensured a level of abstract goodness independent of the talent or lack of talent possessed by architects as individuals. The architects, in the sense of the de-signers, (usually simply the builders) were anonymous—that is to say, their personalities culturally irrelevant. The mass of small houses, of village cottages and of terraces in the market towns in which this universal vernacular mani-

185

fested itself, grew almost spontaneously from the habit of mind of their builders, whose creative capacity was exercised only in a subordinate sense, almost as instinct.

Though the architecture of the eighteenth century was based on an imported mode, and though it was the age of that anti-social being, the talented amateur or connoisseur, it absorbed that mode into a genuine folk art: no longer imported, but the natural—the only—means of expression of genuine folk *work*. Though the stylistic form (which for our purpose is irrelevant) had undergone a change, and though the social order was changing, this universal tradition of the eighteenth century may be regarded culturally as the continuation of the mediaeval tradition. In mediaeval times the anonymity—and the universality of the idiom—was even more characteristic. The impulse—or purpose whose unity made this tradition possible—was a religious rather than a civic one: an emotional rather than a rational.

In the case of the mediaeval period the whole social hierarchy was more permanent, and even the great, the original monuments of architecture were largely conceived in the anonymous spirit. The centuries following had their Wren and their Vanbrugh, but its assimilation of the architect's disturbing entrance into architecture is the eighteenth century's claim to vitality—also its proof of proper cultural adjustment.

The same spirit did not, however, disappear altogether when the nineteenth century's confusion of purpose brought a break in this unconscious adherence to a standard. The architects invented the styles; the spread of popular education diffused them; but for a time the speculative builder preserved the tradition of unselfconscious building. The great building schemes of expanding London—the Ladbroke estates, Pimlico, Bayswater, Camden Town; their equivalents in the provinces; all represent the last flowering (in the art of architecture labelled as such) of the anonymous spirit; though even these builders, lacking the assurance of their predecessors, lacked also the exact aesthetic standards—the subconscious selective judgment—that maintains the aesthetic quality of a folk art.

During the first years of the nineteenth century, however, one other manifestation of this spirit showed itself. The great engineers of this period, engaged as they were in the active exploration of their newly discovered techniques—iron and steam—had no time for a selfconscious search for style and no need for the exploitation of their personalities. They found sufficient satisfaction in the pioneer nature of the work they were doing.

THE PRINCIPLE OF ANONYMITY

The engineering tradition of the nineteenth century was the last great English contribution to European culture. Though the epoch was founded and punctuated by great men who showed genius as individuals, its spirit was a perpetuation of the mediaeval or eighteenth-century spirit. Within the sphere in which they worked, that of the application of science to civic and industrial expansion, they had the same unity of purpose as the builders of the mediaeval cathedrals. Further, their leading figures had the same versatility as the figures that established the artistic unity of the Renaissance: Telford was a bridge-builder, a road-maker, a designer of harbours and canals; Brunel a designer of bridges, railways and of steamships; Stephenson of locomotives, railways and roads; Rennie of engineering structures of all kinds; Paxton, (perhaps the last of this remarkable line), of gardens, waterworks and conservatories, and an administrator and financier as well.

These were the leaders of this great epoch—the true architects of the nineteenth century, who created order while their academic brethren asserted their own confusion in argument about the merits of the styles. And, what is significant to our argument, for a time at least, a genuine tradition of design was established by them, again owing little to the creative ability of the designers but owing everything to the vernacular standards—this time of engineering structure—absorbed into their minds as a habit of thinking. For a time they established an unselfconscious engineering tradition of true cultural validity, pursued, by the mass of designers, anonymously.

If we ask whether today we can restore this tradition of anonymity, and regain a vernacular architecture, I suppose the answer is that we must re-establish first that unity of purpose—that settled continuity of social life and of the formal expression of it—which we have spoken about. An alternative answer, of course, might be that we already have an anonymous folk architecture of our day: the mass-produced villas and bungalows that constitute the acres of suburbs surrounding all our towns and cities. In these the speculative builder carries on the work of his early nineteenth-century ancestor, with the same impersonality and a similarly standardized vocabulary. But his vocabulary is an artificial one and a debased one, and his enterprise without civic consciousness. His products form no part of a socio-cultural whole. Modern speculative housing is a machine product organizationally but not culturally. Though possessing some of the virtues of standardization and having escaped at least from the tyranny of the architect and his personality, it only serves, in its cultural insignificance, to emphasize the cultural maladjustment of this time.

The answer, then, to the question how we can regain a true folk architecture remains a sociological or political one. But the process by which our own confused and selfconscious individualism could be transformed into an unselfconscious vernacular can be observed in advance and, indeed, initiated even within the limitations of our present political condition. Some degree of cultural readjustment, that is to say, can be undertaken, as it was early in the nineteenth century, in advance of the new sociological and spiritual impulse necessary for it to become wholly effective. In the nineteenth century the sociological era that the engineers foreshadowed never materialized and the vernacular tradition they established was lost. The process of transition can be very clearly visualized—and this is where the observations that we have made about the Middle Ages, the eighteenth century and the early nineteenth century apply to our own problems: the process can be visualized because this quality of anonymity which we have isolated as a virtue (or as the direct concomitant of a condition of virtue) is closely related to the qualities the design of the present day already possesses of its own nature.

The characteristic qualities of the machine aesthetic, which is our present-day aesthetic, have often been defined. They are lucidly set out by Lewis Mumford in his book, *Technics and Civilization*. They include an acceptance, indeed an exploitation, of mass-production: the multiplication of standard patterns, implying the elimination of personality from the process of manufacture. They include therefore the disappearance of the handicraft respect for technical virtuosity, and respect for rarity as such. They include also the acceptance of a new formal vocabulary, derived from the needs of machine production and influenced by the example of machines themselves.

Now all these qualities that the art of a machine age naturally possesses are impersonal qualities. In fact such tradition of machine art as there is, is already an anonymous one. Its vocabulary owes nothing to the designer's hand, and though his personality enters into the initial business of formal selection within the limits of functional necessity, even this is partly determined by the standard type forms—the anonymous traditions—that the machine age already begins to evolve.

Therefore, although it may appear that, in concentrating on the re-establishment of the anonymous tradition, we are putting the cart before the horse: anticipating the social unity of which this anonymity is supposed only to be the evidence, it is clear that each, to a certain degree, can contribute to the other. A ready acceptance of the new impersonal vernacular that the machine art

188

offers us, at least would help to establish some degree of a modern equivalent of the standardized design vocabulary of the eighteenth century, in the spirit of which, the perfecting of the type form could be pursued—*and in the spirit of which the re-establishment of a stable cultural purpose could also be pursued*—if necessary we must wait till later to enlarge the technical sphere to include the sociological.★

One of the things that the potential new tradition of natural anonymity that we see again on the horizon can do, is to release us at least from the irrelevances of architectural 'self-expression' and the confusion of idea that accompanies it. Whether we can expand this potential tradition into a new folk architecture, owing as little as the work of the Georgian architect-builder or of the Victorian architect-engineer to the exploitation of personality or to connoisseurship, one of recognizable standards—a true vernacular—depends on the growth of what Lethaby called 'a movement in the common mind'. We can start by giving the common mind its opportunity.

★That, even if the sociological side is tackled first, the cultural cannot be relied upon to readjust itself immediately is shown by the case of Russia. There, the social unity of purpose which has successfully been re-established has not yet crystallized itself into a new cultural one; art of a bourgeois nature still flourishes, partly in reaction against the extremist, revolutionary movement that tried to set up an abstract ideology with inadequate technical equipment; but largely because, owing to *psychological* instability, the superficial advertisement of progress becomes more important than the fact of progress—sociological development has progressed so much faster than educational.

TOWN PLANNING
By E. Maxwell Fry

I CANNOT see that the art of town planning is in any real sense different from architecture. Town planning as practised in England today is the counterpart of the architecture from which it sprang; is either sentimental or commercial— or is no more than a petty human activity, a habit brought recurrently to mind through being printed clearly in a Parliamentary book of rules.

It may be that what is called 'national planning' is beyond the capabilities of our presently constituted society, and that this thought which I know torments many of us, this idea of a society so at peace with itself as to organize on a grand and moving scale the background of its living over wide surfaces of the earth, is a delusion that fogs the realization of a more even advance towards it. Yet between the largest possible conception of a planned world and the smallest part of modern architecture there is a correspondence. There springs and there moves a feeling of certainty that however great the demand made upon it by contemporary society, modern architecture could answer out of its vocabulary, and give even more than was demanded.

In a sense this is all that is necessary, or possible: to have an architecture capable of anything. The eighteenth century had it, in that its architecture was something in course of slow evolution and therefore well understood and practised with confidence not only by the best but by the common run of architects; and by reason of the fact that its spirit permeated society. Further, there was little from among all the needs of society that could not be well satisfied by this architecture which found its right materials to hand and was neither strained by, nor in its turn strained, the economic or mechanical resources of its time.

What is happening today is just such another confluence. At close quarters the picture is exact and the parts to scale. But in the large nothing is so clear, because though it is possible for individuals to see and to decide, nothing so

190

definite is possible for society as a whole. Even revolution, involving as it would seem so much of decision for society, is powerless to distribute understanding more quickly than it can be made to move from a few spirits outward to the many.

As in the materials of building so in the material of larger co-ordination there are economies that correspond with demand. Somewhere between gross waste and perilous dexterity there is a state of balanced tension, arrived at in the architect by an intuition, the result of a mysterious juncture of mind and body. This selection finally involves the architect in the whole fabric of society and binds him with life, for it cannot be made unless he understands the whole with the part, or at least the implications of the whole with the part, which is the immediate concern of his selection.

He sees that it is the rational and inevitable economy of contemporary production to use the machine with an ever-increasing knowledge of both its capabilities and its shortcomings, and translating the machine's power into terms of building for human needs he seeks the economic unit of building, not only in terms of the larger but within the smallest parts of it.

What he cannot avoid in this is the desire for centralization as a means to unity, for unavoidably he sees beyond the range of his present limited activities the gathering together of great powers—at conflict with society now heavily on the move—but not out of scale with the mechanism of his architecture, nor yet with his own conception of what the whole might be in an idealized state of balanced tension.

He recognizes in such a work as the Tennessee Valley experiment a movement towards this state; the consciously planned distribution of power in a scale of adjusted economies related at each step to human needs. And he says that he is prepared to accept the outlines of this machinery as corresponding with the results of his smaller-scaled experiments because human needs and contemporary means appear to balance one another more closely here than in socialistic experiments elsewhere.

If the religion of modern town planning is human welfare, its creed is mechanics. How otherwise could the Tennessee Valley experiment have been carried through in America, the most commercial of countries? All the legislation needed was the power to make a thorough job of work in producing electricity by water power, and of distributing the benefits of this power over a wide area. But as its work proceeded it could point with sober logic to problems not exactly coming under the head of electricity generation but bound up

nevertheless with its vital economy. It found, for instance, that earlier exploitation had laid bare the earth to the winds and rains, and that denudation and soil impoverization were affecting not only farming but the value of the area for water-catchment purposes. And planting and soil reclamation meant better farming, more people and more money to spend on electrical energy. Even so, a population with the heart taken out of it by years of poverty is a poor stock to battle for good things to come. Therefore they must be educated. And so it goes on, spreading from a great dam, a work of technics, and entering the lives of large numbers of people as a new idea of living.

In England the solution must move in the same direction. I am convinced that approaches to planning that appeal for the preservation of ancient beauty, for beautification of towns and so on—the well-worn paths of the Garden City Movement, and the C.P.R.E.—defer the general acceptance of the possible harmony existing between industrialization and human welfare, and the establishing of planning as a vital and securely based social activity.

The idea is actually crystallizing out at both ends—in the machinery of national planning, however imperfect it may be at this stage; and in the progressively larger undertakings of housing authorities. The one deals with the organization of powers; the other with constructive planning on a smaller scale. But both are direct, and in essence practical. Regarding them as forming part in one gradually evolving planning structure, I am crediting them neither with similar nor equal purpose; still less am I attempting to judge of their quality. What seems to me important is to discover wherein lies the strength of the movement to plan land use. Is it attaching itself to the directing powers or being deflected anti-socially? Can large-scale housing, as it develops, bridge the gap between the two and become the instrument for the practical distribution of major economic power in the form of cheap social services in finely developed social structure?

Any honest planner will admit that town planning as now practised lacks direction, and fails where it is most necessary that it should succeed. But the immediate answer presents us with the dilemma, evoked by the choice between the danger of concentrated power and the stalemate of democratically controlled individualism. It is necessary to the evolution of town planning through modern architecture that we should look past the dilemma, and prepare blue prints for an urbanization within a structure of social planning, and having recognized the fact we may safely return to the study of housing as being a field most likely to yield results of service to the larger machinery of the all too clouded future.

192

ARCHITECTURE AND MATERIAL
By Marcel Breuer

'NEW materials, new possibilities, new constructions, new forms: these are the bases of a modern art of building.' What is there in this thesis? How far is it true? This is what we propose to examine briefly in the following notes.

The ordinary man, even if he builds and paints and is a home-made philosopher, will soon meet the perennial question: what was first, the hen or the egg? Which is the primary, a change in the sense of form, which creates for its realization its own materials, or the technical and economic evolution which blindly, so to speak, creates new products, whether or no these may lead to new forms.

I am not in a position to produce any order in my thoughts on this particular question. In spite of the prevailing fashion, I am not in a position to specialize the mind. I do not believe that a decided attitude on this point is at all necessary. We need not decide between the visionary and anticipatory sensitiveness of the artist-inventor and the massive force of the systematic technician. The mind does not travel on rails, nor is it mechanically guided. It chooses the method which will most effectively advance it: in jumps, or step by step, by trial and error, or by logical precision. What is already there is adapted: what is lacking is created anew.

I would therefore regard it as a matter of indifference whether modern architecture is called upon to fulfil the spirit of the new materials, or whether the new material (an inanimate thing in itself) should only serve the will of the new architecture (a new aesthetic?).

To give a rough idea of what I have in mind, the following facts about our activities may be mentioned:

1. A large number of new materials serve practical purposes in a manner which it has not hitherto been possible to achieve at all, or at least, to achieve

only imperfectly. For example, a bakelite table top is less sensitive (more hard-wearing), easier to clean and pleasanter in use than the other materials hitherto known.

These new materials are chromium, the different aluminium alloys, artificial silk, rubber, oil products, reinforced concrete, glasswool, asbestos, etc.

2. Older and more generally known materials can have their most important characteristics altered by new work processes and methods of construction. They are thereby also cheapened and made more generally accessible. Plywood for example is something quite different from wood. Glass, steel and cork, well known for a long time, exhibit today different characteristics and offer new and wider perspectives.

3. The modern movement in architecture utilizes these new materials. It tries to discover their laws without any aesthetic or technical prejudice. It endeavours to find the language of their form. A new aesthetic develops in which the new materials are given their new place.

4. The basis of modern architecture, however, is not the new materials, nor even the new form, but the new mentality; that is to say, the view we take and the manner in which we judge our needs. Thus modern architecture would exist even without reinforced concrete, plywood and linoleum. It would exist even in stone, wood and brick. It is important especially to emphasize this because the doctrinaire and unselective use of the new materials is not only harmful to the prestige of the modern movement, but falsifies also the basic principles of our work. We are particularly interested in the new materials, not because of any so-called desire for style, but we investigate, foster and utilize them only if we can thereby achieve a genuine improvement, a greater degree of clarity, a greater ease, and a truer exposition of living as a whole, including aesthetics.

194

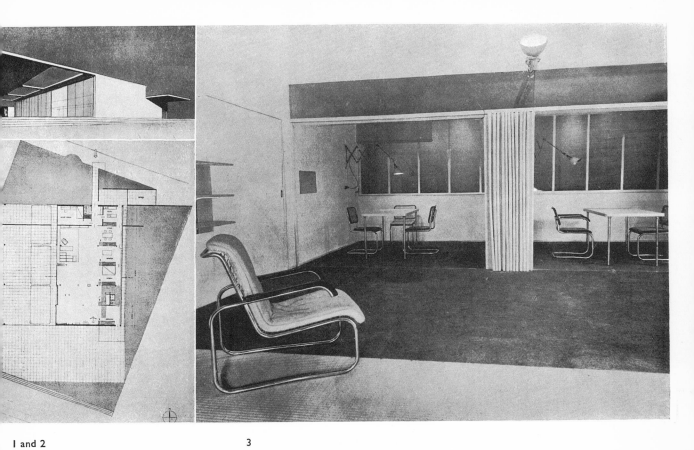

I and 2 3

Illustrations I, 2, 3

This house, intended as a sports club, shows the change that has taken place in the plan under the influence of new methods of construction. Since the roof is carried on slender steel supports there is a complete freedom as far as the walls of the house are concerned. The different units are separated from one another either by cupboard units or by movable folding screens. This provides the highest degree of free space and the greatest possibility of variation. The training terrace can be united with the interior of the house by means of sliding glass screens. The indirect lighting achieved by movable reflectors, the furniture made of resilient steel tubing, the cork floors, the soundproof sliding walls made of oilcloth, all these are made possible by the new materials.

195

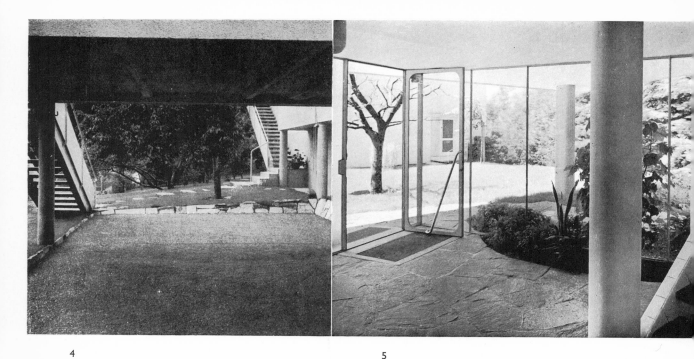

4 5

Illustration **4**

If we separate the house wholly or in part from the ground by building it on steel or concrete supports, we should be able to utilize the built-up area itself for gardens or playing space. It is possible to see underneath the house, to walk underneath it and consequently the free space has been enlarged. The outside staircase constructed in concrete also allows a maximum of free space. (Harnischmacher house, Wiesbaden.)

Illustration **5**

The garden may continue underneath the house and even into the glass-enclosed entrance hall. (Doldertal buildings, Zurich.)

196

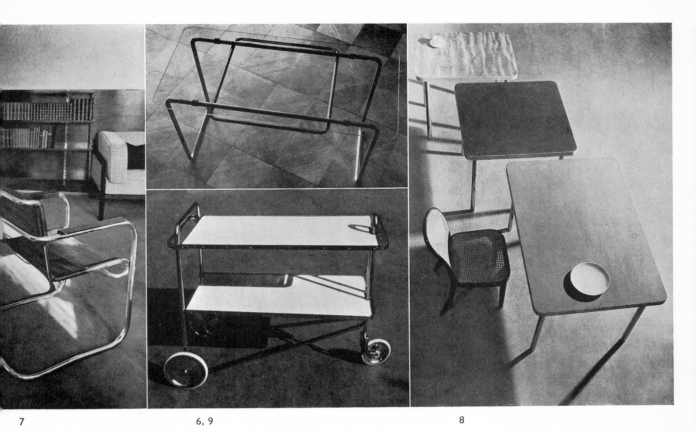

7 6, 9 8

Illustration 6

We expect from the new architecture not only a practical economy of space but also a visual gain. We want to remove the restricting impression of our necessarily small room. The slender and transparent glass-topped table does not fill the room. The plate glass is fixed to the supports by rubber rings only.

Illustration 7

Steel tubing, though known for many years, became adaptable for furniture only through a careful consideration of the type of construction to which it most easily lends itself, that is bending, and of its qualities of resilience. A new and characteristic form arose. The shiny metal hitherto 'cold and strange' found its proper place in the shape of steel furniture and in the new architecture and furnishing. The development of resilient and light pieces of bent furniture, chairs in the first instance, has only begun and is, as yet, a long way from completion. The effect of this development is now noticeable in other materials, for example wood, aluminium and plywood. (Chromium chair covered in leather.)

Illustration 8. (Typical examples; tables of steel tubing and plywood.)

Illustration 9. (Tea trolley, steel tubing and bakelite.)

197

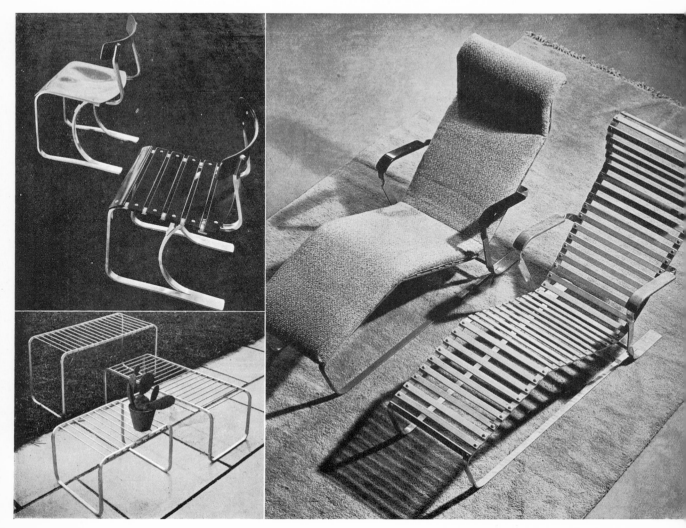

Illustration 10. A band of aluminium, slit, with the two parts bent to different heights and reunited—this principle of construction resulted in a resilient and springy chair skeleton made in a metal which is normally regarded as being particularly soft and lacking in resilience. The excellent qualities of this new material, light weight and freedom from rust, will contribute towards the further development of metal furniture. (Aluminium chairs.)

Illustration 11
(Aluminium chaise-longue. The upholstery is of rubber-hair.)

Illustration 12. (Stools or occasional tables in aluminium.)

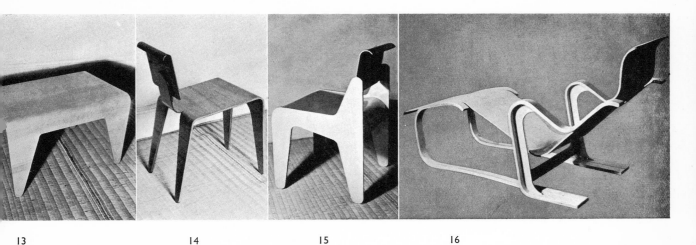

13 14 15 16

Illustration 13

Tea-table made of a single piece of bent plywood. Here the plywood is not used merely as a panel or as a plane surface borne by separate structural members; it performs two functions at one and the same time—it bears weight and forms its own planes. Here we have a new material and a new form which has very little resemblance to the tubular steel furniture shapes from which it was originally derived. Here, the usual joinery construction gives place to the new bending technique.

Illustration 14

Chair, also made out of a single piece of plywood.

Illustration 15

The characteristic quality of plywood is that it removes the possibility of warping and breaking, which in ordinary wood depends so much on the direction of the grain. Comparatively thin sheets can be used and yet remain stable. Each side of this chair is cut out of a single piece of plywood and joined by the thin bent seat and back.

Illustration 16

Resilient chaise-longue. This shows a combination of the two previous plywood constructions. (The rubber-hair upholstery used with this chair is not shown in the illustration.)

199

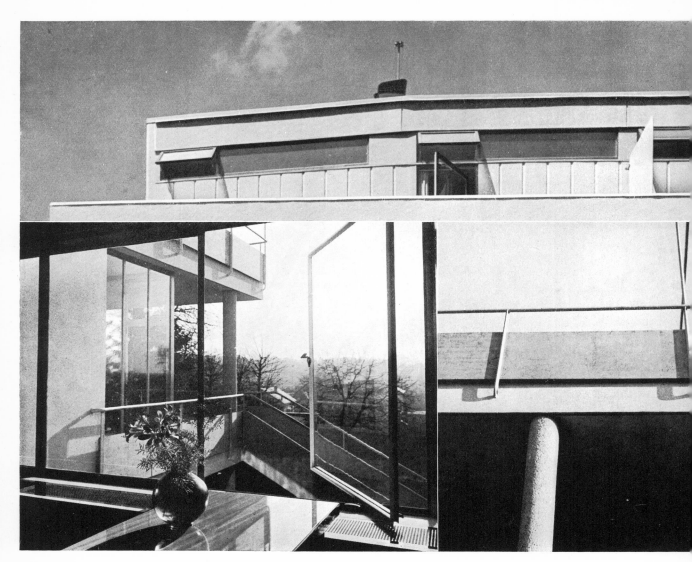

Illustration 17. Asbestos cement is a new material which has not yet received the recognition to which it is entitled by virtue of the great possibilities which it opens up. (Terrace balustrade made of unframed slabs. The Harnischer house, Wiesbaden.)

Illustration 18. The exterior of an attic storey in asbestos.

Illustration 19. Steel window frames will allow bolder combinations, thinner bars, bigger windows and more perfect proofing. The glass walls of the terrace form a winter garden; these may be taken down in the summer and the whole terrace thrown open. The table top is of grey opaque glass and the window seat of perforated chromium metal.

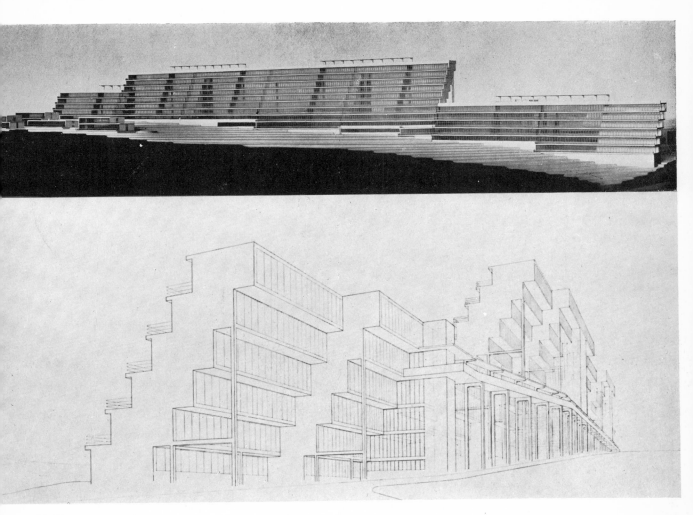

20, 21

Illustration **20**

Glass and steel, together with the modern sound and heat insulating materials (cork, glass-wool, etc.) lead to a new type of hospital: buildings are from six to twelve storeys built in recessed stages so that wide terraces for the patients are formed immediately in front of the sick-rooms. The system prevents the shading of lower storeys by the usual balconies and provides a maximum amount of sunlight and view and a minimum of built-up area and passageway, thus saving unnecessary walking and transport. (Elberfeld Hospital, 1,100 beds, south aspect.)

Illustration **21**

North aspect, showing free-standing steel construction.

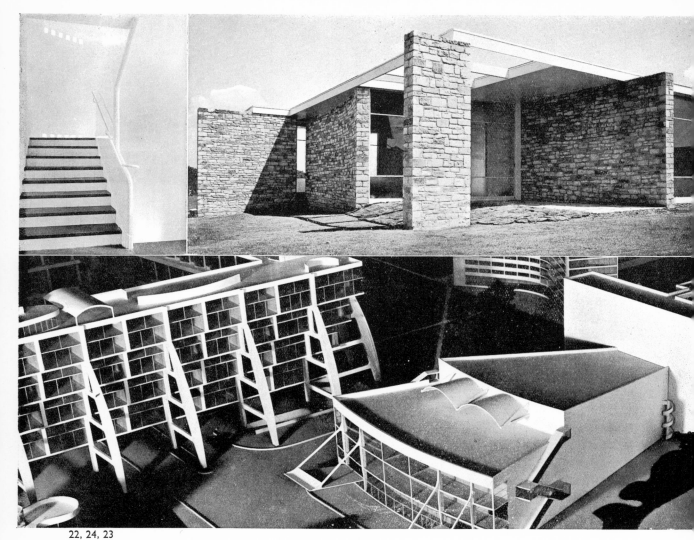

22, 24, 23

Illustration **22**. Reinforced concrete often leads to characteristic new forms. (Staircase, Doldertal, Zurich.)

Illustration **23**. Typical forms of reinforced concrete showing the freedom in the construction. (Model, 'The Garden City of the Future.')

Illustration **24**. The most traditional of all building materials, natural stone, is here combined with window walls of glass in steel frames. Even the oldest building material has changed and obtained new content and form. In this sense and in special cases the more traditional materials can be used to express modern ideas of building just as readily as the newest materials; for this reason we must not underestimate their values.

202

ROUTES OF HOUSING ADVANCE
By Richard J. Neutra

HOUSING of the unsheltered would be a comparatively easy task. It is rehousing of the traditionally conditioned, the reconditioning of populations as to dwelling habits which unrolls all the psychological complications of this socio-economic issue.

Rehousing of populations can take place in various ways, of which comprehensively planned effort is only one. It certainly has not been the way followed in U.S.A. before the last half-decade of depressed activity. Whether or not the consumer—instead of being a mere victim—becomes an active agent in the process by developing an effective consciousness and a selective acceptance of certain habitational standards to fit his particular circumstances, will give, or fail to give, wholesome character to an entire period.

First: Rehousing can happen without any specific consciousness as an inert reiteration of past habitational conditions by piecemeal replacement of depreciated residential structures. In this now ill-reputed case there can be no co-ordinated effort against obsolescence at large and it is the shortening of obsolescence periods by the pace of present technological development and its variegated social and economic consequences, that obstructs such peaceful stagnation and complicates it with sectional booms and drops in property values. Population shifts follow and evacuations of quarters, now doomed to sink into the cast reservoir of blighted areas, over which there is as yet no central or communal control.

Second: Rehousing emerges and appears as an ideal goal to consumers' groups who first may have organized themselves for minor purposes. In U.S.A. such co-operative programmes have been proclaimed, for example, within the numerous so-called 'Co-operatives of Unemployed' to whom the writer gave professional assistance for years. Groups with greater financial substance

have in America scarcely shown interest in habitation as a co-operative scheme.

Third: Rehousing has in a great number of foreign cases and in still rare American instances taken place through the initiative of governmental agencies, assuming representation of consumers.

Fourth: Rehousing can find its way into existence as a consequence of the technological progress of industries behind dwelling construction, which by its own momentum begins to bear psychological, commercial and political pressure on the masses of consumers and their representatives. In this case the primary initiative is within the ranks of the producing forces, material manufacturing companies, and the consumers' interest must be campaigned for.

The first form of rehousing, as we see, calls but for a minimum of conscious consumer's acceptance of what can be considered the type of habitational commodity and it concerns only in exceptional cases directly the lower-rental classes. Under this form of building activity types of habitation change rather too gently and often imperceptibly outside of inconsequential novelties in ornamental embellishment and certain technical improvements without true integration. The more depreciated units automatically slide down to lower rental levels, thus providing dwelling facilities for the financially weak. The lower rental brackets of the population remain second-hand and third-hand consumers, find the typical difficulties in repair, upkeep and operation of second-hand and third-hand commodities and therefore more or less fail in the proper maintenance of these properties. This is equally true for working people owning and operating a ten-year-old originally costly 'motor car, which except for its deeply reduced purchase price does not fit their requirements'—and for a low-wage-class family inhabiting and sub-letting a spacious apartment or obsolete mansion. Amassed neglected structures are and have been the result in nearly all American cities far beyond the areas commonly designated as slums. A premeditated functional differentiation of the sections comprised in a city or regional plan is thus frustrated and the true meaning of site values becomes in many instances more than cloudy.

Possibly one of the most detrimental features of such a development is the lack of rational relations between proportioned dwelling areas and well-connected employment markets within reasonable commuting distance. Unable to pay even the low rental of the second-hand dwelling commodity, or unable to find any employment in its neighbourhood, consumers in an increasing number of cases have attempted 'self-help' action, and like the Co-operatives of Un-

employed have, particularly in the West of the country, proceeded with housing schemes of their own.

So far such action had in America with few exceptions the character of an emergency measure. Labour, even qualified labour, trained in field work, can be supplied in abundance, but current material prices cannot be paid. The consequence is that a precious amount of energy and brainwork is wrought into structures, which by the very nature of their material specification are doomed to a short life and, what is worse, to a perpetual repaid activity or patching campaign. The disproportion of labour and energy to the value of the material worked upon, has—in view of the surrounding technological level—a demoralizing influence. However, there frequently may appear demonstrated the advantage of types of low-cost habitation deliberately, even enthusiastically, approved before production and chosen by the inhabitants often located in immediate relation to their place of work.

As an example might serve housing for farm workers, who are being settled by the Federal Emergency Relief Administration on an estate, which was lost by the original owner and now is co-operatively run by new settlers. A colony which incidentally also represents the tendency of redistribution of population by reclamation of unused land.

However, with the increase of governmental subsidy, like the subsistence homesteading—in which the Roosevelt Administration has invested considerable effort—the initiative of the settlers as to type of home is considerably reduced. It is often minimized, when the pertinent decisions are made by the office which handles the financing and supervises the execution of the whole development; acceptance of the consumers, who in this case become 'applicants', is expected to follow automatically.

In the case of an emergency situation of these applicants, acceptance of the new habitational type is indeed readily obtained. However, in designing and executing such colonies under very similar circumstances for foreign governments and living in them as an observer, the writer had occasion to find that this full acceptance is frequently withdrawn as soon as the grim grip of emergency loosens. The theoretical computations of a governmentally guided architect as to the habitational needs of, for instance, an industrial population transplanted as part-time workers into a semi-rural section, soon have a tendency to appear as an octroy of outsiders, as dictated by doctrinaires, whose failures are gladly exaggerated by the subsequent users. Racial psychology gives this condition different degrees of acuteness in different countries.

ROUTES OF HOUSING ADVANCE

The municipally built workers' colonies of Osaka, or white-collar apartments in Tokyo, Japan, or housing blocks for longshore-men erected by the Harbour Commission of Singapore—the writer found more readily accepted in spite of their grave deviation from the country's habitational tradition, than the well-known 'Siedlungen' done by excellent German architects, or certain Swiss, Austrian and Dutch colonies.

In the most fortunate examples of governmentally initiated and planned colonies, good communal grouping, economical but convincing unit layouts, and reliable, if rather traditional, material specification have been accomplished. Some steel-frame designs for multi-storey housing in Germany and France perhaps constitute an exception to this rule and surpass the average. In American cases these developments have been rather slow to stimulate a truly progressive technical design and have reverted to the structural routine of yesterday's practice, which seemed to offer easier possibilities of secure advance cost computation and of building up to the necessary working organization from existing resources.

The fourth possible initiative in housing and rehousing activity might, as mentioned, have its origin in, and might receive its impetus from, a group of technologically advanced industries which planfully move into a largely new market as an outlet for pressure of production. The various schemes of advanced shop preparation, which in the last years caught the attention of magazine readers and by structural connoisseurs had been predicted for decades, are an exemplification of this aspect. However, it is here, where mass acceptance of habitational innovations becomes a burning issue and where the possibility of an unmitigated 'octroy' or imposition on the consumer appears as out of the question.

The largely shop-prepared construction or complete pre-fabrication will, in order to be economical on a higher technological level, call for new layouts, new subdivisions and grouping, new appearances; in short for practical, psychological, aesthetical acceptance of the consumer. Inventive individuals have prepared a way, earned interest, embarked on educational dissemination of ideas. But here mass acceptance becomes a premise, as this new industrial application has but a limited chance to cater to individual predilection. If and when accepted, however, the new field of activity seems nearly boundless, especially as it ushers in an unprecedented turnover, a shortening of the obsolescence and replacement period of the dwelling commodity.

In the United States at the present moment, the initiative of the govern-

206

ment, of 'self-help' groups and of productive basic building material industry have moved into the foreground as possibly active factors. Whatever the detail arrangements of financing and distributing shelter may be, the characteristics of these three factors will pronounce themselves in the planned and executed production.

The slowest motion is that of governmental action, the structural results, as mentioned, will be solid rather than very advanced technologically, the length of amortization periods will be exaggerated, future elasticity obstructed. The scope and volume of course might be truly amazing and greatly surpass similar developments abroad, which in the last decade have been so impressive to American visitors that some of the here indigenous political aversion against a 'government in the building business' has crumbled. The activity of financially weak 'self-help' groups will—provided certain treasury grants are made to them—be speedier, even hasty, but in the majority of cases it may turn out technologically reactionary, inferior and even primitive. It will, like the subsistence homestead movement which produces low-grade crops in a largely inefficient way, relieve the emergency situation and the social difficulties of the moment, but from the point of view of a technologically determined civilization it is bound to appear as retrograde.

The programme of a production industry to introduce advanced technical methods into the field of housing might actually be in tune with mass requirements or by careful study be brought into tune with it; it might improve economic conditions by opening new employment markets, but as a self-styled commercial enterprise and dependent on a huge acceptance problem, it is obviously packed with too many risks and faces too great a weakness in purchasing power at this time, to get started on its way without priming by some external forces.

Meanwhile shop fabrication of dwellings seemed for years to make clean-cut sound promises. *Technologically* not only promises, but numerous solutions are at hand. Full shop-fabrication appears in many ways almost ready to reduce the American building-site to a short-term assembling yard. *Psychologically* the matter is not solved sufficiently to secure a serious financial backing for this industrially fabricated house, and piecemeal financial underpinning does not help much. Possibly it does harm in demonstrating half-raw results and bankruptcies of rushing entrepreneurs.

Industrial pre-fabrication of habitation is being announced by commercial enthusiasts as today's great chance for capital investment and delectable returns

207

on it. Why does capital not grasp this chance? Answer: there is no way known to ascertain whether a quantity acceptance will exist, when the market opens.

Is acceptance not insured if we offer:

> Low cost?
>
> Smooth functioning of increased equipment?
>
> Quality with durability and low upkeep for a definite term of amortization?

Will not the pre-fabricated 'House of the Future' as pictured in the Sunday papers indeed offer this? and who could resist such an offer?

The truth is that the house of the future rises beyond a period of transient experimentation, which so far, however, no experienced capitalist group wishes to finance. Low cost, smooth functioning, timed durability and quality are the by-product of a carefully modelled and yearly remodelled quantity production. It requires an expensive and definitely directed laboratory research in the co-ordination and integration of many elements. The problem is one of *neatly joining* all the parts to a consistent and combined performance that will convince. Just what may constitute a liveable environment at this historical moment becomes an issue of a high-priced campaign of convincing; subjected to an undirected American plebiscite it remains highly controversial.

To pay for the maintenance of laboratories, test executions, high-grade research workers' wages, may spell bankruptcy if sales on a large scale cannot soon be induced. Quantity sales cannot be secured except by a costly nation-wide advertising action. This again is senseless before the machinery set up for production is at hand, so that inquiries can immediately be answered with deliveries—a vicious circle!

Big finance—before implicating itself—returns to the crucial question: Can pre-fabricated houses be sold in ten-thousand lots, if only in such quantity they can be distributed at reasonable price and in superior quality?

No big manufacturer in U.S.A. has, for example, succeeded in standardizing inter-city buses so that a machinery set up for light-weight all-metal frames has proven justified. This is characteristic and it speaks through analogy. Called in by the largest American bus-building company to re-design their product and process of production for all-aluminium construction based on an immense tool investment, the writer found a fine occasion for getting instructed on what acceptance problems clog the way to standardized pre-fabrication; and bus-operating companies could be expected to be less individualistic, by pressure of their circumstances and predilections, than householders.

208

The first motor-car models were developed by tinkering little mechanics, not by strong companies nor under gigantic financial risks. They were scarcely in conflict with accepted mass standards. The grandparents of most car owners of today did not use any private vehicles of transportation, and so there existed no sentimental relation to the problem.

The well-integrated, standardized prefabricated, not built but assembled, house is in conflict with mass prejudice, which, as we know, first would have to be dissolved. Obliging concessions to individualistic formal diversification threaten the manufacturer with economic failure. *Model consciousness* would have to be created in consumers as has been done in the automotive field. The shop-made house cannot be camouflaged, without losing prefabrication advantages.

The tinkering little auto-mechanic of 1895 has perhaps his parallel in the experimental architect-engineer, who today invests his energy in the problem of truly advanced dwelling construction and its appendages. His heart-breaking small-scale efforts pave the way to an increasing confidence on the part of an increasing fraction of consumers. Each of his exemplary executions which, while individually put up, easily prove themselves applicable to series fabrication and shop preparation, gains the interest of manufacturers in neighbourly fields of production. Each publicity success of his work brings the hesitant capital interests a step closer to financing this experiment. The illusion of mass acceptance which he paints becomes a reality in more and more single instances.

Recognizing many years ago the factors described above, we have faithfully endeavoured to give a good number of individual jobs entrusted to us a character which easily would lend itself to series production. We further attempted to introduce meritorious materials in which strongly entrenched manufacturing interests are invested. This is opening a vista on new markets for steel in forms applicable to light-weight dwelling construction, for Diatom, asphalt, etc.

We have combed the neighbourhood of the housing field to demonstrate the advantages of typification, there, where fewer prejudices resist it. Standardization of the elementary school, for example, of the 'drive-in' retail market, of the highway auto court and restaurant, the vacation cabin, municipal beach resorts, motor-service stations. A special study has been carried out to attack with the practice of prefabrication such dwelling problems as offer obvious difficulties in usual field construction: distance from supply sources of skilled labour and construction equipment; unwillingness of loaning institutions to give financial support and to take risks on thus handicapped projects.

Illustrations show efforts of proving the applicability of mill-prepared unit-

type constructions, standardized wood chassis, weatherproof super-plywood shells, light-weight steel skeletons and externally exposed, internally insulated hollow-steel wall systems. Aesthetic appearances, finishes, heating and ventilating installations are of course consequential to the chosen system of fabrication and erection.

Example:

Application of hollow-steel elements for dwelling and school construction. General use of H. H. Robertson floor units 'Keystone' and of simultaneous structural research by Frankland, Lindeberg, V. Palmer.

The vertical wall elements erected in multiple sections are based in a typical grooved concrete footing, later grouted out with waterproof cement to produce a fixed bearing of the wall elements which now act like upright cantilevers and individually are designed to take lateral stresses of wind attacks or earth shocks. The male and female joint of the standard sections tightened with caulking rope and compressed A. C. Horn Vulcatex, a rubber-like vulcanization of china-wood oil applied with an air gun, permits relative elastic movement of the series of bottom-fixed cantilevers. Lintels are formed of the same sheet-steel elements, which, equipped with holes, are traversed by $\frac{3}{4}$-inch round steel bars to take tension stresses at the bottom zone of such girders and combine the top zone to compressive strength.

The ground floor is of double-shell construction of twelve inches overall depth. The upper slab of integrally coloured and waxed Diatom cement composition is a plenum chamber of six inches clear depth which extends under the entire building and into which, when desired, hot air is pressed electrically from the furnace. The Diatom cement slab forms and acts as a low-temperature radiating panel during the cold season, while a retarded convection carries the air volume of the sub-floor void into the vertical follows of the cellular steel walls.

Integration of structural and heating system. On the building fronts which are exposed to direct sun radiation, small intake openings at the foot of the cellular steel elements initiate simultaneously with the warming up of the exterior surface an automatic air convection to cool these walls and minimize heat transmission to the interior caloriferic insulation board lining. The sun rays themselves operate this cooling system. The roof construction was for comparative experimentation with building economy executed partly in electrically welded steel truss joists and partly in standard Robertson sections, both carrying composition roofs on insulating slabs.

Sashes are of polished cadmium steel, horizontally sliding, of novel detail ball-bearing. Exterior metal, glass and metal screen doors of full height are horizontally sliding. All door bucks steel. Interior partitions largely surfaced with a concealed, locked, nailless, dense panel board covering according to Muhlbacher.

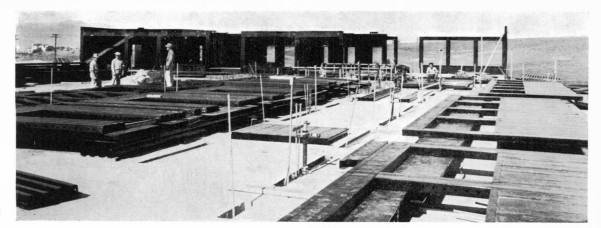

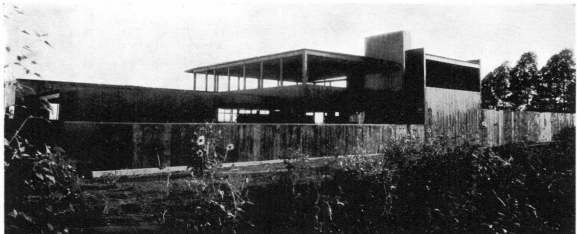

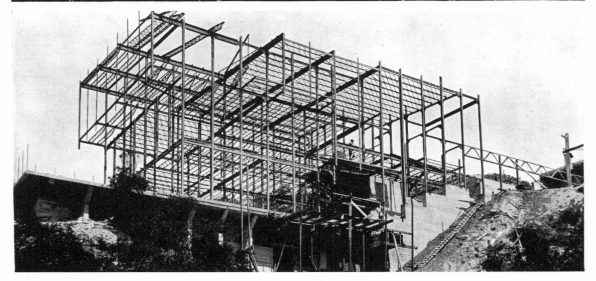

1. CALIFORNIA MILITARY ACADEMY. PREFABRICATED STEEL WALLS READY FOR ERECTION.
2. STEEL WALLS IN POSITION FOR THE ALL STEEL HOUSE FOR JOSEF VON STERNBERG.
3. PREFABRICATED STEEL FRAME AND SKELETON OF A HOUSE FOR DR. P. M. LOVELL, ERECTED IN 40 WORKING HOURS.

COLOUR IN INTERIOR ARCHITECTURE
By Alberto Sartoris

DUE to the course of development, that which appeared legitimate in the first stages of the new constructive movement in the sphere of interior architecture, is no longer so today. The reaction against colour, brought about by decorative abuses of the nineteenth century, served in the first instance to establish new ideas in architecture but has no longer any justification in the present day, when sensitiveness has rid itself of all its useless and superfluous elements. At one time, this reaction represented a very praiseworthy attitude, but its effects have now been left behind and a new future development is open to us. Everything that is connected with the interior equipment of the house must now be modified and revised according to new principles, in order to accompany naturally the integral development of rational architecture.

Since the discoveries in the field of art and optics brought about by movements such as the futurist, cubist, metaphysical, abstract and surrealist, and within the limits of these, we are bound to see the problem more profoundly than hitherto. Colour is a vital complement to architecture; it is one of its logical and indispensable elements. But, like architecture, it must now express itself in a new manner and must follow the laws of constructive functionalism. At the moment two methods confront each other and mutually complete each other: what may be called the *dynamic* method and the *neoplastic* method. Both are firmly linked to the theories of architectural functionalism which have revivified the building art of our time.

Above everything else, colours, chosen from a physiological point of view, must allow those special surroundings to be created which result from a logical and well-defined purpose. We know that there are colours which reflect the light and others which absorb it; those which are acoustic, those which are so to a less degree and those which do not react at all to the laws of acoustics, and

212

still others which—like blues—are perfectly suited to the office or the kitchen because they do not attract insect life. But beyond all this, colours will serve to bring out new perspectives, to reveal certain parts of the structural organism and to arrange, in the most rational way, the furniture, paintings or sculptures used in the interior of the house. They again provide scope for mural painting or sculpture which have, surely, as much right to live as architecture itself.

Following my own experience, a good method is to treat all surfaces which do not receive direct light in white or very light colours; those in half light or full light will be treated gradually in a stronger manner. But each colour will have to respect the wall, its form, volume and purpose. This *dynamic* method leads us to the possibility of having several walls of different colours in the same room. This method (the results of which must always remain within the framework of pure architecture and never within that of decoration for its own sake) opens a vast field for the new application of colour according to the sensitiveness of contemporary optics.

The *neoplastic* method proceeds in a different way. It treats the same wall in different colours (always uniting them with greys, whites and blacks) while preserving all the time special character and form and even accentuating it where the architectural scheme demands. In this case I prefer to use pure and primary colours, yellow, blue, red, while the *dynamic* method makes use of the whole scale of known colours and in addition, of those which the invention can produce.

Contrary to the principle of the fashionable tailor or upholsterer who seeks to achieve a harmony by a fictitious arrangement called '*ton sur ton*', what I propose is that one should follow the musical theory of dissonance and contrast. Through a voluntary, illusory discord of colours—appropriate to our epoch—one succeeds in creating a moving total, a living unity, a harmony which is vital and at the same time restful to the eyes. These theories oppose the monotony of monochrome interior architecture, they are against monochord composition and they serve as the normal link for harmonizing disparate furniture. The architect is thus enabled to provide furnishing of wood, glass and metal widely differing from the different materials of the construction. The colour may be obtained either by painting directly on the wall (oil, distemper, fresco) or through the use of plain papers, lincrustas, linos or rubber, or through the use of different materials and coatings fixed to the wall, in relief, or finished off in wood, metals, glass, making full use of all that modern technique has supplied to the architect.

COLOUR IN INTERIOR ARCHITECTURE

After this short statement it will be clear that we are envisaging the interior colour of the house from an original point of view, which unfortunately has not been rationally put into practice until the present time. At the same time this statement may be an answer to the, often justified, assertion that some modern architects, in simplifying their vision (which is reasonable within determinate limits), have voluntarily abolished, in an excessive and untoward rigour, the plastic appeals and the practical and physiological advantages which colour provides in the functional dwelling.

214

THE STATE OF TRANSITION
By J. L. Martin

THE modern movement in architecture has developed rapidly in this country during the last few years. By this I do not refer to the increase of *modernistic* garages, or the *moderne* dance halls and amusement palaces of our seaside resorts. Whilst at first glance these 'imitations' may seem to point to a growing interest in contemporary design, on closer observation it becomes clear that they are not only misguided effort but even a positive danger. It should be said at once that the appeal of the 'modernistic' is the spurious appeal of surface decoration: yet another manifestation of that passion for 'façade' which dragged out its life through the nineteenth century and which now presents itself in its most heterogeneous form.

The conditions under which modern architecture has to develop are particularly confusing and it is perhaps worth while, even at the risk of retreading well-worn ground, to consider the position in further detail. The difficulty which must at once arise is that of seeing a development with which we are so closely connected in anything like its proper perspective. But it is possible, at least, to see more clearly the prevailing conditions of the nineteenth century in which the present has its roots. From even the most cursory glance at the course of change from the early nineteenth century to the present day, it is clear that, in most spheres of activity, a rapid development has taken place: but we must at the same time recognise that this development consists largely of one-sided advances. The nineteenth century presents itself as a series of divided activities; in architecture, a tremendous gain in the structural and engineering development offset by a loss of form. The result is a lack of co-ordination; a separation of the formal, technical and social problems with which architecture is unavoidably linked. The formal has created its own separate and independent world. The technical development has introduced

215

the great practical advantages of standardization, but, through lack of a balancing social and aesthetic consciousness, has by its application of standardization debased human environment in the creation of the industrial slum. Building today (as manifested particularly in the output of the speculative builder) illustrates this cultural disintegration at its lowest ebb. As an inheritance from the nineteenth century, it maintains a basic opposition—a partial acceptance of the new world in the sphere of technique (machine production) and a contradiction of its existence in the form (imitation of earlier handicraft styles).

The origin of this separation of form and technique rests, of course, in the romantic outlook which sees the machine essentially as a creator of ugliness—a dehumanising agent. It would be useless to deny that there is some truth in this belief; the examples of misapplication are unfortunately all too well known. But it is also equally false to deny the machine's potentialities as a source of enrichment to human life; and the separation of art and technique in the nineteenth century is, at root, the equivalent of that denial. From the point of view of art, the disaster is that in creating its own separate and independent world, it loses contact with life, and not only this, it fails also to exercise its proper function as a controlling influence. The denial of the mechanical environment by the world of art did not stop its development (which was in any case assured by the practical advantages introduced), it merely left the machine unmastered, uncontrolled and at liberty to do its worst.

It is now possible to see what that worst may be. Acres of jerrybuilding have demonstrated the chaos inherent in an art form which has no connection with contemporary methods of production and which is now tudor, now georgian, now 'modernistic'. The new technique, instead of being the means of a cultural advance, has merely mass produced this artificial 'art'. It has now been proved that 'the only possible departure for artistic creation is modern life', and that life includes *all* contemporary realities. The balancing and controlling counterpart to a contemporary technique is an equally contemporary aesthetic. The aesthetic corresponding to the machine technique is no longer a matter for speculation. The new aesthetic exists in the motor car and the aeroplane, in the steel bridge and the line of electric pylons. Its values, precision, economy, exact finish, are not merely the result of technical limitation. They are the product of artistic selection. The modern architect and the industrial designer, confronted at every point in the technical process with the

216

choice between alternatives, moves instinctively towards simplicity and econ-omy. Even the painter and the sculptor, freed as they are from expression 'through machine technique', have, in non-figurative work, abandoned the accidental for the exact and have replaced the ornamental by the construc-tional. The fact that the various arts have independently evolved a contem-porary formal vocabulary is evidence of a step in the transitional phase towards cultural unity. It is important to add that the elements which these arts have in common (non-figurative form, impersonal technique) they have received separately from their common background and have evolved within the limits of their own materials. Each art maintains its own scale of values; in the case of painting, the thrust and tension of balanced colour, in the case of sculpture the play of forces and volumes in space.

It is as well to remind ourselves that in adopting a principle similar to that which has by common consent proved universal in the abstract art of architecture, non-figurative painting and sculpture does not necessarily sacri-fice its 'human' appeal. But it may be true to say that it avoids the 'personal' element in order to make its 'human' appeal more profound, and that it has abandoned 'realism' only in its effort to get a firmer hold on 'reality' itself. In this respect it is important to recognize that the building of a new 'reality' is a task not confined to modern art alone. It is a matter of common know-ledge that in science, the world of 'appearances', of parallel systems in which the dead world and the world of living organisms are clearly marked off from each other, has been abandoned. The world of appearances has given place to a world in which things unrelated to each other in appearance are united in the completeness of a single system. In science as in art, 'appearance' has been jettisoned in favour of a world discovered only through the penetration of appearances.

The parallel is a significant one and may, perhaps, be extended into the field of architecture where the rapid advance of constructional science which began in the engineering structures of the nineteenth century exploded the belief in appearances at an early stage.* It is now well known that strength

*The key inventions of the nineteenth century are well enough known; it is enough to say that this remarkable advance of constructional technique shows no sign of abating. Leaving on one side all the new material which science promises to provide in the very near future, one may mention because of the immediate possibility of its application the work of the French engineer, M. Freyssinet, whose recent studies, based on the laws of molecular attractions, have provided a 'treated' reinforced concrete ten times stronger than ordinary reinforced concrete, and which, when fissured under pressure, possesses a molecular activity which will actually re-seal the lips of the fissures, so that the concrete returns to its normal strength.

does not depend on mass. In place of the massive static effect of the stone wall modern architecture makes use of the dynamic effects of the steel and reinforced concrete structure. In place of solid volume, it has introduced new spatial values.* In its unity of external and internal and by its integration of structural heating and ventilating systems, the world of separate effects and separate systems has been broken down. The building is itself something in the nature of a living organism. The implications are far reaching—planning for air, sun and view—only the reshaping of the town can ensure that these things are commonly available. The modern building is essentially a part of the town planned as a healthy working unit, not merely another building in a vast spread of the unplanned in which the occasional vista and the imposing revivalist façade make a last despairing effort to 'keep up appearances'.

It remains only to add that the ultimate and final link between the work of the modern architect (or the abstract artist) and the man in the street is neither so distant nor so impossible to achieve as we are apt to suppose. The work of the modern artist is not an isolated problem, but like all creative effort it is linked to powerful common experience. There is ample evidence from history to show that even the most abstract scientific theories had their origin in contemporary needs. I believe that the work of the abstract painter and sculptor is no exception to this rule, and the merely practical advantages of modern architecture are surely obvious enough. There is every reason to assume that as the rational utilization of the contemporary technique becomes more and more in evidence through the application of the principles of modern architecture, the need for its balancing counterpart in the shape of a heightened sensitiveness to form, colour and proportion will become all the more urgent. This does not mean that the aesthetic of the machine age will be far removed from the ordinary man. On the contrary, since it addresses itself to the sensibility it is a question of feeling and not of knowledge and as such makes itself universally accessible. The response which the general public has shown to the machine aesthetic of the aeroplane and the motor car is one of the encouraging signs of the development of a deepening sensitiveness; the fact that the general public does not as yet observe the incongruity between its motor cars and its tudor villas shows exactly how far that development has still to go. But however far that may be, it is only through a common acceptance—conscious or

*The means of achieving these effects is not, of course, now limited to the use of new materials. The revelation which the new constructional technique has introduced is in itself the source of a series of revaluations and a new exploitation of older and well-tried structural forms; the rejuvenation of the timber structure is the first example that comes to mind.

218

unconscious—on the part of the public, that architecture and the arts can again become an integral part—a formative influence—in the life of society. And one of the assurances of ultimate success lies in the fact that this new awakening of the arts is not merely a fashion but has its basis in the psychological, economic and social needs of the present moment.

CONSTRUCTION AND AESTHETICS

(Notes on the Reinforced-Concrete Bridges designed by the Swiss Engineer, Robert Maillart.)

By Siegfried Giedion *(English Version by P. Morton Shand)*

THOSE whose aesthetic sense has been formed or developed by the art of the present age can hardly fail to be stirred by Maillart's bridges, for their appearance may be trusted to arrest them before they can even ask themselves why. But among public authorities the entire freedom from traditional aesthetic bias which characterizes their structure has called forth marked antipathy, misconception and resistance.

Maillart's surprising designs, which attract some as much as they repel others, are the product of the uncompromising application of a new method of construction. They have almost as little in common with the solid arches, stout piers, and monumentally emphasized abutments of the usual 'massive' type of bridge as an airplane has with a mail coach.

Although the first of his bridges have been standing these thirty years, and their adequacy for their purpose has long since ceased to be questioned, they still continue to arouse antagonism among local bodies, many of which regard them as positively hideous. It happened that most were built across remote Alpine valleys, where they were considerably cheaper to erect than other types and (an equally important consideration) comparatively few people would see them. The stark, lean assurance of their construction belies the aesthetic lights of a wide section of the public owing to its elimination of any emphasis on the means of support, and the taut, web-like appearance of the arch-spans which results. 'I am sick of these pastry-work bridges' was the way the chairman of one of these local bodies expressed his aversion. This remark is worth mentioning since it shows what an influence aesthetic feelings exercise alike on those

who commission the building of bridges and those who merely chance to look at them; and how often these feelings are the secret determining factor of decisions apparently dictated solely by questions of cost and efficiency.

It is therefore not unprofitable to enquire—taking Maillart's bridges as the basis of our investigations—how the aesthetic effect produced by a new type of construction arises and what underlies it.

The Technical Position. Technology has long since passed the stage of open-minded experiment. A century of practical experience has now become crystallized into definite forms, definite methods. Established formulas are, of course, indispensable, but the *a priori* inevitability with which they fetter the mind, compelling it to adopt a prescribed direction, presents a grave danger of fossilization.

Today technology has put the period of bold, often leap-frog advances behind it, and has entered a stage of routine based on acquired experience. At present it seems harder to strike out a new line in construction than in art, and resistance to the former has increased. Whenever a new idea emerges, past experience and present methods are at once called in aid to prove that its adoption would be a step in the wrong direction. Hence the structural engineer is now deprived of that unprejudiced outlook which amplified his powers of achievement during the last century. The names of those who, in our own day, can use their imagination in the field of construction without letting accepted formulas and existing practice hamper it could be counted on one's fingers.

The Artistic Position. In the course of the nineteenth century technology created a whole world of new forms: steam cranes, railway bridges, and exhibition halls with unprecedented roof-spans. These were esteemed as structural achievements and milestones of 'progress', or for the functions they performed. But in terms of emotion people could neither appraise them, nor fit them into the scheme of things. Being unable to grasp their emotional content, they renounced the attempt and refused to admit its existence, relegating one and all of them to the category of the merely useful.

This brings us straight to the most interesting question of all: How did the severance implied occur, and what causes brought it about?

There was a difference in principle between the methods which had led engineers to evolve such unexpected forms and those that prevailed in contemporary painting; for the means employed in each were on a wholly different level.

Aesthetics could not assimilate these new realities because in his own

221

sphere the artist was using symbols that belonged to an earlier phase of intelligence than the forms which mechanical technique was producing. Take, for instance, the Eiffel Tower (1889). How could he hope to analyse a structure that tells the eye little of its real nature when seen from any one fixed point in perspective, and which can only be gauged by climbing into the cage of intersecting lines it patterns against the sky, where top and bottom lose all significance as such? When painting—that is emotional vision—had not yet been able to get beyond Renaissance perspective, how could painters be expected to grasp the emotional quality of buildings that embodied time as a fourth dimension?

It was not till 1910, when the Cubists first succeeded in painting pictures which were no longer meant to be viewed from a single angle of vision, that this time-lag could be adjusted.

The advance in terms of time which painting then accomplished made it possible for humanity to begin to appreciate the new reality it had itself created in terms of emotion. With it art attained a level of resource which science and mechanical technique had achieved much earlier on.

Maillart's Structural Principles. What, then, is the peculiarity of Maillart's methods of building?

In the early days of reinforced concrete this material was applied to the same methods of construction as were employed with timber and iron. Being the trunk of a tree timber grows lengthways, just as iron becomes when rolled into long girders. One dimension always predominates, which is that transmitting the load. As Maillart himself puts it: 'The engineer was so accustomed to use these basic materials, which only provide one-dimensional support, that they became second nature to him, and restrained him from exploiting other possibilities. This was the state of affairs when reinforced concrete was introduced, and at first no change ensued.'

Maillart was a pupil of Hennebique;* and Hennebique's reinforced-concrete structures had beams and columns like timber-framed buildings. Following the model of timber construction, his beams spanned from wall to wall and column to column, the roof stretching across them being in the form of a flat, inert slab. This was the point where Maillart began his life's work. Like all great constructors, he has consistently followed a single line of thought, which he has progressively developed and expanded in the course of his career.

*Early in his career Maillart was the engineer in charge of the construction of a concrete sanatorium at Davos for which Hennebique was the contractor.

222

In designing a roof or a bridge, Maillart began by eliminating all that was non-functional; thus everything which remained was an immediate part of its structure. He did this by improving the reinforced-concrete slab until he had turned it into a new structural element. What Maillart has achieved since then is based on one idea: that it is possible to reinforce a flat or curved concrete slab in such a manner as to dispense with the need for beams in flooring or solid arches in bridges. It is very difficult to determine the forces present in slabs of this nature by calculation alone. To obtain positive results entailed a complicated process which cannot be entered into here, except to say that it was based partly on calculation and partly on experiment.

Slabs had hitherto played a neutral or passive part in construction. Maillart transformed them into active bearing surfaces capable of assuming all forms of stress; and subsequently developed this principle into a comprehensive system of support that is now adopted for types of building in which it had previously been considered impossible to use concrete. Whether engaged in perfecting a new form of flooring or striking out new principles in bridge construction, he has always adhered to the same basic method of using reinforced-concrete slabs as active structural elements.

Mushroom Flooring.★ Maillart's experiments with beamless flooring date from 1908. He treated a floor as a concrete slab, converting it into an actively co-operative structural member by distributing the reinforcement throughout its whole area. Since every part of the surface now became self-supporting, beams disappeared, their function being resolved into the floor itself. The heavier the load this homogeneous type of flooring is called upon to bear, the greater is the practical inducement to adopt it. Consequently it is usually found in warehouses, factories, or other large multi-storeyed buildings.

The appearance of the branching columns which support this type of flooring somewhat recalls certain traditional styles, resembling the heavy pillars of a romanesque crypt in the basements of warehouses and the slender palm-like columns of Late Gothic in their upper storeys. In point of fact, however, mushroom-headed columns have nothing beyond these superficial resemblances in

★*Translator's Note.*—Like so many technical terms that have emanated from the United States 'mushroom-slab flooring', derived by a process of rather slipshod translation from 'Pilzdecke', is, figuratively, a rather misleading one; since the head of the edible mushroom (*agaricus campestris*) is quite flat underneath, while its top is more often convex. The German term 'Pilzdecke' means literally 'fungus flooring'. Certain kinds of toadstool commonly eaten on the Continent (notably *agaricus cantharellus*) have hollow lily-shaped heads which forcibly recall the trumpet-mouthed form of the capitals of 'mushroom-headed columns'.

223

common with either; since the peculiarity of the system resides neither in the formation of their shafts, nor the extruded corbelling of the capitals that crown them, but wholly in forces in the ceiling above which do not meet the eye.

As floors of this type provide a uniform bearing surface throughout their length and breadth, their ends can be cantilevered out to carry supplementary loads. They are therefore ideal in combination with non-supporting walls, such as continuous expanses of horizontal fenestration. It is hard to realize this in the obscurity of a warehouse, for the latent possibilities of mushroom-slab construction can only find architectural vindication in buildings which are flooded with the light of day on all sides.★

The American engineer C. A. P. Turner† had been experimenting with the mushroom-slab system at the same time as Maillart, but he did not venture to carry the slab to its logical development and use it as a self-sufficient structural entity. American designers have not been able to rid themselves of the idea that a slab is subject to stress in separate directions, and embed their rods diagonally across the floor like intersecting beams. American practice has not fully grasped the structural role of the slab, and consequently the forms of its

MUSHROOM-SLAB FLOOR RE-IN-FORCED ON THE MAILLART PRIN-CIPLE

THE RE-INFORCEMENT OF A TYP-ICAL AMERICAN MUSHROOM-SLAB FLOOR

★The first specifically architectural endorsements of this principle did not occur until twenty years after Maillart's initial experiments. Brinkmann and Van der Vlugt's splendid Van Nelle Factory in Rotterdam (1927-28) is the outstanding example, although it embodies the ponderous American type of mushroom-headed columns.

†Cf. *Concrete-Steel Construction*, by C. A. P. Turner, published in Minneapolis in 1909.

mushroom-headed columns manifest a certain characteristic heavy-handedness. It can be recognized at the first glance by the presence of an intermediate slab introduced between the head of the pillar and the ceiling as in the Doric order of columnation. To the best of my knowledge the Americans have not even yet thought of using the slab as a basic element in bridge construction.

Maillart had embodied this principle in a bridge as early as 1900; and in that over the Tavanasa (1905) he dared to strip his construction of all disguise. The Tavanasa bridge represented a wholly unprecedented form, for in it Maillart discarded massive beams just as he was also shortly to eliminate the beams from floors. Instead, he employed a shallow curved reinforced-concrete slab for the arch, which with the horizontal slab of the platform, and a series of stiffened vertical slabs used as ties to articulate them together, constituted the entire structure.

Thus Maillart resolved bridge-building into a system of flat and curved slabs so juxtaposed as to achieve a positively uncanny counterbalance of all stresses and strains arising between them. The first realization of a stiffened elliptical concrete bridge with an arch of 'egg-shell' thickness (his Valtschiel-Brücke) followed in 1925.

The elimination of all non-functional members has led Maillart during the last few years to dispense with the usual separate decking slab. In these later bridges, trains and motor cars run directly upon their naked structural framework: that is to say on the longitudinal slab of the platform itself.

In Maillart's hands, the slab's rigidity, hitherto an incalculable factor in construction, became an active bearing surface, which being under initial tension opened up possibilities that had remained a closed book for reinforced-concrete engineering. Thus the torsional strains that would have to be allowed for in a concrete bridge built on a curving alignment were previously deemed to defy calculation. Maillart's Schwandbach-Brücke in the Canton of Berne, opened in 1933, was the first example of a road bridge carried out in that material with a sickle-shaped platform.

One of Maillart's latest designs, a rather larger bridge, carries the recently reconstructed main road between Zurich and St. Gall over the River Thur at a point where it traverses broken country with a flat-topped hill in the background. A single arch spans the river-bed, flanked on each side by a short approach viaduct supported on remarkably slender columns.

To appreciate the full plastic beauty of the form of this bridge—the flattened curves of the twin hollow ribs, and the manner in which they are yoked to-

225

gether; their three-pin articulation on a level with the crown and at the abutments (the slightly ogival pointing of the summit of the arch which results should be noted); the upright slabs that act as vertical ties between the arch-ribs and the platform; as also the interplay of the pattern of these members with that produced by the unusual section of the columns of the viaducts—you must not only go and see it, but clamber down the shingle to the river's bank so as to gain a view of the structure from underneath. There are few contemporary technical buildings in which the solution of the structural problem approaches so closely to pure plastic expression.

Construction and Aesthetics. Before I throw out the question which underlies this analysis one or two striking features of Maillart's bridges may be touched on without entering into the technique of his structural methods.

Sculpture and Nature. One of the problems in art in which research has not yet made much headway is the relation between sculpture and nature—and beyond this again the inter-relations between sculpture, painting and architecture. It is easier for the constructor to find a convincing solution than the artist, because physical factors (like the width of the interval to be spanned, the nature of the foundations, etc.) dictate its conditions. All the same there is something altogether out of the ordinary in the way Maillart succeeds both in expressing and sublimating the breadth of a chasm cleft between two walls of rock (i.e. in his Salginatobel-Brücke, 1929-30). His shapely bridges spring out of shapeless crags with the serene inevitability of Greek temples. The lithe elastic resilience with which they leap from side to side, the attenuation of their dimensions, merges into the co-ordinated rhythms of arch, platform and the upended slabs between them.

A bridge designed on a system of slabs of various shapes no longer resembles the ordinary kind of bridge either in its form or its proportions. For eyes that are blind to the optical vision of our own day, slanting columns with grotesquely splayed-out heads, like those of the Thur-Brücke's approach viaducts —a form imposed by purely structural considerations that enabled Maillart to make two columns do the work of four—are bound to appear somewhat ugly; whereas eyes schooled by contemporary art recognize in these shapes an echo of those with which modern painting has already familiarized them.

When Picasso paints half-geometric, half-organic plastic images on canvas —forms which in spite of their apparently capricious projection somehow achieve a singular degree of equipoise—and the constructor (proceeding from purely technical premises) arrives at similarly absolute forms by substituting

226

two vertical supports for four, there is a clear inference that mechanical shapes and the shapes evolved by art as the mirror of a higher reality rank *pari passu* in terms of development.

It is, of course, easy enough to retort that this is simply the result of chance, and that such resemblances are purely superficial. But we cannot afford to leave the matter there, for what concerns us is the question which must serve as our point of departure:

Are the methods which underlie the artist's work related to those of the modern structural engineer?—In fact is there a direct affinity between the principles now current in painting and construction?

We know the great importance which *surface* has acquired in the composition of a picture, and the long road that had to be traversed—starting from Manet's light-fusion of paint, by way of Cézanne's flat colouration and the work of Matisse, and ending with Cubism—before this was finally recognized.

Surface, which was formerly held to possess no intrinsic capacity for expression, and so at best could only find decorative utilization, has now become the basis of composition, thereby supplanting perspective, which had triumphed over each successive change of style ever since the Renaissance.

With the Cubist's conquest of space, and the abandonment of one predetermined angle of vision which went hand in hand with it, surface acquired a significance it had never known before. Our powers of perception became widened and sharpened in consequence. We discovered the interplay of imponderably floating elements irrationally penetrating or fusing into each other, as also the optical tensions which arise from the contrasts between various textural effects (the handling of colour *qua* colour, or the use of other media like sand, bits of dress fabrics and scraps of paper to supplement pigments). The human eye awoke to the spectacle of form, line and colour—that is the whole grammar of composition—reacting on one another within an orbit of hovering planes; or, as J. Sweeney calls it, 'the plastic organization of forms suggested by line and colour on a flat surface'.

If Maillart, speaking as an engineer, can claim to have developed the slab into a basic element of construction, modern painters can answer with equal justice that they have made surface an essential factor in the composition of a picture. The slab for long remained unheeded and unmastered: an inert inadaptable thing which defied calculation and so utilization. But just as a great constructor has transformed it into a medium for solving structural problems that had always been considered insuperable, so the development of surface

227

into a basic principle of composition in painting has resulted in opening up un-tapped fields of optical expression.

This is no longer a fortuitous optical coincidence, as might be objected, but a definite identity of methods. By what mental processes the constructor and the painter have arrived at it defies analysis. We can only authenticate a par-ticular phenomenon in a particular case: that a new method of construction has found its simultaneous echo in a parallel method in art. But this proves that underlying the special power of visualization implicit in each of these fields similar elements have emerged which provide a creative impetus for both of them.

If the constructor, who necessarily proceeds from quite different considera-tions, finds he has to adopt substantially the same basic element as the artist in order to solve his own technical problems, this signifies that in each case similar methods have informed optical imagination.

Contemporary artists continually reiterate the claim that their work forms part of Nature's. This they explain as follows: 'modern art has reached the same results as modern science by entirely independent, intuitive steps. Like science it has resolved the shape of things into their basic elements with the object of reconstituting them in consonance with the universal laws of Nature.' Now those forms in concrete which ignore former conventions in design are likewise the product of a process of 'resolution into basic elements' (for a slab is an irreducible element) that uses reconstruction as a means of attaining a more rational synthesis.

In this connection mention should be made of the 'egg-shell' concrete vaulting which Freyssinet used for some locomotive-sheds he built at Bagneux, outside Paris, in 1929; though since then that particular branch of reinforced-concrete engineering has produced forms of almost phantastic daring. On the same principle of using the slab as an active structural member, the Finnish architect, Alvar Aalto, has struck out an entirely new line in furniture design. He uses thin sheets of plywood, which, like the concrete slab, was formerly re-garded as useless for purposes of structural support.

In the community of method which now prevails in so many departments of human activity we may read a presage of far-reaching developments. The growth of this spontaneous identity of approach, and its repercussions on society, are being separately studied in every branch of knowledge. That there is a re-markable analogy between recent departures in philosophy, physics, literature, art and music is a fact which has frequently been commented on. In the light

228

of the particular case we have just examined, it is worth considering whether the field of structural engineering cannot be included as well.

New methods are new tools for the creation of new types of reality. The greater the degree of identity in respect of what is fundamental to each of the creative spheres, and the closer the extent of their approximation to one another in terms of achievement, the sooner will the prerequisites for a new phase of culture be forthcoming.

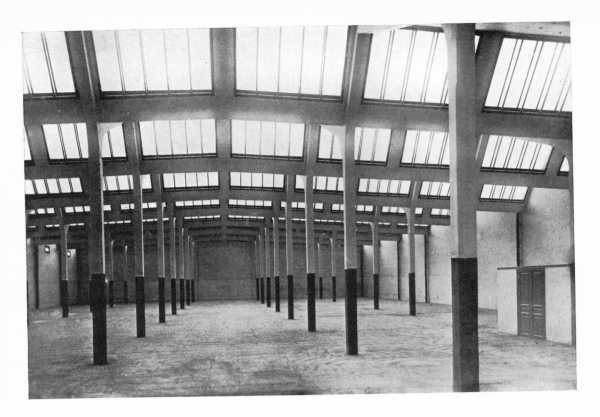

1. A FACTORY AT BARCELONA

An early ferro-concrete construction by Maillart. The illustration shows the lightness of construction and economy of material attained.

2. AN ENGINE SHED AT BAGNEUX PARIS

The work of Freyssinet. Lightness and economy are again illustrated. The roofing slabs are only $2\frac{1}{2}$ inches thick.

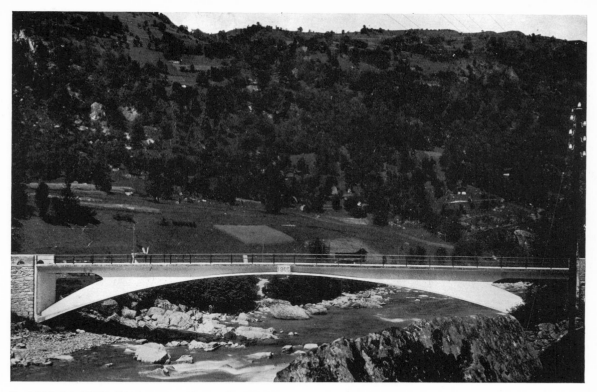

3. BRIDGE OVER THE TARANASA, SWITZERLAND, by MAILLART built 1905 now destroyed.

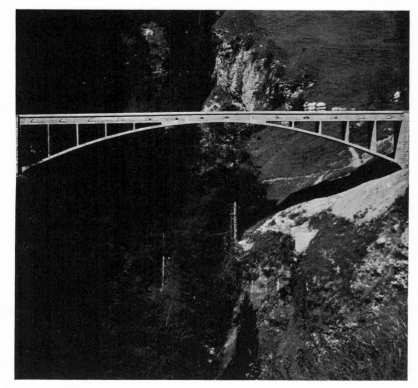

4. VALTSDRIEL BRIDGE by
 MAILLART 1925-6

 The system of slab ferro-
 concrete construction is
 by now clearly evident.

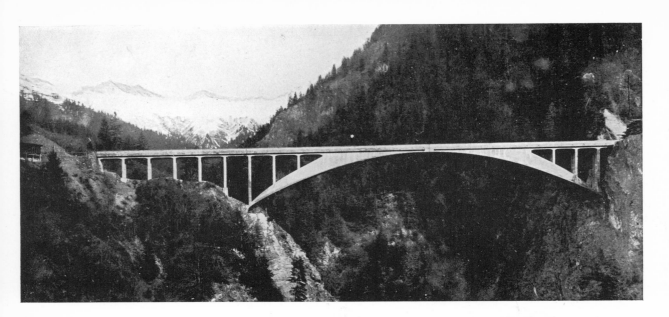

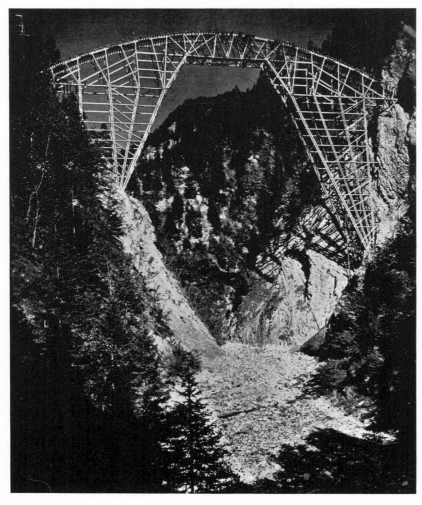

5. BRIDGE OVER THE SALGINA-TOBEL, SWITZERLAND, by MAILLART 1929-30, span 92 metres.

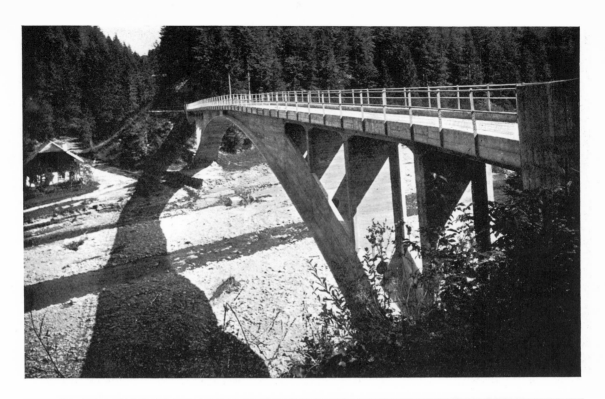

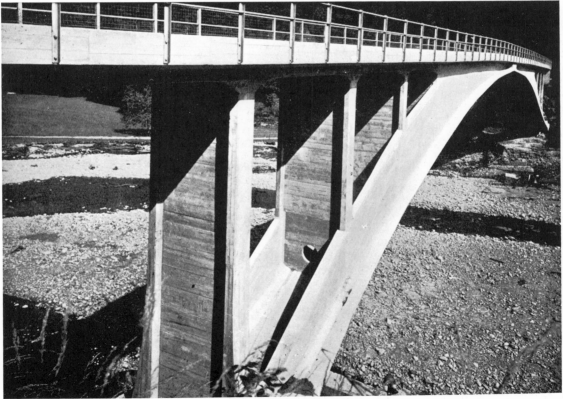

6. BRIDGE OVER THE ROSSGRABEN, CANTON DE BERNE, SWITZERLAND, by MAILLART 1932

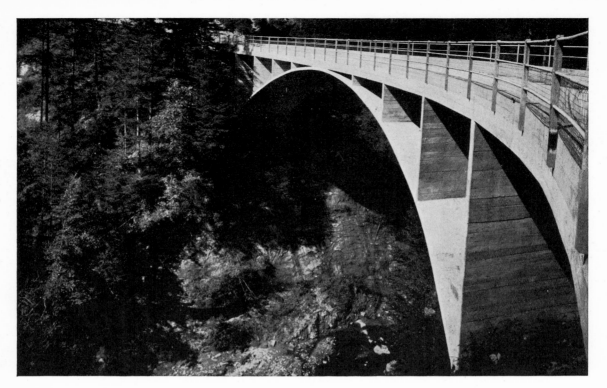

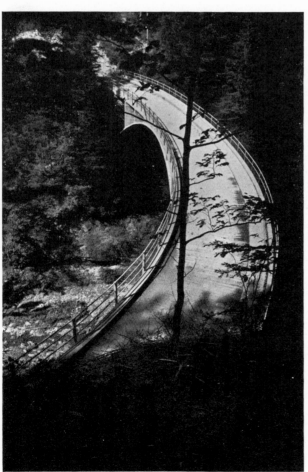

7. BRIDGE OVER THE SCHWANDBACH,
CANTON DE BERNE SWITZERLAND,
by MAILLART 1933

The curved plan form, used here for the
first time, shows the adaptability of
Maillart's reinforced concrete system. The
curved plan allows traffic to make an easy
turn across the narrow valley.

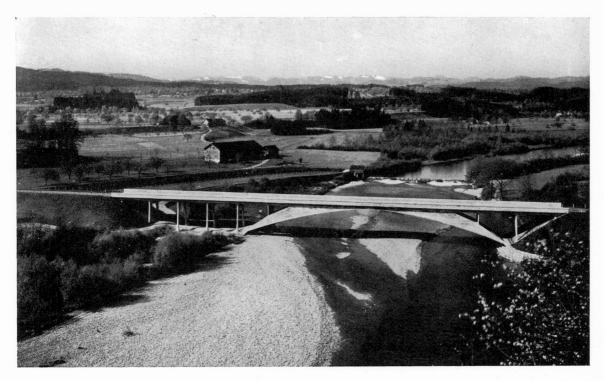

8

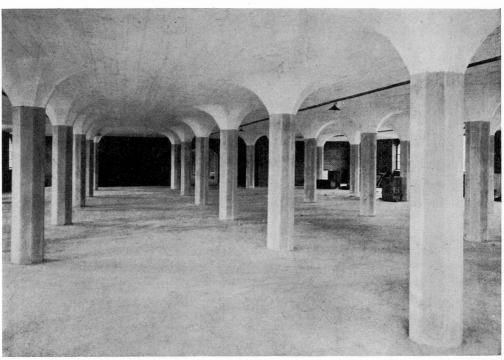

9

8. BRIDGE NEAR FELSEGG (ST. GALLEN) by MAILLART 1934-35
9. LAGERHAUS IN ZURICH by MAILLART 1908
 The first mushroom construction in Europe

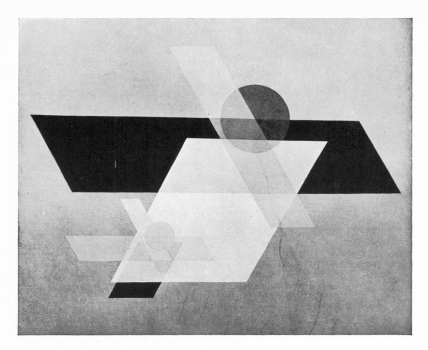

PAINTING BY
MOHOLY-NAGY 1924

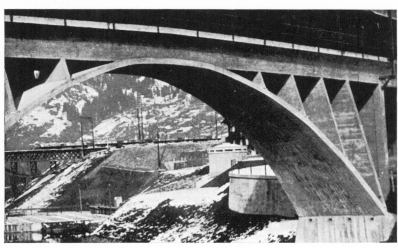

LANDQUART BRIDGE
by MAILLART 1930

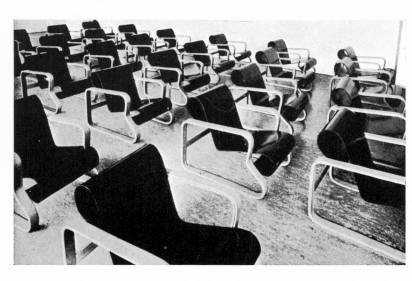

PLYWOOD CHAIRS
by ALVAR AALTO

IV. ART AND LIFE

ART EDUCATION AND STATE*
By Walter Gropius

THE history of the evolution of things into shapes is the story of a struggle between the demands made by man on the purpose or object of the thing on the one hand, and on its expression, that is to say, its form, on the other hand. The questions concerning the object or purpose of a thing are of a super-individualistic nature; they represent the organic evolution as we see it in nature. For example, the development of a technical apparatus, such as a locomotive, is the result of the intellectual work of numerous individuals who, like links in the chain of development, built up on the efforts of their predecessors.

On the other hand, the demands which we impose on the Expression, that is to say, on the form of a thing, are of a purely spiritual nature. The form is not a product of the intellect, but of human desire, and is therefore closely associated with the individual, with the nation and with place and time. The history of art contains many examples which reflect the struggle between intellect and desire, even to the most absurd contradictions between purpose and shape. In our mechanical age, however, a new conception is beginning to make itself felt. Today, we insist upon the form of a thing following the function of that thing, upon the desire for expression of its creator following the same direction as the organic building-up processes in nature, and not running counter to that direction. We insist upon harmony again being achieved between intellect and desire. We are once again striving towards unity in the cultural world around us, out of the boundless diversities in which the individual feels himself helpless and alone. The age just past, with its 'isms' and its historical imitations, was, perhaps, merely the reflection of our unconscious desire to probe the secrets of the whole visible world, in order, in our longing for totality, to overlook nothing of importance in a new world.

*See *The Year Book of Education, 1936*. Montague House, London, W.C. 1.

238

Out of contradiction and affirmation, research and intuition, a principle has gradually crystallized which has spiritually permeated the technical age in which we are living: no longer must the isolated individual work continue to occupy pride of place, but rather the creation of the generally valid type, the development towards a standard.

This was to be the principal aim of all modern schools intended for artistic and technical training, since, both from the cultural and economic aspect, its realization is of the utmost importance to the State.

What can the State do independently of private initiative to bring the artist into closer contact with the life of the whole population, particularly with the practical industry? The role which it has to play is, indeed, a difficult one. It must exercise the greatest circumspection if it is to prove of assistance in achieving the goal; in fact, the things which it must refrain from doing are often far more decisive than its active interest. Art needs no tutelage; it must be able to develop in complete freedom. The direction of art by public authorities, central supervisory organizations and laws are more likely to destroy creative impulses than to assist them. By its very nature, creative work also cannot be determined in advance; no one knows what direction its originator will take—often he himself does not know, because he creates out of the unconscious. Therefore, the very most that the State and public authorities can do is to concur intelligently in the initiative which comes from the artists themselves, by supporting, benevolently and wholeheartedly, every attempt to stimulate industry and the public, and especially exhibitions. Such exhibitions are the appointed 'Cultural Exchanges' between the artist and industry. At these, not only can ideas, visible to all, be brought to the knowledge of the public in general, but the work of preparing the exhibition itself provides the first line of communication between the designer and manufacturer. During this work each can study the possibilities of the other. The more fundamental and homogeneous the theme of such exhibitions—if possible under the direction of *one* creative mind—the more fruitful the results will be. At the same time, a certain onesidedness can do no harm, and is even necessary for the sake of clearness. Artistic questions can, by their very nature, be decided in each case by the individual alone and not by committees.

We regard keen support of exhibitions on the part of the public authorities as being particularly helpful. Measures of this kind do not, however, go down to the root of the matter. Our century has been so revolutionary, and the conflict between tradition and new technical progress so great, that in the re-

239

organization of the system of artistic training, the State must go deeper if it desires to restore the gifted artist to the sphere of practice. And it is in connection with training that the practical possibility of its active intervention would to a certain degree appear to lie. The predominating question is, how can those gifted with talent be sifted out from the new generation as a whole, as so to enable them to receive effective training? This would mean, in the first place, a general basic training in art for all, starting with the smallest child, followed by *special* training as soon as necessary but as late as possible. We need a new groundwork for all schools, a preliminary artistic training which—differing in degree according to the age of the pupils—would enable them to broaden their vision. The following trade training should as well undergo a certain reformation in its curriculum. It should not implicitly impart merely a knowledge of trades and specialized subjects, but also things which constitute the most essential condition of every kind of creative work, such as spatial perception, power of presentation, knowledge of materials and an understanding of business and industry, and the proper handling of materials and ordinary machines. The 'how' of the training is therefore primarily of greater importance than the 'what'. If manual skill, the understanding for materials and the powers of observation and thought are first properly trained, any specialized training can be absorbed rapidly and without effort. As in the case of all attempts at a reformation, the State will be wise first to concentrate on *one* key-school, in order to determine what influence such a school for specially talented students would be capable of exercising on architecture, industry and handicrafts. For this experiment it should get together the best teachers, give them far-reaching powers and leave them at liberty to discover in actual practice an elastic form of organization, because only in this way can a high level be reached. To maintain this level only a small number of schools of this kind for talented students will be possible even at a later stage, but the tendency of the training accomplished therein will be able to influence other kinds of schools for the artistic and technical professions and render them productive. In our opinion, less importance attaches to the nature of the organization which tradition and local requirements will evolve in these schools, than to a homogeneous fundamental tendency of the training in all schools in the country. This, however, can only be achieved by the gradual recruiting of personalities that the training in these schools for talented students will progressively produce.

Whereas the ideal is to concentrate these schools for talented students at a few centres only, the State should—by extending all the existing instruction in

240

manual skill and drawing—make the general artistic training obligatory in all schools. This would be in keeping with experience gained from Froebel to Montessori and would bring the whole problem a gigantic step nearer to solution.

I. GROUNDWORK FOR THE ART EDUCATION

Principle: Each individual is originally capable of producing spatial forms, but the optical-spatial sense must be early developed.

1st Stage: Créches. Kindergarten.

Modelling, drawing and painting in very free form as play, which is intended to attract the child and stimulate its imagination.

2nd Stage: Elementary Schools. Secondary Schools. Public Schools.

Awakening the creative substance in the growing child. Modelling and simple handicraft instruction for all kinds of materials in conjunction with free training in design. Bipartite but simultaneous instruction in manual skill and form perception. Modelling, building, assembling, free-hand and geometrical drawing and painting throughout the whole duration of the training. No schemes, no specimens, no elimination of the urge to play, i.e. no artistic tutelage. The whole task of the teacher is to keep the child's imagination awake and constantly to stimulate its desire to model and draw.

II. ART TRAINING FOR MORE ADVANCED PUPILS

3rd Stage: State and Local Art and Handicraft Schools. Schools for Apprentices in Industry. Trade and Technical Schools of lower and higher grade, including all kinds of Architectural Schools.

Intensified instruction in design and handicrafts—duration about six months to a year—as obligatory preliminary training with a view to weeding out artistically talented pupils from all schools for training in the special schools. Thereupon division into two courses of professional training, A and B of the fourth stage.

4th Stage: A (for pupils remaining in 3rd-grade schools).

Continuation of trade instruction in same schools, special training in manual skill for the trade selected, work on machines, technical drawing, works technique, costing, etc. Result: Trade workers for industry and handicrafts, industrial and architectural draughtsmen, works technicians, works foremen, handworkers.

241

ART EDUCATION AND STATE

4th Stage: B. School for talented pupils (partly in conjunction with and supplemented by existing special schools for architecture) particularly for pupils possessing artistic talent.

Extensive instructional powers. Comprehensive hand and brain training. Free introduction to independent design in modelling and drawing. Extensive handwork and machine practice. Active training which enables the students to discover results for themselves and opens the way for their creative powers.

Result: Independent architects, sculptors, painters. The men responsible for the experimental and designing work for industry. Art teachers. Independent art handworkers.

The most essential factor in artistic education is the *unity of its entire structure in all stages of development*. It can only grow concentrically, like the annular rings of a tree, embracing the whole from the beginning, and at the same time gradually deepening and extending it. The dividing up of the training into individual sections, carried out separately as regards time and place instead of simultaneously, must destroy its unity. It is the sense of coherence in what he learns, and not the accumulation of organically unconnected scraps of knowledge, which makes the adolescent harmonious, far-sighted and productive. A creative art training such as we have here attempted to outline as an ideal aim would fuse art with technique, and reintegrate the artists into the daily work of the nation.

242

CHOREOGRAPHY
By Léonide Massine

YOUR questions interest me very much. They embrace the main problems of contemporary choreography. Taken collectively, they mean, 'In what direction is choreography heading?' I can answer only for myself, by referring to my own work and my own special way of resolving all the difficulties which every choreographer must face today.

I should like to point out at the beginning, that choreography and the dance are not always one and the same thing. Whereas the dance certainly exists in choreography as an element, choreography as an art is something more than merely a dance. I still think that the classical choreography is one of the monumental bases for all the choreographic creations of today, and will be for a long time in the future, although I do not see why these classical principles should not be enriched by new elements which correspond with the new spirit. I should say that the old classical choreography was more abstract than many of the newer forms of today. I can see a method of producing drama in choreography today without destroying the classical and purely abstract elements of the ballet, and this I try to do as far as possible. Certainly we choreographers are dependent to a large extent upon the human body and the nature of human impulses. We still cannot be so far abstract as to exclude the human body altogether from our art. In most choreography the human body is the first element, but it must be realized that this element can be used in such a way that it does not predominate over the pure choreographical idea; it may be compared with the material of a sculpture or with the colour used in painting.

But we cannot regard choreographic art in the same way as painting or sculpture. Choreography is tightly linked to other kinds of art, for instance, to music and the art of the stage, so that its development tends to be slower and a

243

revolution becomes more difficult. In my use of the human body, I am not so limited as the figurative painter and sculptor is because I think that there are still a certain number of new movements and an unexplored richness in the postures of the human body on the stage. I agree that the human body is a limitation in art generally. I know from my own experience that we often have difficulties in the choreographic composition due to this fact. I try to avoid this evil by projecting the human body further in space than human muscles allow through the multiplication of the number of dancers and the creation of compositions with the chorus. I agree that this is not enough, because this multiplication takes place mainly on the horizontal plane and has, to a certain extent, vertical limits, but I think that a remedy might be found for this limitation.

I do think about and work on the elaboration of a new elemental and universal dance language. This work is very important, and the experience of others who have tried to do it convinces me that such a work must not be done hurriedly.

Certainly I do not see why, in the abstract film, as in a dance movement, there should not be some possibilities for kinetic sensations. But to be honest, I have not yet seen any completely satisfying abstractly designed film. I do not mean that it cannot be done, but it will always be something distinct in itself. It will never be able to replace a choreographical creation on the stage, which is and must always be spatial and conserves the immediate contact with the audience. A dance, I think, must be warm; I mean that literally.

Your questions about dramatic and political expression in the dance can be covered by a single reply. I am not against expression in the dance. A dance may express a certain theme; but this theme must correspond with fundamental human feelings or with psychological problems which concern everybody rather than with political slogans. I think that political tendencies do as much harm to politics as to the dance.

LIGHT PAINTING
By L. Moholy-Nagy

IT is an astonishing fact that, although photography has been in existence for a century and the cinematograph for forty years, although these great industries have been built up in which thousands of pounds are invested, there has never yet been a systematic course of instruction in the use of light. There ought to be an Academy of Light, which would be devoted to teaching and would educate its students to an artistic and economic consciousness of the new creative factor.

The founding of such an academy could be justified on economic grounds alone by reference to the changes in the economic situation, the new forms of appeal to the public—press photos, book illustrations, theatrical lighting, advertising of films and illuminated advertising, to say nothing of the developments the future may bring and all that would be directly born of such a centre devoted to the theoretical and practical study of the uses of light.

On every hand, every day, in spheres of fashion, the films, use of space and in art, we constantly encounter misplaced and misunderstood uses of colour and light. It would only be possible to bring about improvements on a large scale if great numbers of people became clearly awakened to the importance of experiencing colour.

The preliminary condition of such teaching is that the apprehension of colour should be valued as a primary biological law, just as necessary and indispensable for human beings as the fulfilment of other biological functions. The harmonious use of colour is of primary importance as a vitalizing and constructive factor.

All use of colour is dominated by the fundamental law of complementary colours. Every building-up of colour values is based upon our physical perceptions of complementary colour contrasts. Our eyes react automatically to red

245

with the sensation of green, to yellow with blue and so on. Scientific spectrum analysis or Goethe's experiments with coloured shadows clearly demonstrate this.

To be sure, it must be remarked that all use of colour up to the present has shown certain minor variations in the use of the complementary contrasts or, as we might also express it, complementary colour contrasts were not used according to purely physical laws in the historic periods of painting, but according to individual interpretations. Certain colours, particularly broken tones, such as pink and grey, being mainly constructional elements employed by painters, took a very long time to sink into human consciousness. It was not only the religious canons of colour set up in the Middle Ages which were responsible for this, but also the development, step by step, of the power of appreciating and differentiating between shades of colour.

It would be the task of an Academy of Light to examine these questions from the historical, physical, physiological and other points of view and to render the results available to all creators in colour. It looks as if an entirely new colour consciousness were coming into being at the present day. The principal influence comes from the Impressionists, who, as early as seventy-five years ago, were working with great intensity to purify complementary contrasts and render them more objective. They carried out their observation of colours in the open air in all kinds of weather or in the full glare of the sun, in great contrast to their predecessors who had worked only in the light of the studios.

We know that the Impressionists (Manet, Seurat), studied the objectives aimed at by contemporary scientists and technicians and that they divined something of the great problems of the age of industry and the machine. Since that day the problem has become continually more complicated, and today, having given rise to much cause of conflict, it has developed until it has also become part of the artist's problems.

Many of the great conflicts of our age are to no small extent the result of the uncritical acceptance of technical results, which in many cases exceed the results previously achieved by individuals or are, indeed, directly opposed to these. Technical achievement ran rough-shod over humanity through automatic production of all kinds of objects which had hitherto demanded creative thought and individual labour to produce.

Thus the spread of civilization and of the machine brought with it automatized colour results which had not been digested by man and were not subject to his command; and, by means of mass production, they are in command

246

of visual life today. The theatre, the colour film, advertising in light, etc., pro-
duce colour combinations which very often seem to be contrary to all previous
principles of colour, because the light machines, reflectors and lamps produce
purely physical complementary contrasts which have never hitherto been em-
ployed since they show automatic effects of light which have not been passed
through the medium of the human eye.

The great problem put before our generation is to find the balance be-
tween our psycho-physical limitations and the uncontrolled achievements
which proceed without any ordered limits from the machine which we our-
selves have created.

It seems to me that the artistic and scientific work of the twentieth century
shows an instinctive beginning in this direction and that every step farther and
every partial problem solved is of vital importance to the whole further deve-
lopment. An Academy of Light which would raise the intuitive proceedings to
the level of consciousness and make practical and pedagogic use of them
would be the first and most important step towards systematic co-operation
between the scattered forces of art and technics.

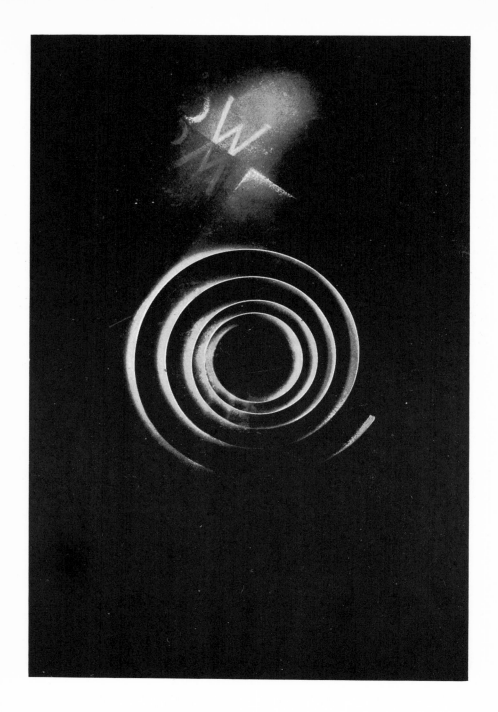

PHOTOGRAM BY MOHOLY-NAGY

NEW TYPOGRAPHY
By Jan Tschichold

THE new typography aims at a clear presentation of typographical images by immaculate technique and by the use of forms which correspond to the new feeling for space. Every deviation from tradition is by no means new typography in our sense of the word. We demand also that the resultant form should be beautiful—thus it would be wrong to designate the new typography as anti-aesthetic. But we consider the use of ornament and rules in the manner of earlier styles as disturbing and contrary to the contemporary spirit. The form should arise clearly and unequivocally out of the requirements of the text and pictures only, and according to the functions of the printed matter. New traditionalism in typography demands exactly the same. Yet in spite of the great austerity and purity of its manner as well as other qualities its products are characterized by a certain sterility because these works proceed from an earlier feeling of space. Even this can exercise a certain charm on the man of today, but it corresponds to the charm that emanates from an *old* work of art. It seems to us that the attempt to create from the contemporary feeling of space is more worth while.

In the technical sense the new typography cannot claim any essential progress. Fundamentally, types are set today as they were 500 years ago. Machine-setting only imitates hand-setting and is hardly in a condition to create anything formally better or even a legitimate form of its own. The potentialities of the modern setting-technique (speaking purely technically) must anyway be regarded as perfect. Our efforts, too, at employing as simple a technique as possible in planning the layout coincides with the methods of the early printers and therefore need not be especially emphasized. The real value of the new typography consists in its efforts towards purification and towards simplicity and clarity of means. From this comes the partiality for beautiful sans such as the Futura and the Gill Sans.

NEW TYPOGRAPHY

We seek to achieve clarity by contrasts. Contrasts as such are not necessarily beautiful. There are beautiful and ugly ones; thus every insertion of bolder types is not good new typography. In general the casual compositor uses everywhere too large and too heavy type; a considerable reduction of sizes of type even makes the reading of the type more agreeable.

The formal problem of the new typography is *the creation of an asymmetrical balance from contrasting elements*, the proportions naturally chosen according to the sense. In books too a contrasting form which nevertheless preserves the unity of the whole in all the multiplicity, should be aimed at.

The diffusion of good new typography is not proceeding everywhere at the same pace—it shares this fate with the other efforts of visual culture. In any case considerable time will elapse before the new potentialities are exhausted. Only new needs which for the time being are still unknown can engender new forms.

EXAMPLES OF TYPOGRAPHY BY JAN TSCHICHOLD pages 252-255

250

TABLE

NEW TRADITIONALISM	NEW TYPOGRAPHY

Common to both

Disappearance of ornament
Attention to careful setting
Attempt at good proportional relations

Differences

NEW TRADITIONALISM	NEW TYPOGRAPHY
Use of harmonious types only, where possible the same	Contrasts by the use of various types
The same thickness of type, bolder type prohibited	Contrasts by the use of bolder type
Related sizes of type	Frequent contrasts by the use of widely differentiated types
Organization from a middle point (symmetry)	Organization without a middle-point (asymmetry)
Tendency towards concentration of all groups	Tendency towards arrangement in isolated groups
Predominant tendency towards a pleasing appearance	Predominant tendency towards lucidity and functionalism
Preference for woodcuts and drawings	Preference for photographs
Tendency towards hand-setting	Tendency towards machine-setting

251

Fünftausend Jahre Schrift

Die Schrift, ihre Entwicklung, Technik und Anwendung

Vorstufen der Schrift, Schriftersatz

Gegenstandsschrift: «Denk»stein (Menhir). Kerbholz. Paß- und Botenstab. Knotenschrift usw.
Zeichnerische Vorstufen: Felszeichnung. Eigentums- und Hausmarke.
Ideenschrift (Piktographie): Bilderschrift der nordamerikanischen Indianer. Gaunerzeichen.

Allgemeiner Entwicklungsgang der Schrift

Von der Wortbilderschrift zur Buchstabenschrift, dargestellt an der ägyptischen «Hieroglyphenschrift».
Ägyptische Hieroglyphen.
Bilderschrift und «Hieroglyphen» der Azteken.
«Hieroglyphen» und Zahlzeichen der Maya.

Technik der Schrift

Plastische Techniken Steinschriften verschiedener Systeme und Kulturen. Werkzeug und Arbeitsproben aus dem besonders für Grabsteine in unserer Gegend gebräuchlichen Steinmaterial, zur Veranschaulichung der Beziehungen zwischen Technik, Material und Form.
Inschriften in Holz; Werkzeug und Arbeitsproben.
Inschriften in Metall; Bronzeinschriften in verschiedener Technik; Gravierung; Eisenguß.
Inschriften auf Geräten aus Metall und keramischem Material.
Ritzschriften. Werkzeuge und Proben der südindischen und singhalesischen Ritzschriften auf Palmblättern, Bambus usw. Frühchinesische Ritzschrift auf Knochen.
Die antike Wachstafelschrift; Werkzeug und Proben.
Farbschriften, unter Berücksichtigung der Zusammenhänge zwischen Beschreibstoff, Werkzeug und Schriftform.
Schriftbeispiele der Battaker. Material: geglättete Baumrinde. Werkzeug: Schreibstöckchen, das schnurartige Gleichzüge ergibt.

4

Schrift der Ägypter; Material: Papyrus. Werkzeug: am Ende zerfaserter Pflanzenstengel, der etwas differenziertere Züge ergibt. Ähnlich: griechische Papyrusschriften.

Pinselschrift der Ostasiaten (China und Japan). Material: Papier. Werkzeug: Haarpinsel, chinesische Tusche. Japanischer Schreibkasten. Chinesische und japanische Schriftstücke.

Breitfederschriften der Griechen, der islamischen Völker, der Hebräer (hebräische Quadratschrift) und des mittelalterlichen Abendlandes. Material: Papyrus, Pergament, Papier. Werkzeug: Holzspatel oder Rohrfeder, mit mehr oder weniger breitem, schräg zugeschnittenem Schreibende, das wechselnd schmale und breite Züge ergibt (Wechselzüge).

Die allmähliche Verfeinerung dieser Schreibtechnik wird am Beispiel der arabischen Schrift dargestellt: am Anfang die breiten, aus senkrechten und wagrechten bestehenden Bandzüge des kufischen Duktus (9. Jahrhundert), später die feineren und eleganteren Bandzüge der Nes'chi- und Talik-Schrift (seit dem 13. Jahrhundert).

Kielfederschriften vom 15. bis zum 18. Jahrhundert. Zusammenhang zwischen dem elastischen Werkzeug und der kurrenten Schriftform.

Stahlfederschrift des 19. Jahrhunderts in Nachahmung der lithographischen Schriften.
Die heutige Füllfederschrift.

Die Vervielfältigungstechniken: Stempel, Holztafeldruck, Letterndruck, das Durchschreiben, der Schreibmaschinendurchschlag. Die lithographische Schriftgravüre. Lichtsatz.

Die Entwicklungsstufen der wichtigsten abendländischen Schriftformen

Die griechische Steinschrift.
Die römische Steinschrift (Kapitale).
Die Kapitalschrift als Buchschrift der Spätantike (etwa 2. bis 5. Jahrhundert).
Die Rustika der römischen Steinschrift.
Die lateinische und die griechische Unziale in der christlichen Spätantike und im frühen Mittelalter (5. bis 8. Jahrhundert).

5

kunstmuseum luzern 24. februar bis 31. märz 1935

these
antithese
synthese

arp
braque
calder
chirico
derain
erni
ernst
fernandez
giacometti
gonzalez
gris
hélion
kandinsky
klee
léger
miró
mondrian
nicholson
paalen
ozenfant
picasso
täuber-arp

Gewerbemuseum Basel

Ausstellung

Fünftausend Jahre Schrift

Die Schrift, ihre Entwicklung, Technik und Anwendung

14. Juni bis 19. Juli 1936

A NOTE ON BIOTECHNICS
By Karel Honzík *(English Version by P. Morton Shand)*

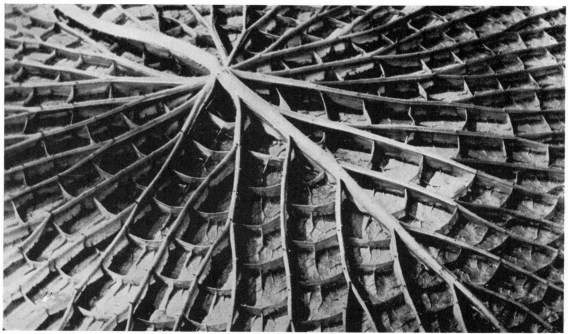

1. THE REVERSE OF THE LEAF OF THE VICTORIA REGIA, PHOTOGRAPH by KAREL HONZÍK

ALMOST every year the illustrated papers publish photographs of Victoria Regia water-lilies* in full blossom, with their yard-long, platter-like leaves

*This South American water-lily was first discovered in the eighteen-thirties, and was named after Queen Victoria. It created a great sensation in the botanical world, firing the leading horticulturists of England with the ambition to be the first to have grown it successfully in Europe. The Duke of Devonshire and his head gardener, who was afterwards known to fame as Sir Joseph Paxton, were equally excited about it and equally determined to win that

256

floating languidly on the surface of their hot-house tanks. Few who glance at these pages realize that those thin leaves can support a large dog or a young child as on a raft. But the engineer who examines their under side is astonished to find that they might serve as scale models of reinforced-concrete roof-spans. For here the monolithic system of columns supporting radiating beams with slab decking between them was fully embodied æons before François Hennebique first worked it out. In the same way the parts of these leaf-beams where the tension is most pronounced are reinforced with haunches to increase their sheer value.

Biology is already familiar with a variety of natural organic forms that closely resemble forms that have been devised by man. It was Ozenfant, I believe, who said that if Nature had had to produce a bottle she would have evolved one closely resembling a bottle as we know it. In this connection he might have referred to the Samura tree that grows in the desert parts of Argentina. The trunk of this tree looks like a Chianti flask, and it is a real bottle, for in it is stored the supply of water needed for the branches and leaves during periods of drought.

Thus there are clearly two branches of technology in constant process of evolution, one human and the other phytogenical, which being mutually ignorant of one another yet attain the same ends. It is therefore rather tempting to presume that every problem on which an engineer or architect may be engaged has its solution in natural laws which inexorably inform his invention, and even his calculations and drawings. A whole series of phenomena corroborates the assumption that the interplay of certain natural forces with various kinds of matter finds its equipoise in constantly recurring forms.

A surface subject to pressure must be supported in one direction, and eventually, if the minimum quantity of matter is to be used, it must be sup-

coveted distinction. Victoria Regia obstinately refused to flower at Kew, but shot out 140 leaves and 112 blooms in rapid succession at Chatsworth. This flattering acclimatization of a tropical plant, whose 5-6 ft. diameter leaves can support a loading strain of 100 lbs. without sinking, compelled Paxton to build a new home for it in double-quick time. The construction of its new hot-house, which had a 33-ft. diameter tank and a 61 ft. by 49 ft. ridge-and-furrow roof, embodied the structural principles of the lily's foliage, as did all Paxton's subsequent greenhouses. In explaining his plans for the Great Exhibition Building of 1851 (the Crystal Palace) to the Fine Arts Society, many years later, Paxton held up a leaf of the Victoria Regia, and pointing to the 2 in. deep ribs radiating from its centre like bottom-flanged cantilevers, and the delicate system of cross-bracing fibres that prevents the webbed membranes between them buckling, he modestly remarked: 'Nature was the engineer, providing the leaf with longitudinal and transverse girders and supports that I, borrowing from it, have adopted in this building.'

ported in the other direction as well. This is inevitable, for there is no way of avoiding it. The resultant form is one of the most constant in nature. It is a shaping by natural forces at which man arrives by intuition, experience and calculation, and a plant by its own tropism.

Internal and external forces are also shaping dead matter that is being discarded and replaced, and it is not difficult to find an analogy to this process in human products. See how sand will slide down to settle at a slope of 34-37 degrees, and try to make a pyramid, which is its natural form at rest, its expression of equilibrium between the conflicting forces of gravitation and friction among its component grains. The cone, the pyramid, parallel lines, the plane and the globe are all of them 'constants' of Nature's technique and organization. Living and dead matter seems to follow a single impulse, displacing and reorganizing itself, or growing, with the object of attaining equilibrium, under the direct influence of internal and external forces. Nature seeks that ideal state of equilibrium, or rest, in the balance of these forces, and the moment she succeeds in this she ceases to be formless and assumes a characteristic shape as in flowers, crystals and other organisms that are the expression of the forces that mould them. We are told that everything on earth is changing and so moving, but an equally universal law governs their movement: the seeking of a state of rest or harmony, crystallization or maturity. The shape in which matter finds its balance of strength is its perfection: a solution of its own problem in terms of such consummate economy that there is no superfluity, nothing left over. If we add to, or take something from, that perfection, the shape loses its equipoise, its characteristic appearance, and has to start in quest of both afresh.

So, too, human products and structures develop through the will and intention of man and move towards their intrinsic perfection. They seek a final form that can only be spoiled deliberately by the emergence of new conditions. For instance, the best possible shape of chair can be superseded by a new form, arbitrarily invented for the purpose. But that new and arbitrary shape will soon disappear just because it is not the perfect one. Or if humanity were willing to start sitting in a new position the perfect shape of chair would have to be modified accordingly.

A man who is able to foresee all the various forces which a given building will be exposed to should be able to attain perfection because, by the nature of things, he is likely to avoid all transient and merely fashionable influences. But such an achievement, being a rare exception, belongs to the highest order of

258

creative work. Perfection is far more often approached by groping after it generation by generation; by virtue of intuition; or by the combined experience and reasoning of hundreds of different men. It is for this reason that the masterpieces of architecture are the expression and achievement of whole nations, certain epochs or phases of society; and that their purely personal significance fades into the background.

This abstract perfection of form is, of course, veiled by a whole sequence of different semblances, and exists only as an ideal. We have to presume that our own work is subject to errors, and that our technique is very imperfect compared to Nature's. But even in Nature a perfect co-ordination of form and purpose can seldom be found, Examples such as the beams of the Victoria Regia water-lily and the column of the bamboo are rare. Some investigators in the field of biotechnics, like the German professor, Raoul France, have recourse to arbitrary explanations as to what was Nature's practical intention in evolving this, that and the other shape. But they cannot hope to explain the existence of hundreds and hundreds of variants among plants and animals of a single type. Why, for instance, should there be 6,000 varieties of the unicellular Diatomaceae although they live under identical conditions? Which of all these thousands represents its perfect form? On the contrary, this infinite variety and multiplicity may lead us to doubt that single general law. In *The Intelligence of Flowers*, Maeterlinck has described very beautifully their dramatic struggle for shape, revealing secrets of Nature's workshop which are so intricate that they can only be fathomed by living in the closest contact with plants and as the fruit of prolonged observation. He gives us examples of trial and error and the evolution of properties by experiment that read like the deductive work of modern laboratories. He follows the growth and function of flowers, and that inventive activity of theirs while they are *still* striving to achieve their purpose. The correlation of form and function, and that isochronous coincidence of the two which so rarely appears in the works either of Nature or of Man, is a field for research still waiting to be explored. Among the many instances which Rémy de Goncourt cites of how form tends to outlive function is the stagbeetle, whose claws have now become a useless ornament. These may have been provided as a means of defence against an extinct enemy of which we know nothing. The persistence of form! Do we not know the force of this truism in every walk of life? From time to time we succeed in shaking off old forms that have become so much ballast or dead lumber. And yet at the same time we revolt against the new shapes that appear because they announce the form of a

2. A DETAIL OF THE LEAF OF THE VICTORIA REGIA, photograph by KAREL HONZÍK

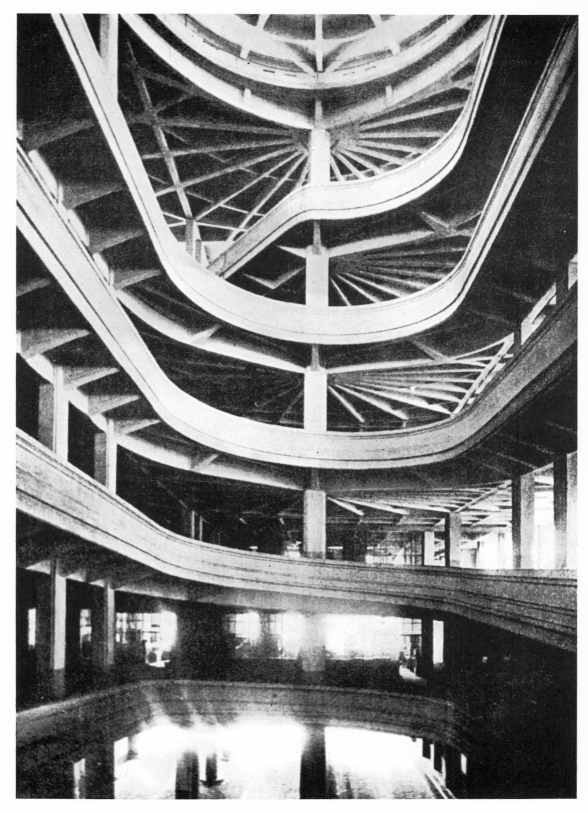

3. CONCRETE CONSTRUCTION IN THE FIAT FACTORY AT TORINA
Compare with the construction of the Victoria Regia

new content. It seems as though form preceded function, or anyhow outlived it. Between them there is a continual oscillation, as between the two scales in a balance; and we feel, or seem to divine, that both aspire to an ideal permanence of equilibrium in which their separate identities would henceforth be fused. Perhaps one day we shall discover the explanation of this separability of form and function which makes us so uneasy in the work of men's hands. The anticipation of a form, or its survival, is a fact that is apt to blind us to the object, the mission, of the form itself—which is something that can only be appraised with difficulty, between, rather than from, its lines, or slowly gleaned from a study of its tropisms, its instincts, its craving for an ideal perfection expressed in the harmony of an ultimate balance.

THE DEATH OF THE MONUMENT
By Lewis Mumford

THE human impulse to create everlasting monuments springs perhaps out of the desire for the living to perpetuate themselves. To achieve this in terms of biology only one means is possible: organic reproduction, and all the classic civilizations, above all the most enduring of these, that of the Chinese, have regarded the begetting of children as a sacred duty as well as a blessing. Renewal through reproduction is one means of ensuring continuity: but there is still another, springing not out of life but out of death: to wall out life and to exclude the action of time by carving monuments in durable materials: the primitive burial mounds, the big stones of the Salisbury plains and of Brittany, the pyramids and sphinxes of Egypt, the ironic gestures of Sargon and Ozymandias and the Pharaohs, of Louis XIV and Peter the Great.

Ordinary men must be content to fix their image in their children: retrospectively they may seek to ensure immortality by imposing the cult of the ancestor. But the rich and the powerful do not have trust in the powers of renewal: they seek a more static immortality: they write their boasts upon tombstones, they incorporate their deeds as well as their astronomical lore in obelisks: they place their hopes of remembrance upon stone joined to stone, dedicated to their subjects and heirs forever: forgetful of the fact that stones which are deserted by life are even more helpless than life that is unprotected by stones.

In general, one may say that the classic civilizations of the world, up to our own, have been oriented toward death and toward fixity: a Heraclitus might observe that all things flow, a Lucretius might see that man is a part of the eternally changing cycle of nature: but the aim of the civilization was permanence and fixity: the dead hand felt frustrated unless it could keep within its rigid grasp the fate of the living. Men die; the building goes on: the burial

ground encroaches upon the city, and the city, with its dead buildings, its life-less masses of stone, becomes a burial ground.

So long as men are oriented toward death, the monument has a meaning: no sacrifice is too great to produce it. Just as a poor religious family today will spend half a year's income to celebrate fitly the death of one of its members, money that it would find it impossible to spare to make possible the birth or education of a child, so the civilizations of the past sacrificed their life and their income and their vital energy to the monument. The pastoral nomad alone spared himself that sacrifice, until he copied the ways of men in cities: he travelled light. Civilization today, for different reasons, must follow the example of the nomad. For the most radical change in our modern cosmos has come about through our changed conception of death and immortality: for us, death is an episode in life's renewal, the terminus of a radical maladaptation: continuity for us exists, not in the individual soul, but in the germ plasm and in the social heritage, through which we are united to all mankind and all nature: renewal comes in the sacrifice of the parent to the child, in the having lived to the living and the yet-to-live. Instead of being oriented toward death and fixity, we are oriented toward life and change: every stone has become ironic to us for we know that it, too, is in process of change, like the 'everlasting' mountains: time is a bomb that will split the most august temple open, if the wanton savagery of men's swifter bombs does not anticipate time.

The patterns and forms of past ages die slowly: the idea of survival has persisted despite the challenge of our modern world pictures: but the notion of material survival by means of the monument no longer represents the deeper impulses of our civilization. Indeed, one has only to behold the monuments that have been built during the last century to observe how hollow the notion is. These Valhallas and Lincoln Memorials, these Victor Emanuel Monuments and Vimy Ridge Memorials, these 'Eternal Lights' which go out when the electric power station breaks down or the bulbs blow out—how many buildings that pretend to the august and the monumental have a touch of the modern spirit in them: they are all the hollow echoes of an expiring breath, rattling ironically in the busy streets of our cities: heaps of stone which either confound the work of the living, like the grand but over-crowded and confused Public Library in New York, or which are completely irrelevant to the living. The very notion of a modern monument is a contradiction in terms: if it is a monument, it cannot be modern, and if it is modern, it cannot be a monument.

This is not to say that a hospital or a power station or an air beacon may

264

not be treated as a memorial to a person or an event: nor is it to deny that a contemporary building might easily last two hundred years, or even two thousand years: that is not the point. What will make the hospital or air beacon a good memorial is the fact that it has been designed for the succour of those who are ill, or for the guidance of men piloting airplanes: not that it has taken form out of a metaphysical belief in fixity and immortality and in the positive celebration of death.

Here one must note a vast change in ideology: a real split. In most civilizations the activities of the living are not real unless they can be transposed into terms of death: in our civilization death is meaningless unless it can be transposed into terms of the living. In Christian culture life was a preparation for death, that is, for after life: in our emerging civilization, death is a making way for life, and all the fixed and memorial processes, the written record, the painting, the sculptured stone, the photograph, the recorded voice, are offerings to the living—to be accepted, not out of a duty to the dead, but out of a loyalty to other remoter generations capable of deriving life from them, even if closer ones cannot.

The death of the monument has been intuitively forecast by more than one spirit during the last century; for the fact is that it has implications that go beyond the conception of individual tombs, memorials, or public buildings: it affects the character of our civilization and the design of the city as a whole. Why should each generation go on living in the quarters that were built by its ancestors, in quarters many of which are stale and dirty, most of them planned for other uses and other modes of life, a good part of them mere makeshifts even for the purposes for which they were originally intended? It was Nathaniel Hawthorne who asked this question: he put it into the mouth of the young photographer in the *House of the Seven Gables* and repeated it elsewhere; and it is only now perhaps that one can see its full significance. Our cities, planned as monuments, made of permanent materials, with heavy capital investments, duly incorporated under capitalism in the existing mortgages and land values, are incapable of adjustment to fresh needs and fresh demands; and what is true for the city as a whole is true likewise of its individual houses.

We have created for the community as a whole physical shells, when what we need is not so much shells as organic bodies capable of circulation and renewal in every part of their tissues. The protective function of the city, tendencies toward fixities and permanence of function, have been overdone: for a living creature the only real protection and permanence comes through growth

265

and renewal and reproduction: processes which are precisely the opposite of petrifaction. Mr Clarence Stein has explained the rich architectural tradition of the Balinese as due in part to the fact that they use an exceedingly impermanent volcanic stone which lasts only about fifteen years: hence they have to renew their buildings frequently and recarve the stone, and this continued demand for art keeps alive and active a tradition in the building and the decorative arts. The glass and the synthetic materials used in our modern buildings are valid symbols of this new attitude toward life: the avoidance of encrustation, the creation of an environment that shall be a product of the living and be responsive to their demands. It would be of course a foolish waste purposely, to design buildings which would collapse in fifteen years, so that they could be renewed: a perversion just as foolish as the modern one of fashioning a motor car to go out of style in five years in order merely to increase the demand for production and profit: but it is wisdom to design buildings in such materials and in such a fashion that they may be easily renewed and made over.

This in fact is the greatest justification of the steel-framed structure, in which the internal frame can be made more strong than the outer shell, and in which the internal arrangements can be completely recast, by a flexible system of partitions. Mies van der Rohe has made an essay in this type of construction in an apartment house; the late Mr Raymond Hood, with less fertility of invention and less adroitness of design, made similar plans on paper. Mr Clarence Stein has created the flexible interior of a museum encased in glass. The fact is that modern architecture, based upon modules of construction, has yet to incorporate effectively in its building the great principles of flexibility—as well as cleanness—already achieved in the Japanese dwelling-house. Even in the dwelling-house, even in the business office, the architect still labours under the ancient shadow of the obsolete monument: he has still to utilize modern technics and the modern world picture in creating his designs.

Does this mean that the modern city is to be renewed every generation? Does this mean that the city is no longer to be an accretion of the memorials of the past, in which the needs of the living are narrowly fitted in between ancient landmarks, whose value no longer lies in direct service, but in sentiments and piety? Yes to the first question, no to the second. The accretion of the past, the very mark of the historic city, with its successive stratifications of spirit, may well remain: but the preservation of the works of the past is not to be left to chance and accident; nor will the surviving memorial itself be endangered and diminished by being made over—now with a system of gas lighting, now with

266

a toilet, now with a 'restoration' in the barbarous manner of the Victorian restorers. On the contrary, if the city is to escape being a museum, what belongs to the past must either be put into a museum or be transformed as a whole into a museum—set aside; put to the special uses of education *but no longer lived in.*

The very value of the art museum and the museum of social history lies in this act of detachment. By confining the function of preservation to the museum, it releases space in the rest of the city for the fresh uses of life. Where the fragments of a local culture are to be preserved, the best means of effecting this is perhaps by the use of a local building, such as the Taft Museum in Cincinnati, the Behn Haus and the St. Annen Kloster in Lubeck, and the Historical Museum in Edinburgh. The museum gives us a means of coping with the past, of having intercourse with other periods and other modes of life, without confining our own activities to the mould created by the past. Starting itself as a chance accumulation of relics, with no more rhyme or reason than the city itself, the museum at last presents itself to use as a means of selectively preserving the memorials of culture: here at last is a real escape for the monument. What cannot be kept in existence in material form, we may now measure, photograph in still and in moving pictures, and summarize in books and papers: we may— and should—do this at a time when the life is still present, so that we shall have, filed away for future reference, not merely an image of the shell, but a working knowledge of the physiology of the building or the work of art.

As far as works of pure art go, this detachment may become complete: what makes a work of art eternal in the human sense is not what it carries over in the setting of its own generation, but what it signifies against the background of our own experience. It follows that while the social museum must necessarily seek to preserve the background, the museum of art properly speaking should forego any such attempt: one does not need a mediaeval house to appreciate a picture by Roger van der Weyden or Breughel the Elder, nor does one need a French salon to find sensual pleasure in a Fragonard or sober respect in a Chardin: indeed, the more complete the detachment, the more effectively we can screen a symbol from what it meant to another generation, the more specific and final is our own response. For a work of art is not a monument: if it has life at all, it exists as a contemporary fact: a museum, properly designed, with ample facilities for storage and preservation as well as for show, serves to enlarge the circle of contemporary experience. But our intercourse with the past is selective: it cannot be otherwise. The encyclopaedic culture of the metropolis,

267

which attempts to preserve everything and to show everything, which mistakes acquisition for appreciation, and a knowledge of names and incidents for an aesthetic intuition, had turned the museum into another metropolis, creating purposeless congestion, and complete intellectual bewilderment. On the mere laws of chance, something of value must accumulate in this débris, by mere reason of its extent: but in the new museum, designed on a less acquisitive pattern, each generation should have the opportunity to be in control of the past—with no duties toward it except that of living in the spirit.

The principles of flexibility and adaptation have another side: our distrust for the monumental does not merely apply to actual tombs and memorials; it must apply even more to the physical apparatus of city life, in particular, to its mechanical equipment. These, too, are capable of taking on a monumental character; indeed the Roman roads and aqueducts and sewers have survived at least as well as the Tomb of Hadrian and the Arch of Constantine. The more the energies of a community become immobilized in such material structures, the less ready is it to adjust itself to new emergencies. A two-storey building, with small foundations, may be easily torn down, if a different type of structure or the widening of a street to accommodate a new type of traffic proves necessary. But a twenty-storey building has a deeper foundation and a more elaborate superstructure; it is served by a greater variety of expensive mechanical utilities, such as elevators: it is not easily removed: moreover the water mains and sewers and wired connections that serve such a building are all correspondingly large and expensive: one does not readily tear such a structure down; and above all, one does not tear it down when it is to be replaced by a smaller building, or no building at all.

It follows that every temptation to elaborate the mechanical shell should be counterbalanced, under a biotechnic régime, by the impulse to travel light: to reduce mechanical equipment to the minimum, instead of permitting it to expand: to refine it, to adapt it more exquisitely to human ends: but not to permit it to dominate. The wholesale investment in electric street railways in the eighteen-nineties certainly retarded the development of automobile transportation: it is very easily possible that our present investments in sewage disposal systems, including special treatment stations and sewage farms, may retard the introduction of some simple apparatus which will liquefy and transform sewage locally, at a point before it leaves the premises. The economy of travelling light consists not merely in a lower capital outlay and a lower overhead: its value comes also in the greater readiness to meet change. Small cities

268

THE DEATH OF THE MONUMENT

where people continued to cycle to work, instead of using street cars, were better prepared to take advantage of motor transportation than large cities that had invested heavily in trolley systems, elevateds and subways.

The deflation of our mechanical monuments is no less imperative than the deflation of symbolic monuments: the biotechnic age, surely, will be marked by a simplification of mechanical utilities: a simplification which is made possible by the limitation of city growth and by the orderly relation of the functions of a city so as to permit a minimum expenditure upon the mechanical means of living. So a well-planned city will be oriented as a whole for sunlight and prevailing winds: the architecture, in turn, will be adapted to the special climatic conditions, even to such an extent that special sun-reflectors may be used as auxiliary heaters in the cold months. This will do away with the need for overcoming the effects of bad planning and orientation by means of expensive air-conditioning apparatus—just as the development of better insulating materials than the plaster wall and the brick or stone exterior and the single glass window will permit the use once more of simple forms of radiant heating.

Our present overload of mechanical utilities in the dwelling-house and the city, particularly conspicuous in American metropolises, is a symptom of our inability to think in terms of the total reality: when we utilize our available knowledge of geography and climatology, of the strength of materials and the properties of insulation, a good part of our mechanical substitutes are superfluous. But the fact is that the so-called Machine Age has treated machinery as ornaments: it has retained the vacuum cleaner, when it should have done away with the rug; it has retained the steam-heater to produce sub-tropical heat in the dwelling-house, when it should have invented a permanent form of insulation which would have done away with the extravagant heating of cold walls; it has retained the private garage as an ornament to the private free-standing dwelling-house—effectively spoiling its immediate open space—when it should have used the art of community planning to group both houses and garages in such a way as to create a livable environment.

If the machine were not an ornament, if it did not symbolically express a quality of futile contemporary desire, almost our contemporary religion, such perversions of energy could not be explained. It only remains to note that this is a bastard religion: half its achievements mock the very mechanical and scientific principles it seeks to enthrone. As a monument, the machine is subject to the same ironic deflation that applies to all other attempts to wall out life: indeed, the first condition of our survival in cities is that we shall be *free* to

269

live, free to apply the lessons of biology, physiology and psychology to our use of the whole environment. In the past, what have been called the triumphs of civilization have turned out too frequently to be the studious collection of encumbrances which finally stifle the possibilities of adaptation, movement and effective improvement, and lead to its ultimate downfall.

APPENDIX

THE WORK OF THE C.I.A.M.
(Congrès Internationaux d'Architecture Modernè)
By Siegfried Giedion

As one who is in close contact with the daily work of the Congresses and who has helped to organize them from their inception, I regard it as particularly important to inform the public about the details of this work and about the benefits which each contributor derives from contact with it.

The character of this work is quite simple: our road was marked out by the Manifesto of La Sarraz (25th-29th June, 1928). This we have been able to follow, without deviation, down to the present day. Indeed we are now even touching the nerve of the problem of urbanization which was set out then in all its implications under the title 'L'Urbanisme et l'organisation des fonctions de la vie collective'.

A few months later, there took place in Basle (2nd February, 1929) the first delegates' meeting, which settled in detail the subjects and proceedings of the Congresses. On this occasion methods of work were determined: these methods were first applied to the problem of 'The subsistence minimum dwelling' at the Frankfurt-a-M. Congress (24th-29th October, 1929).

The procedure is as follows: the subject is decided, and all the national groups then work on the problem, following the same principles, the same methods, and using the same kind of data. The direction of the Congresses, C.I.R.P.A.C. (Comité International pour la réalisation des problèmes d'architecture contemporains) establishes the method. Each group receives a completely worked-out example to follow in principle. The object is to ensure an easy survey and a rapid comparison of the entire subject matter.

At the Congresses, this uniformly treated material is exhibited on large screens and serves as the basis for the proceedings. The national groups can, at

272

a later date, obtain this material for exhibition and propaganda purposes (unfortunately neither England nor U.S.A. has as yet arranged such an Exhibition).* Subsequently the material is also published. 'The dwelling for the subsistence minimum' which formed the theme of the second congress has already appeared in three editions. We have also found that our treatment and method of exposition have been used very extensively.

As was mentioned in the preface to the published results of the third Congress (Brussels, 27th-29th November, 1930), these International Congresses aim at planning out the main lines of future development by means of something which has hitherto appeared impossible, that is, a collaboration of all productive forces. This plan is not to be based on emotion but is to have its roots in realities. A knowledge of contemporary conditions and of contemporary facts is necessary; only with the aid of these things can we assume the responsibility of setting up general directives.

The third Congress, which dealt with 'Rational Methods of Siting', attempted to examine different types of lay-out (low buildings, free grouping, north-south exposure, east-west exposure, buildings of medium height, high buildings, medium height and high buildings combined, historical examples) and to examine their relative effectiveness.

It is a big step from the rational division of the site to the examination of the whole town, and the necessary research requires an enormous expenditure of time and personal sacrifice. But C.I.A.M. ventured for the first time to take this step of expounding in a uniform manner an analysis of thirty-three towns from various parts of the world in order to be able to compare their structure. Only the feeblest beginnings for such a survey existed: the work should have been the task of an international institute rather than that of a few architects from eighteen different countries who were prepared to work in a disinterested way. But these architects will not have regretted their work: they have learnt—more than others—to know the structure and organism of their own towns. It took three years to collect all the material. The general principles were supplied by van Eesteren and the Dutch group using Amsterdam as their example. The fourth Congress, 'The Functional Town' with this material as its basis, was to have taken place in Moscow but was postponed two months before its opening date, and actually matured on board the *Patris* dur-

*As this article goes to press, the English group of modern architects, M.A.R.S. (Modern Architectural Research), announces its first large scale exhibition which will take place in the New Burlington Galleries in October 1937.—ED.

273

ing the passage from Marseilles to Athens and back (29th July to 10th August, 1933).

The previous Congress methods of illustrations on screens and a published commentary could not be applied to the problem of the 'Functional Town'. The technical difficulty alone was great; towns as different as Los Angeles, Berlin, Zurich or Dessau obviously were difficult to illustrate in drawings to the same scale and to reproduce in one and the same publication. The organism of a town actually requires a much more elaborate treatment than is possible by the simple reproduction of plans. These necessary changes of method explain why the first publication dealing with the comparative town structures could not appear as rapidly as those of previous congresses. A further reason is the indifference with which C.I.A.M. has been received by the authorities; C.I.A.M. has received financial support from Swiss sources. It is now time for other countries, too, to raise funds and to facilitate this work, particularly in England and America, where the problems with which C.I.A.M. is concerned have recently been taken up.

International Collaboration. Nothing is more difficult today than international collaboration. At Congresses where each member puts forward his own experience within a special sphere of work, understanding is not difficult. Each one speaks about his own affairs: the others do or do not listen. But C.I.A.M. tries as far as possible to eliminate personal work. The concern of the work of the Congresses is with problems which the individual cannot solve by himself. Only this can lead to directives which are generally valid.

Each one of us has to pass through a difficult apprenticeship before it is possible to adapt one to the other all the different cultures with all their common conceptions of architectural questions. But in attempting this each one has extended and deepened his own understanding.

Language is still a barrier. The Middle Ages, under the supremacy of the Church, had Latin as a means of universal understanding. We have twice applied to the Institut de Corporation Intellectuelle at Paris to demand that the same technical and artistic language should be taught in the schools of all countries, first from La Sarraz (1928) and second from on board the *Patris* (13th August, 1933), both times on the initiative of Le Corbusier and both times in vain.

The CIRPAC Meeting at La Sarraz, 9th to 11th September, 1926. Eight years after its foundation, Madame de Mandrot put the Château La Sarraz once again at the disposal of C.I.A.M. The Congresses form an organism which can

274

only live if everyone who participates is actively collaborating. The direction of C.I.A.M. has constantly asked itself the question, 'How can it be ensured that none of the participants remains unoccupied?' The Congress cannot carry any passengers; every individual contribution is needed.

In the autumn of 1936 at La Sarraz, the first consistent attempt was made to concentrate the work into small commissions. It was put this way in the letter of invitation: 'Experience has shown that full meetings are not very effective, they are therefore reduced to a minimum. The real work must be done in commissions. The national groups will keep in touch with the chairmen of the commissions and in this way closer contact and better results may be achieved.'

The expectation was fulfilled, the amount of work done was increased in an astonishing degree, since every participant now shared in the responsibility. Discussions could with a few exceptions be carried out within single commissions: nine of these were working simultaneously and thus results were achieved much more quickly. Particularly in dealing with difficult questions, such as the editing of the volume *The Functional Town*, which brought out differences in the conceptions of northern and western countries, a discussion on method proved particularly fruitful and penetrating for all participants.

Everyone who attended at La Sarraz felt the friendly atmosphere which common work created. A young Belgian member who attended for the first time expressed it as follows: 'The sympathy, cordiality and mutual understanding of all the participants, the interest of the topics and the enthusiasm with which they are discussed all combine to make these meetings into splendid opportunities for refreshing the mind, removed as they are from the quarrels which shake Europe and from the petty conflicts of nations, races and languages.'

The usefulness of the Congresses cannot be expressed in a quantitative way. Each one of us needs this contact, especially at the present time, if his work is not to ossify or to degenerate into dead routine. Equally important for an objective advance is the human contact and the intangible strengthening of individual contributions through the atmosphere which the Congress creates.

At the CIRPAC meeting at La Sarraz in 1936 the continuation of the publication *The Functional Town* and the arrangement of further Congresses were dealt with. The problem of 'The Functional Town' is to be dealt with by two different methods; first, by means of a 'popular' publication which is being prepared by the French and Catalan groups, and, second, in a 'large and scientific' publication with reproductions of the available material, revised reports

275

Work by the 'Praesens' and 'U' group (Warsaw, Poland) for the fifth Congress (C.I.A.M.).
The illustrations are from Warsava Funcjonalna by Jan Chmielewski and Szymon Syrkus.

1. The great transcontinental line of communication (Europe-Asia).

2. The great inter-maritime communication (Baltic-Black Sea), in relation to No. 1.

3. Local deformation of the transcontinental lines of communication in Central Poland.

4. Chart of the land formation in the Warsaw region.

5. Scheme to show the principal directions of communications in the Warsaw region,

6. The functional arrangements of land area constituting the 'Parados' of greater Warsaw.

7. Scheme of housing zones in the extension of greater Warsaw.

8. Points of intersection of housing zones.

9. Scheme of total urbanization of greater Warsaw.

10. Scheme of districts in which urbanization is actually urgent.

11. Existing chaos in the region of Warsaw.

12. The theoretical scheme adapted to existing conditions—lines of communication in the Warsaw region.

and plans and easily comparable analyses of towns, which the Dutch group is preparing.

The programme of the fifth Congress includes regional planning, town planning and clearance, etc. It is now no longer a question of analysis but of practical proposals for special cases. At the Amsterdam meeting of CIRPAC in June 1936 it was decided to treat these three topics so that they shall be closely related to each other.

EXHIBITIONS

'THESE, ANTITHESE, SYNTHESE'—KUNSTHALLE, LUZERN, 1935

Arp, Braque, Calder, Chirico, Derain, Erni, Ernst, Fernandez, Giacometti, Gonzalez, Gris, Hélion, Kandinsky, Klee, Léger, Miró, Mondrian, Nicholson, Paalen, Ozenfant, Picasso, Täuber-Arp.

'CUBISM & ABSTRACT ART'—MUSEUM OF MODERN ART, NEW YORK, 1936

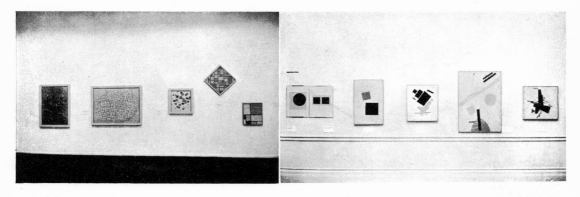

Painting and Sculpture—Archipenko, Arp, Balla, Belling, Boccioni, Brancusi, Braque, Calder, Carrà, Cézanne, Chirico, Delaunay, Derain, Doesburg, Domela, Duchamp, Duchamp-Villon, Ernst, Feininger, Gabo, Gauguin, Giacometti, Gleizes, Van Gogh, Gonzalez, Gris, Hélion, Kandinsky, Klee, Kupka, La Fresnaye, Larionov, Laurens, Le Corbusier, Léger, Lewis, Lipchitz, Lissitzky, Malevich, Marc, Marcoussis, Matisse, Miró, Moholy-Nagy, Mondrian, Moore, Nicholson, Ozenfant, Pevsner, Picabia, Picasso, Piranesi, Redon, Rodchenko, Rousseau, Russolo, Schwitters, Seurat, Severini, Tanguy, Tatlin, Vantongerloo, Villon.

EXHIBITIONS

Photography—Brugière, Moholy-Nagy, Ray.

Architecture—Doesburg, van Eesteren, Gropius, Le Corbusier, Leusden, Lissitzky, Lubetkin, Mendelssohn, Mies van der Rohe, Oud, Rietveld, Sant'elia, Tatlin.

Furniture—Breuer, Chareau, Hartwig, Kiesler, Le Corbusier, Léger, Lurcat, Picasso, Ray, Rietveld.

Typography and Posters—Bayer, Cassandre, Doesburg, Ehmke, Gan, Gispen, Humener, Klusis, Lebedeff, Leistekow, Lissitzky, McKnight-Kauffer, Moholy-Nagy, Muller, Nockur, Rodchenko, Schmidt, Stenberg, Sterenberg, Tschichold.

Theatre—Exter, Gamrekeli, Goncharova, Jakulov, Kiesler, Larionov, Léger, Nivinski, Picasso, Popova, Prampolini, Schlemmer, von Trapp, Stepanova, Tatlin.

Films—Eggeling, Richter, Léger, Ray, Exter, Reimann.

'ABSTRACT AND CONCRETE'—LEFEVRE GALLERY, LONDON; LIVERPOOL; OXFORD; CAMBRIDGE. 1936

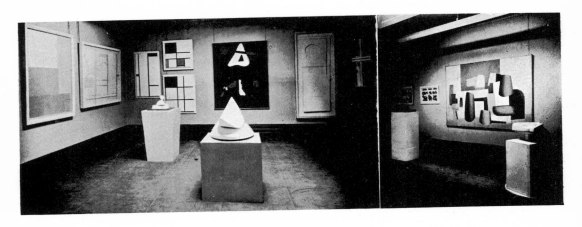

Calder, Domela, Gabo, Giacometti, Hélion, Hepworth, Holding, Jackson, Kandinsky, Miró, Moholy-Nagy, Mondrian, Moore, Nicholson, Piper.

'ABSTRACT ART IN CONTEMPORARY SETTINGS'— DUNCAN MILLER LTD. LONDON, 1936

Gabo, Giacometti, Hélion, Hepworth, Holding, Jackson, Miró, Moholy-Nagy, Mondrian, Moore, Nicholson, Piper, Woods.

280

'CONSTRUCTIVISM'—KUNSTHALLE, BASEL, 1937

Baumeister, Calder, Dexel, Doesburg, Domela, Eggeling, Freundlich, Gabo, Gorin, Hélion, Kandinsky, Klee, Kljunkov, Leck, Lissitzky, Malevich, Mondrian, Moss, Pevsner, Picasso, Richter, Rodchenko, Schwitters, Stazewski, Strzemski, Tatlin, Täuber-Arp, Vordemberge-Gildevart.

'ABSTRACT SECTION'—ARTISTS INTERNATIONAL ASSOCIATION, 1937

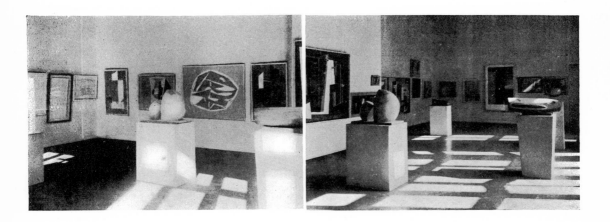

Angus, Dismorr, Freundlich, Glass, Hélion, Hepworth, Hitchens, Holding, Howard, Jackson, Kandinsky, Léger, McIntyre, Moholy-Nagy, Nicholson, Ozenfant, Piper, Stephenson, Thain, Woods, Yates.

'CONSTRUCTIVE ART'—THE LONDON GALLERY, 1937

Calder, Dacre, Gabo, Giacometti, Hélion, Hepworth, Holding, Jackson, Moholy-Nagy, Moore, Nicholson, Piper, Stephenson.

BIBLIOGRAPHY

This list of books and periodicals is not intended to be a general bibliography, but includes only a selection of the more recent publications which have special reference to the contents of '*Circle*.' Those who wish to consult a more general list of references should consult the well-arranged bibliography in Mr. Alfred H. Barr's book '*Cubism and Abstract Art*', published by the Museum of Modern Art, New York, in 1936, or the excellent list of books compiled by Konrad Faber and included in the Catalogue of the '*These, Antithese, Synthese*' exhibition, which took place in 1935 in the Kunstmuseum, Lucerne.

BOOKS

BARR, Jr., Alfred H. *Cubism and Abstract Art*, Museum of Modern Art, New York, 1936. 3 dollars.

BAUER, Catherine. *Modern Housing*, Houghton, Mifflin Co., U.S.A., 1934.

GIEDION, Dr. S. *Bauen in Frankreich, Bauen in Eisen, Bauen in Eisenbeton*, Leipzig.

GIEDIEON-WELCKER, C. *Modern Plastic Art*, Ed. Dr. H. Girsberger, Zurich, 1937. 15s.

GROPIUS, Walter. *The New Architecture and the Bauhaus*, Faber & Faber, London, 1935.

LE CORBUSIER and Pierre Jeanneret. *Œuvre Complète de 1910-1929*, Ed. Dr. H. Girsberger, Zurich.

LE CORBUSIER and Pierre Jeanneret. *Œuvre Complète de 1929-1935*, Ed. Dr. H. Girsberger, Zurich.

LE CORBUSIER. *La Ville Radieuse. Editions de l' Architecture d' aujourd' hui.*

LIVING ART, *Museum of. A. E. Gallatin Collection*, Catalogue 1937. New York University.

LOGHEM, J. B. van. B.I. *Bouwen, Bauen, Batir, Building 'Kosmos'*, Amsterdam.

LURCAT, André. *Groupe Scolaire de Villejuif. Editions de l' Architecture d' aujourd' hui.* 15 francs.

BIBLIOGRAPHY

McGRATH, Raymond. *Twentieth Century Houses*, Faber & Faber, London, 1934.

MOHOLY-NAGY, Ladislaus. *The New Vision*, Brewer, Warren & Putnam Inc. New York.

MUMFORD, Lewis. *Technics and Civilization*, Routledge & Sons, Ltd., London, 1934.

NELSON, Paul. *Cité Hospitalière de Lille. Cahiers d'Art*. Special Number, Paris, 1933.

PEVSNER, Nikolaus. *Pioneers of the Modern Movement*, Faber and Faber, London, 1936.

READ, Herbert. *Art and Society*, Heinemann, London, 1937. 10s.

READ, Herbert. *Art Now*, 2nd Edition, Faber & Faber, London, 1936. 8s. 6d.

READ, Herbert. *Art and Industry*, Faber & Faber, London, 1934.

ROTH, Alfred. *Architecture, Contemporary Problems—Contemporary Solutions*, Dr. H. Girsberger, Zurich, 1937.

SARTORIS, Albert. *Gli Elementi dell' Architettura Funzionale*, Ed. Ulrico Hoepli, Milano, Italy.

SWEENEY, James Johnson. *Plastic Redirections in Twentieth Century Painting*, University of Chicago, 1934. 7s.

'THESE, ANTITHESE, SYNTHESE', Catalogue, Kunstmuseum, Luzern, 1935.

TSCHICHOLD, Jan. *Typographische Gestaltung*, Benno Schwabe, Basel, Switzerland, 1935.

YORKE, F. R. S. *Modern House*, The Architectural Press, London, 1934.

Housing, published for The Building Centre by the Rolls House Publishing Co., Ltd., Vol. I, London, 1937. 30s.

PERIODICALS

Abstraction-Création, 26 Boulevard Masséna, 13ᵉ, Paris, 1933-

The Architectural Review, 9 Queen Anne's Gate, Westminster, S.W. 1, London, Monthly, 2s. 6d.

A.T.O. Bulletins, Sec. F. Skinner, 15*a* Gloucester Gate, London, 4d. each.

Axis 1935, 1936, Ed. Myfanwy Evans, Fawley Bottom Farmhouse, Henley on Thames, Oxon., England. Quarterly, 2s. 6d.

Cahiers d'Art, Ed. C. Zervos, 14 rue du Dragon, 14ᵉ, Paris.

The Concrete Way, The B.R.C. Engineering Co., Ltd., London, Monthly, 9d.

Gaceta de Arte, Ed. Eduardo Westerdahl, appartado 223, Santa Cruz de Tenerife, Islas Canarias. Quarterly, 15 pesetas annually.

BIBLIOGRAPHY

De 8 en Opbouw, Amstel 22, Amsterdam. Price 30c.

Plastic—Plastique, 21 Rue des Chataigniers, Meudon, S.-et-O., France, annually, 25 francs.

Praesens, by Senatorska, 38/13, Warszawa, Poland.

Rationelle Bebauungsweisen, Julius Hoffmann Verlag, Stuttgart.

Telehor, Ed. Fr. Kalivoda, 37 Plotni, Brno, Czechoslovakia.

Ter es Forma, Ed. Dr. Virgil Bierbauer, Budapest II, Zarda u. 57.

Transition, Eds. Eugene Jolas and James Johnson Sweeney, 113 West 42 Street, New York, U.S.A. Quarterly, 50c. English agents: Messrs. Faber & Faber Limited, 24 Russell Square, London, W.C. 1. 2/6 net each issue, or 10/- per annum.

Warszawa Funkcjonalna, by Senatorska, 38/13, Warszawa, Poland.

Weiterbauen, Dianastrasse 5, Zurich, Switzerland.

284

INDEX TO ILLUSTRATIONS

PAINTING

285

INDEX TO ILLUSTRATIONS

INDEX TO ILLUSTRATIONS

ARCHITECTURE

INDEX TO ILLUSTRATIONS

288

GENERAL INDEX

GENERAL INDEX

ACKNOWLEDGMENTS

THE editors wish to express their thanks to all who have assisted them in preparing this book and specially to the following:

Professor Erich Roll for his translations and his readiness to assist in all matters of language difficulty.

Mr. P. Morton Shand for his permission to reproduce the illustrations which form Plates 1, 2, 23, 24 and 25 of the Architecture section and others used to illustrate the two English versions of the articles by S. Giedion and Karel Honzík which he also kindly provided for this book.

Mrs. C. Giedion-Welcker and Professor Walter Gropius for permission to reproduce the photographs, taken by them of Stonehenge.

Mr. Jan Tschichold for the photograph for plate 15, Painting section.

The Mayor Gallery for the photograph for plate 38, Painting section.

The *Architectural Review* and the Architectural Press for permission to include illustrations on plates 28, 29, 49, and plate 20, Sculpture section.

The Concrete Way for kindly loaning several of the blocks.

Plate 7B, page 129, is taken from *Ancient Civilisations of the Andes*, by Philip Ainsworth Means, by kind permission of the publishers, Charles Scribner's Sons.

Plates 13 and 14 are taken from Le Corbusier, *Œuvre Complète de 1929-35*, by kind permission of the editor, Dr. Girsberger, and the editors are indebted to the editors of *L'Architecture d'Aujourdhui* for plates 15 and 16.

This list of acknowledgments would not be complete without a word of thanks to Miss S. Speight, Miss Barbara Hepworth, Mr. Herbert Read and Mr. Richard de la Mare.